Dawn Ades has written about many aspects of Dada and Surrealism: her publications include *Dada and Surrealism Reviewed* (1978), *Photomontage* (1986), *Dalí* (1995), *Surrealist Art* (1997). Previous studies of Duchamp include *Marcel Duchamp's Travelling Box* (1982). Among the exhibitions she has organized are 'Art in Latin America' (1989) and 'Salvador Dalí: The Early Years' (1994). She was co-curator of 'Art and Power' (1985) and 'Fetishism: Visualizing Power and Desire' (1995). She is Professor of Art History and Theory at the University of Essex.

Neil Cox is lecturer in Art History and Theory at the University of Essex. He is the author (with Deborah Povey) of *A Picasso Bestiary* (1995) and is currently working on books on Cubism and the Surrealist cult of the Marquis de Sade.

David Hopkins is the author of *Marcel Duchamp and Max Ernst: The Bride Shared* (1998) and numerous articles on Dada and Surrealism. He currently lectures at the University of St Andrews and is working on a study of art since 1945.

World of Art

This famous series provides the widest available range of illustrated books on art in all its aspects. If you would like to receive a complete list of titles in print please write to:

THAMES AND HUDSON
181A High Holborn
London WC1V 7QX

In the United States please write to:

THAMES AND HUDSON INC.
500 Fifth Avenue
New York, New York 10110

Printed in Singapore

D0924273

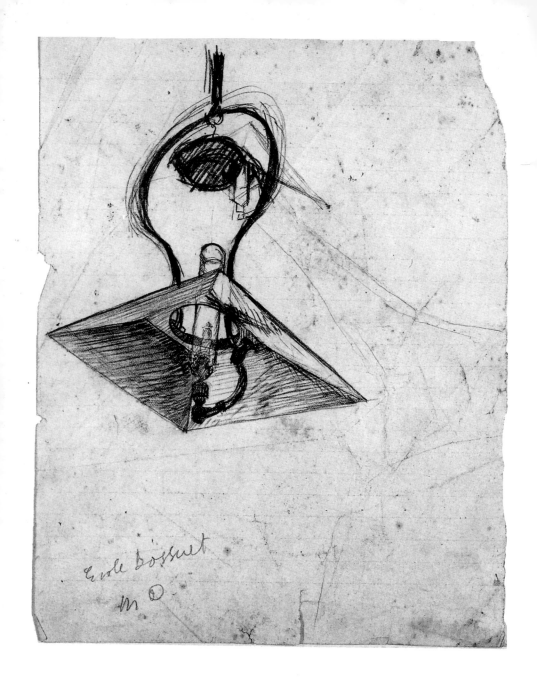

1. *Hanging Gas Lamp (Bec Auer)*, 1903–4

Dawn Ades, Neil Cox and David Hopkins

Marcel **Duchamp**

164 illustrations, 42 in color

THAMES AND HUDSON

Acknowledgments

*Without the generous assistance and considerate advice of
Madame Alexina (Teeny) Duchamp and of Jacqueline Matisse,
her daughter, this book could not have been written. We owe
them a great debt of gratitude, and dedicate this book to the
memory of Teeny, who died in 1995. We would also like to thank
Tamar Francis for her invaluable help at a critical moment.*

First published in paperback in the United States of America in 1999 by
Thames and Hudson Inc., 500 Fifth Avenue, New York, New York 10110

Library of Congress Catalog Card Number 98-61434
ISBN 0-500-20322-9

Designed by Derek Birdsall
Typeset by Omnific
Printed and bound in Singapore

Contents

Preface

Critical histories still have to be written on Duchamp's legacy and his precise influence on major areas of art for over three quarters of a century, while others already published are likely to be tested and dismantled. The construction of his reputation has been in progress since before the First World War and he has been a controversial figure ever since. The scale and longevity of the controversies around him obscure the fact that he himself in no way actively courted this notoriety. Unlike, say, Francis Picabia, Jeff Koons or Damien Hirst, to name only a few examples of artists who have used his ideas and operated on very public platforms, Duchamp's own activities were often disguised or pseudonymous and their effects have often been delayed.

Divisions of opinion about his work are different in kind from those provoked by, for instance, Picasso, with whom it is largely a matter of taste, of liking or disliking his reconstructions and representations of objects and bodies. In the case of Duchamp, it is not only the works he produced themselves that have had an effect but also his whole attitude to art, the artist and the institutions of art. He posed basic questions concerning both the definition and the survival of art in the twentieth century. Merely to question, in a Darwinian spirit, as he did, whether art is an essential and time-less phenomenon and in what new forms it might survive in the modern world has been seen by many as an act of iconoclasm or of bad faith. For others, Duchamp's legacies – for they should be recognized as plural – have offered a sense of liberation from orthodoxies of various kinds, a salutary cleansing of accumulated aesthetic detritus and a release of art from what he considered to be the unquestioned tyranny of the eye.

A conceptual view of art has various strands and sources in Duchamp's work and writings. Of most lasting impact have been the questions raised by the readymades and their offshoots, the rejection of painting as a privileged artistic activity and the withdrawal from an art career as a profession.

Duchamp's critics have to contend with the undeniable scale and diversity of his legacies, whether they like it or not. To dismiss his attitude or seek to incriminate him and demonstrate its fallacies is to reject large swathes of twentieth-century art. This, of course, is part of his attraction for those who see little or nothing of value in it. The view that he conned the public with tricks comparable to the 'Emperor's new clothes' has been a fairly common criticism not only by the wider public but also by art historians, critics and dealers. The insistence that Duchamp represents a dead end becomes ridiculous when much of twentieth-century art is informed by his example. Some historians and critics identify him with the negative side of modernism, seeing him as symptomatic of the collapse of the relationship between art and society, as as a minor figure encompassing the worst aspects of our times. Much of this debate overlooks Duchamp's originality, not only in opening up conceptual approaches to art but also in his inventiveness in terms of the materials and mediums that can be used in making it. If artists, as some hold, have misunderstood his ideas, their lack of comprehension has led unexpectedly to new forms of creativity, which are part of his legacy. The book about Duchamp's legacies remains to be written. This book concerns his actual work that had, and still has, such a profound effect on the ways of thinking about and making art.

Chapter 1: Origins

Henri-Robert Marcel Duchamp was born in the Normandy vill-
age of Blainville-Crevon, near Rouen, on 28 July 1887. The fourth
of seven children, of whom six survived infancy, Marcel, his two
older brothers, Gaston (1875–1963) and Raymond (1876– 1918),
and his younger sister Suzanne (1889–1963) all became artists.
Eugène Duchamp, his father, was the notary in the village: that is,
local tax-collector, lawyer and financial advisor, and later mayor.
Eugène's parents were café owners in the Auvergne, and he was
able to purchase the notarial practice at Blainville thanks to the
dowry of his wife, Marie-Caroline-Lucie Duchamp (née Nicolle),
whose father Emile-Frédéric Nicolle had made a fortune as a
shipping agent in Rouen. Following his business success, Emile
devoted himself to art; in 1878 he was admitted to the Beaux-Arts
section of the World Fair in Paris and became one of Rouen's most
renowned artists with his etchings of the local landscape.

Duchamp later acknowledged his grandfather's artistic
influence on him, but was less flattering about his mother's artistic
talents, describing her watercolours as totally uninteresting. The
example of his two older brothers, both of whom had already
begun to pursue artistic careers by the time he joined them in Paris
in 1904, was important to Duchamp. Both had abandoned careers
in the traditional professions, law and medicine, to launch them-
selves into the much more precarious arena of modern art.
Duchamp's father seems not to have discouraged any of them in
this uncertain enterprise, but to have given them financial sup-
port, which he then meticulously deducted from their inheritance.

Gaston Duchamp had changed his name to Jacques Villon in
1894, possibly out of admiration for the fifteenth-century poet-
outcast François Villon. At the same time he abandoned his legal
training and entered the Paris studios of the academic painter
Fernand Cormon, who had taught Toulouse-Lautrec, Emile
Bernard and Vincent van Gogh. Perhaps following his grand-
father's example, Villon later made a name for himself as a print-
maker, a painter and, especially, a producer of fine prints of modern
paintings.

Raymond Duchamp added 'Villon' to his surname in 1899 when he abandoned his medical training to study sculpture. His tragically short career reached its climax in 1914 with his *Great Horse*, which melds animal and machine elements into a dramatic image of modernity. Both of Duchamp's older brothers moved in the most advanced artistic circles in Paris and were dominant figures in the pre-war Cubist group.

Duchamp said little about his youth, except to remark that he had a perfectly happy and ordinary childhood. In fact, his upbringing may well have encouraged certain traits in him that later supported such a dramatic break, not only with traditional artistic canons, but also with the modernist circles to which his brothers belonged. The French critic Michel Sanouillet describes the characteristics of the class of 'provincial notables' to which the Duchamp family belonged: 'Discretion, prudence, honesty, rigor of judgment, concern for efficiency, subordination of passion to logic and down-to-earth good sense, controlled and sly humor, horror of spectacular excesses, resourcefulness, love of puttering, and, above all, methodical doubt.'

Alongside these social traits, reinforced by his father's work and personality, Duchamp received a formal French education. The most formative years were spent at the Lycée Corneille, Rouen, where his predecessors included not only his brothers but also the great French literary figures Pierre Corneille, Gustave Flaubert and Guy de Maupassant. At the age of ten Duchamp was sent to board at the Ecole Bossuet, whilst studying at the lycée. Half of the seven hundred boys were boarders, and all the pupils followed a strict diet of philosophy, history, rhetoric, mathematics, science, German, Latin and Greek. Duchamp would also have received training in drawing, in what has been called 'the language of industry', a rigorous system based upon abstract geometrical principles and on the mechanical drawing of simple objects. Slightly different programmes were taught depending on the gender of the pupil: both sexes learned perspective, but the boys learned projection as well. Representation was thus potentially double. The resources of this theoretical language were later used and manipulated by Duchamp at many levels. One early drawing, *Hanging Gas Lamp (Bec Auer)* of 1903 to 1904, which hung in the Ecole Bossuet, was prophetic. It seems to be the first appearance of the so-called 'Illuminating Gas', which later animates his two major works – *The Bride Stripped Bare by Her Bachelors, Even*, also known as the *Large Glass*, of 1915 to 1923, and *Etant donnés: 1. La chute d'eau 2. Le gaz d'éclairage (Given: 1. The Waterfall*

1

61

150

151

2. The Illuminating Gas) of 1946 to 1966, both of which are now in the Philadelphia Museum of Art.

Formal schooling also involved considerable attention to discipline and general secular 'moral principles', following on from the national primary school exam on a book called *Civic and Moral Instruction*, as well as the study of the catechism of the Catholic Church. (The constitutional link between the Church and the French Republic was not dissolved until 1905.) Catholicism formed an uneasy part of the pragmatic and commercial world represented by Duchamp's father, although Catholic ritual still took an important place in the domestic life of many French families. It was not unusual to have one agnostic or atheist parent, in most instances the father, and one believer, usually the mother,

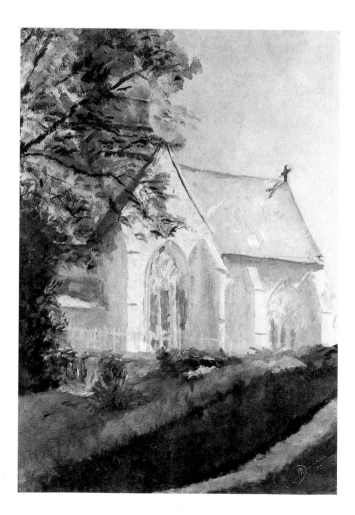

2. *Church at Blainville*, 1902

as was the case for Duchamp. In 1898 Duchamp took his First Communion, at the church in Blainville with five girls and three other boys. This church, which stood close to his house, appears four years later in one of Duchamp's earliest surviving paintings, *Church at Blainville* (1902). As Duchamp pointed out in a lecture in 1964: 'I was still attending school in Rouen at the lycée and two of my classmates were starting to paint. We exchanged views on Impressionism, which was the art revolution of the moment and still anathema in official art schools. However, my contact with Impressionism at that early date was only by way of reproductions and books, since there were no shows of Impressionist painters in Rouen until much later. Even though one might call this painting "Impressionistic" it really shows only a very remote influence of Monet, my pet Impressionist at that moment.'

In the autumn of 1904, Duchamp joined his brothers in Paris, where Jacques Villon was now earning a meagre living as a commercial illustrator. The old Bohemia of nineteenth-century Paris was undergoing dramatic changes. The so-called *belle époque*, the period before the beginning of the First World War, celebrated new leisure activities, captured in the Impressionist painters' images of boating parties, balls, suburban cafés and music halls, while Bohemian artists living on the margins of society dedicated their life to art. Yet at the same time social and political tensions ran high, especially over issues of national identity, the role of women and changing class boundaries. France was rocked by a series of scandals, and deep divisions in society were revealed by such events as the Dreyfus affair during the 1890s, which raised important political issues concerning anti Semitism. At this time Paris was also hit by anarchist bombings. Moreover, Paris was changing physically; railways and new boulevards were carved through the city in a massive thrust of development and urban expansion.

These changes were highly visible from the Rue Caulaincourt in Montmartre where the Duchamp brothers lived on the edge of the *maquis*, which literally means 'scrub' or 'bush'. This Bohemian area of Montmartre contained a ramshackle collection of buildings scattered over the hill, with small farms interspersed with low-life cafés and restaurants, the haunts of artists and their models. At the top of the hill stood the Moulin de la Galette, one of the many windmills formerly operating on the hill that had been converted into a famous working-class *café-concert*. It was sketched by Duchamp from a window of Villon's apartment between 1904 and 1905. From his room Duchamp watched the old *maquis* disappear

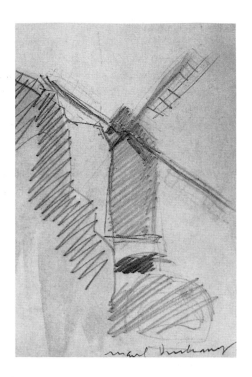

and modern apartment blocks go up in its place. The unofficial artistic community found new ways of interpreting modern city life. It was Duchamp's luck, born into the turn of the century, to be able to apply his intelligence to the emergence of modern life out of the old Bohemia. During his early months in Paris, Duchamp worked to improve his drawing skills while absorbing the life of the city people, with the idea perhaps of becoming the 'painter of modern life' celebrated by Baudelaire. He carried his sketchbook about in the streets and made numerous hasty pencil portraits of his brothers. The *Portrait of Jacques Villon* (1904–5) is an attempt to capture the energy and concentration of the working artist. This drawing may well have been executed after Duchamp had enrolled at the Académie Julian, a private art school founded in 1873, whose most famous teachers were two professors from the Ecole des Beaux-Arts, Adolphe-William Bouguereau (1825–1905), the painter of mythological fantasies and sugary academic nudes, and Jules Lefebvre (1836–1911). We do not know who taught Duchamp, but by his own account he spent more time at the local café playing billiards than in the studio. The proprietor of the Académie, Rodolphe Julian, ran a fair but strict regime geared towards the official Salon or entry to the Ecole des Beaux-Arts.

Duchamp clearly lacked commitment to either. Thus his first great failure as an aspiring artist came when, in the spring of 1905, he entered the biennial competition for a place at the prestigious Ecole, the key to a successful professional career. Duchamp was one of four hundred candidates whose three drawings – perspective, sculptural and figure study – were judged by a panel of four, including Bouguereau and Cormon. It is suitably ironic, given his later work, that his nude figure study was apparently Duchamp's downfall.

Meanwhile, Villon's moderate success in the field of paid caricature – for papers such as *Cocorico, Le Rire* and *Le Courrier français* – provided a natural introduction to the caricaturist group and also to a number of other young artists, including the Czech Frantisek Kupka (1871–1957), Louis Marcoussis (1883–1941)

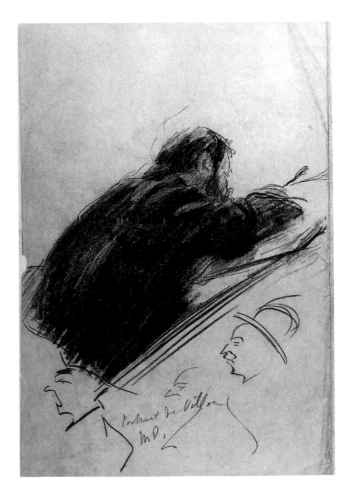

4. *Portrait of Jacques Villon*, 1904–5

from Poland (both neighbours of Villon), the Dutchman Kees van Dongen (1877–1968) and the Spaniard Juan Gris (1887–1927), whose interest lay less in the conventional Salons and for whom caricature offered a temporary way of making a living. So it was, out of a combination of failure and genuine attraction, that Duchamp's greatest interest at this time was stirred not by academic or avant-garde painters, but by the Parisian humorists, caricaturists and poster-artists who frequented the Café Manière on the Rue Caulaincourt. This group of renowned, larger-than-life café figures had an artistic and cultural status that is now perhaps hard to understand. They included Caran d'Ache, Adolphe Willette, Abel Faivre, Lucien Métivet, Charles Léandre, Jean-Louis Forain, Georges Huard and Théophile Steinlen and they continued the tradition of such great nineteenth-century graphic artists as Gustave Doré, Jean-Jacques Grandville and Honoré Daumier. As we shall see, the work of this group spanned two key aspects of recent French culture and society: a philosophical interest in the comic and a fascination with the darker side of life and bad taste.

After his Beaux-Arts failure, however, Duchamp's aspirations were obstructed on another front, when a new law made two years of military service compulsory. Duchamp was quick to discover that a concession of one year was available to 'art workers' and he returned to Rouen to take a crash course as a printer using his grandfather's connections. He passed the final exam with ease and not a little guile, providing each member of the jury with a copy of a print he had pulled himself from one of his grandfather's plates. His written dissertation was concerned with the work of Leonardo da Vinci. When he had finished, Duchamp took a holiday and at the end of 1905 began his one year's army service.

In October 1906 he returned to Montmartre and took an apartment of his own at 65 Rue Caulaincourt, while his brothers moved westwards out of the centre of Paris to Puteaux, a developing artists' community, where Kupka joined them. Duchamp now pursued commercial drawing and in the summer of 1907 exhibited in the first Salon des Artistes Humoristes, organized by the editor of *Le Rire*, at the Palais de Glace. Five drawings were on show, including *Femme Cocher (Woman Taxi Driver)* and *Flirt (Flirtation)*, both 1907. These drawings show Duchamp's remarkable consistency of themes, as they are concerned on the one hand with the profane marriage of woman to machine and on the other with the sexual pun, whose double edge was later invested by Duchamp with great symbolic meaning. In 1906 women were given the

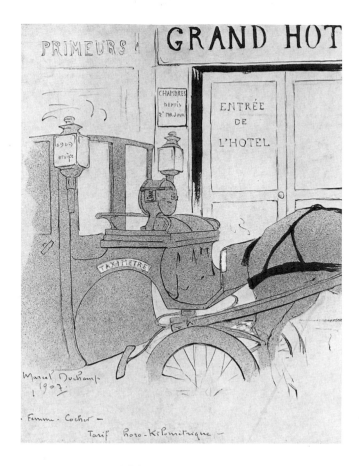

5. *Femme Cocher*
(Woman Taxi Driver), 1907

right to work as taxi drivers and *Femme Cocher* was an up to the minute but rather predictable comment on this new addition to the Parisian workforce. Suffragettes and other *féministes* had fought hard for women's right to such equal employment. Their success was accompanied in November 1906 by the introduction of the clockwork taxi-meter. Duchamp's drawing shows the cab, with meter running, parked outside a hotel. The inference is clear that the woman 'in the driving seat' is also metering sexual favours. The inscription at the bottom includes the phrase *Tarif horo-kilo-métrique* ('time-distance fare'), and in the centre we read *Chambres depuis 2f par jour* ('rooms from 2 francs a day'). From now on Duchamp would be increasingly fascinated by mundane commercial and technical language, investing it with double meaning and human significance at every turn. Ideas of metering, establishing tarifs and claiming efficiency are all turned hilariously sour by him as they become directly rather than indirectly attached to human

functions. In this cartoon lurks the sardonic poetry of the set of notes, *The Green Box* (see Chapter Five), where the Bride runs on 'love gasoline'. In *Femme Cocher*, the taxi stands in for the woman.

Flirt is a different kind of drawing. It features two silly would-be lovers engaged in verbal foreplay, seated at a grand piano:

She: *Would you like me to play 'Over the Waves'? You'll see how well this piano conveys the impression the title suggests.*
He (wittily): *Nothing odd about that, Mademoiselle, it's a watery piano.*

There are two levels of pun here: one is simply the equivalence in French of *piano à queue* ('grand piano') with *piano aqueux* ('watery piano'). The second is more risqué, however, since *piano à queue* might also literally be interpreted as 'piano with tail' or 'prick'.

Duchamp produced very few paintings between 1902 and 1909, continuing to publish humorous illustrations instead. His involvement in the caricaturists' circle must have familiarized him with current arguments about humour and its role in society, which had a distinguished genealogy in French literature, including two prominent figures, Charles Baudelaire (1821–67) and Henri Bergson (1859–1940). Duchamp later acknowledged the

6. *Flirt (Flirtation)*, 1907

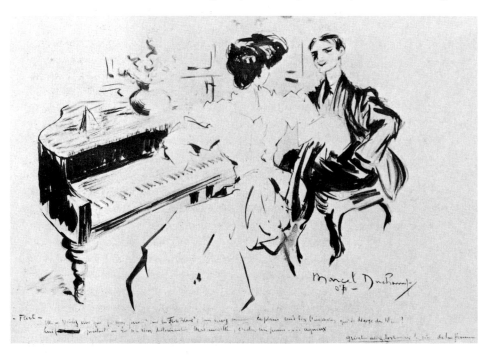

importance for him of two other writers whose non-conformist attitudes to society were expressed in humorous form, Rabelais (*c.* 1483–1553) and Alfred Jarry (1873–1907). Charles Baudelaire's theory of laughter is contained in his highly influential 'On the Essence of Laughter and, in General, on the Comic in the Plastic Arts' (1855). In this he argues that caricature is 'a double thing: it is both drawing and idea – the drawing violent, the idea caustic and veiled'. The artist who creates the comical for us will be aware, unlike ourselves, of its double nature. The higher any society aspires towards absolute goodness, the more it must laugh at what remains of evil, of the animal, of brute matter, and thus its ascent is undermined. In this way comic artists indicate the permanent dualism of the human being, taking both the position of the one who laughs and the one laughed at. They must possess 'the power of being oneself and someone else at one and the same time'. Baudelaire's clever rhetoric, which gave voice to a Satanic struggle between the noble and the brutish, his sense of the double nature of the comic and finally his bestowal on the artist of a divine knowledge of both good and evil transformed thinking about caricature as an art form in France.

Bergson's *Le Rire* (an essay on the meaning of humour) reached a wide public through the *Revue de Paris* of 1900. It is written in the clear and elegant prose for which his very popular lectures at the Collège de France made him famous. Bergson argued that laughter belongs to the category of the human: it is not to be found in animals and anything non-human that provokes laughter does so only because of its connection to human life: 'You may laugh at a hat, but what you are making fun of, in this case, is not the piece of felt or straw, but the shape men have given it – the human caprice whose mould it has assumed.' Furthermore, Bergson points to 'the absence of feeling which usually accompanies laughter' and states that 'indifference is its natural environment'. Baudelaire acknowledged this absence of feeling, but it was Bergson who explained its meaning. The appeal of laughter for him 'is to the intelligence, pure and simple'. Echoes of these ideas are to be found in Duchamp's later work and ideas as well as in his caricatures.

Bergson insists that laughter serves some social purpose. Taking Baudelaire's example of a man who falls in the street, Bergson argues that the crucial intellectual element of comedy here is the 'involuntary element' of the fall: the man suffers from 'rigidity of momentum', from failing to be flexible enough to cope with the everyday obstacles of the pavement. In the same way,

Bergson finds amusement in the creature of habit, who falls prey to the practical joker: dipping his pen in the inkwell in its usual place, he finds instead a pot full of mud. Bergson goes on to develop from these instances of external circumstance the idea of the internal stumbling block, which resides in the personality of the victim. Thus absent-mindedness is described as a sort of automatism, whereby those not sufficiently responsive to immediate circumstances carry all sorts of inappropriate actions from the past or from their daydreams. Hence the humour of Don Quixote's entirely misplaced joust with a windmill. For Bergson, these faults represent deficiencies in relation to the demands of social life. Laughter is a social corrective to the mechanical inelasticity of certain habits. It is prompted by the organic needs of living human society, which requires that we all act freely. The enemy of society defined in this way is mechanical behaviour. Thus the humorous generally takes for its inspiration types rather than individuals. Duchamp's caricatures did exactly this: they traded on stereotypical social situations and remarks. They are, furthermore, fundamentally inspired by the relationship between the sexes. Duchamp was in part merely reflecting the burning issues of the day, but the erotic jokes preserve Baudelaire's connection between the acquisition of carnal knowledge and the humorous cocktail of superiority and shame.

7. (below left) *Au Palais de Glace (At the Skating Rink)*, 1908

8. (below right) *Feminism (The Lady Curate)*, 1908

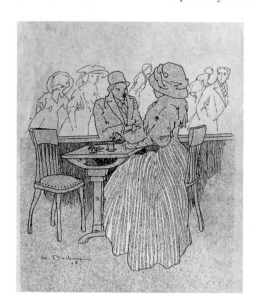

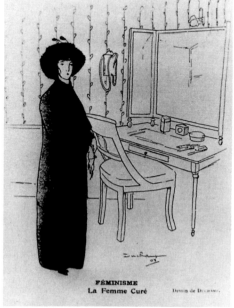

FÉMINISME
La Femme Curé Dessin de Duchamp

It has been suggested that Duchamp's view of modern social life was touched with some of Baudelaire's pessimism. Indeed, his caricatures seem to show a particular cynicism towards women. *Au Palais de Glace (At the Skating Rink)* of 1908, for example, shows a couple observing the skaters:

She: *You see how many people are wearing tricornes this year?*
He: *Oh! you know, a horn or two is always in fashion.*

The pun refers to the old metaphor of the cuckold as horned beast and the reputation of the skating rink as an adulterers' rendez-vous. Once again, Duchamp takes an aspect of contemporary life, a fashion in hats, and re-casts it as a sign of human sexual relations. Furthermore, it is women who do the cuckolding: they wear the hats, but not the horns. This could be taken, as in *Femme Cocher*, either as a mark of contempt for women as guileful and salacious or as a sign of approval for their new-found resourcefulness at the expense of men.

The ambivalence of these caricatures may be more striking today than it was at the time. Nonetheless, Duchamp's attitude to women remains a central question throughout his work. The poets and writers then admired by Duchamp betrayed a chauvinist gloom about sexual relations between men and women. He also took a negative view of women's claims to greater financial independence and equality in the workplace. There were fierce debates about the social position of women around the turn of the century in France. Middle-class women demanded modifications to the Civil Code so that they could have greater control of family finances. In 1907, for example, married women won the right freely to dispose of their own salaries. Such modest alterations to the law were fiercely resisted by conservative politicians and writers, who also worried about the unforeseen consequences of the recent (1880) introduction of secondary education for women, which had led to a rapid increase in the number of women in professional positions. The black-clad *femme curé* ('woman curate') in *Feminism* (1908) might be a satirical comment on women in the professions. There was also great concern about the falling birth rate in France, particularly as there had been a rapid expansion in the population of neighbouring Germany. These worries continued well into the next century. The strength of the conservative reaction can be measured by the fact that women only received the vote after the Second World War in France, while in Britain women's suffrage was achieved in 1918 (although limited until 1928 to women over the age of thirty).

This anxiety about the new woman found expression in two related popular stereotypes. The first was the *femme-homme* or *hommesse* ('man-woman'). Criticism of feminism was conducted through this chimerical figure of the woman who has lost or rejected all her 'feminine charms' in favour of a masculine style and conduct. Favourite attributes of the *femme-homme* were the cigarette, the bicycle and men's cycling trousers; the misleadingly titled *Young Man Standing* (1909–10) probably depicts a *femme-homme*. The other stereotype, developed particularly on the stage, was the frivolous flirt of the *belle époque*: scatterbrained and promiscuous. Duchamp's caricatures used both these images.

It is notable that Duchamp's caricaturist friends were not interested in the avant-garde painters whom we now think of as most important in early twentieth-century Paris: Cézanne

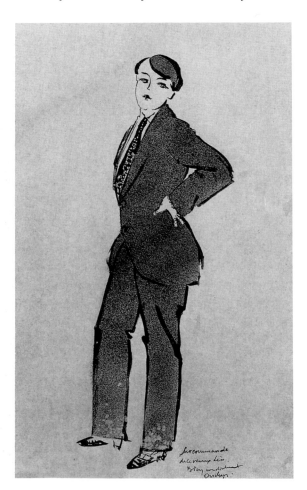

9. *Young Man Standing,*
1909–10

(1839–1906), Gauguin (1848–1903), Van Gogh (1853–90). Rather, their conversation focused on Edouard Manet (1823–83), probably because he had insisted on depicting 'modern life' and also because he cultivated a special personal image of the dandy. There is a subtle but important difference between this way of life and that of the dissolute and rebellious 'Bohemian'. Manet always denied the charge of Bohemianism when it was levelled against him by angry critics. This cool denial of revolutionary ambition – connecting with the horror of excess typical of Duchamp's own class – testifies to the sophistication of taste to which dandyism in art was directed. It assumed in its audience not a revolutionary instinct, but a private and delicate wit. The dandy was an observer, withdrawn and aloof, and as such passed unnoticed. The mixture of these self-imposed demands – to be withdrawn from everyday

10. *Man Wearing a Top Hat*, 1909

life, but to observe it and find enjoyment precisely in its most mundane moments – made for a sublime aristocratic challenge. As Baudelaire pointed out: 'The distinguishing characteristic of the dandy's beauty consists above all in the air of coldness which comes from the unshakeable determination not to be moved.' Few elements of Manet's dandyism are to be seen in Duchamp's behaviour, dress and appearance, but this is consistent with the fact that dandyism had been much transformed in the intervening period. By the time Duchamp came to draw his own dandies in 1909, such as *Man Wearing a Top Hat*, real dandyism had developed into something more negative and intellectual than Manet's had been, while it had acquired an erroneous but stable popular image in snappy dressing.

The principal source for Duchamp's own bitter form of dandyism was the poetry of Jules Laforgue (1860–87), which takes a sceptical attitude to love. The main characteristic of Laforgue's poetry was a strange combination of deep pessimistic despair – directed above all at the pettiness and meaninglessness of urban existence – with nonchalant irony. Life is an endless parade of desolate *Dimanches (Sundays)*, where love is regarded as a mental invention to conceal a monotonous round of desires: *Histoire humaine: – histoire d'un célibataire* ('Human history: –

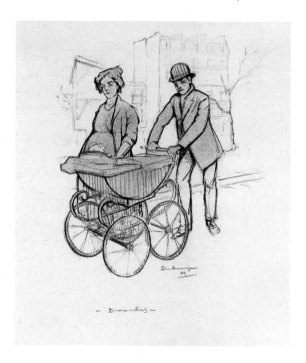

11. *Dimanches (Sundays)*, 1909

22

history of a bachelor'). The notion that life can be lived only in bachelorhood does not refer to real celibacy, but rather to the doubt in the possibility of reciprocal sexual love. For the Laforguian dandy, this doubt is profoundly depressing, though the depression constantly provides the material for a dry parody of poetry. In the sonnet *Triste, triste* ('Sad, sad'), for example, the poet concludes with off-hand melancholy: *comme nous sommes seuls! comme la vie est triste!* ('How alone we are! How sad life is!'). The ideas that Duchamp found in Laforgue's poetry fed straight into his caricatures and their cool mockery of trivialized love, marriage and flirtation. Like Baudelaire's caricaturist, Duchamp smiles wryly at his victims, in the superior knowledge of the universal bachelor condition. The absurd mechanical behaviour of human courtship is seen through the eyes of an ironic intellectual observer with the 'unshakeable determination not to be moved'. His corrective humour is not marked by Bergson's optimism towards society, for Duchamp regards social life as the cause of the problem. Duchamp's position is not definitive, but an amused embrace of the desolate *Mediocrity* (a title Duchamp later borrowed for a drawing) of Laforgue's bachelor. Dandyism now consists in the rigorous preservation of this emotional isolationism, whilst living life as freely as desires dictate. The dandyism of detachment to which Duchamp adhered as a code for many years after was explored by his friend, the writer Henri-Pierre Roché, in the *roman à clef* entitled *Victor*, which describes Duchamp's wartime years in New York, while the 'bachelor' became one of the key figures in Duchamp's ironic universe.

In 1905 a startling juxtaposition at the Salon d'Automne tested the opinions of Duchamp and humorists about modern painting. There was a large retrospective of the work of both Manet and Jean-Auguste-Dominique Ingres (1780–1867). Alongside these French 'masters' was a daring display of the most modern, even offensive canvases in the so-called *cage aux fauves* ('wild beasts' cage'), in a separate room. The leader of this rebellious group was Henri Matisse (1869–1954), in some ways a descendant of Ingres, who continued to gain public notoriety as a Fauvist for the next few years. The brilliant colour and wild handling of these paintings had a profound impact on Duchamp, who noted in his dialogues with Pierre Cabanne: 'An important event for me was the discovery of Matisse, in 1906 or 1907.... It was at the Salon d'Automne of 1905 that the idea of being able to paint came to me.' As a result, Duchamp took up painting seriously from 1908 onwards.

Chapter 2: Catholicism and the Symbolist Inheritance

Duchamp's paintings from 1909 to 1910 possess a new sense of seriousness and artistic purpose at odds with the worldly pessimism of his caricatures. Painted at Veules-les-Roses in Normandy, *Saint Sebastian* (1909) has an austerity, a devotional quality that recalls Gauguin's painted calvaries of the late 1880s. Gauguin rooted his *Yellow Christ* (1889) in the Breton landscape, surrounded by kneeling peasants, and expressed the close connection between the religious symbol and intense everyday piety through dramatic juxtaposition and simplifications that were medieval or primitive in style. Duchamp also brings his saint down into the world by cutting off the picture just below the ledge, although retaining an angled viewpoint that suggests the height of the image on the wall as well as a kneeling spectator. He produces a troubling immediacy in a different way from Gauguin, however, by painting the saint's body as though it were flesh.

The importance of Duchamp's upbringing as a Catholic should not be underestimated. Even though he later adopted a wholly agnostic position, his lifelong fascination with eroticism was prompted, albeit in a negative way, by his religious background. As he said to Pierre Cabanne, eroticism was a way to 'bring out in the daylight' desires suppressed by Catholicism. Despite Duchamp's subsequent iconoclasm and his embrace of the non-conformist principles of Dada, of paradox and nihilism, his work continues to reflect Catholic symbology, even if in an unconscious way. Links can be made between the *Large Glass* and stained-glass windows, between the readymades and the highly charged, though often humdrum, relics of the saints and between the *Boîte-en-valise*, when unpacked, and portable altars. In the case 136 of *Saint Sebastian*, the continuous transposition of ideas from one idiom to another that informs Duchamp's work is signalled in the connection between the arrow-shot saint and the Bachelors shooting at the Bride in the *Large Glass*. A certain economy of thought always seems to operate.

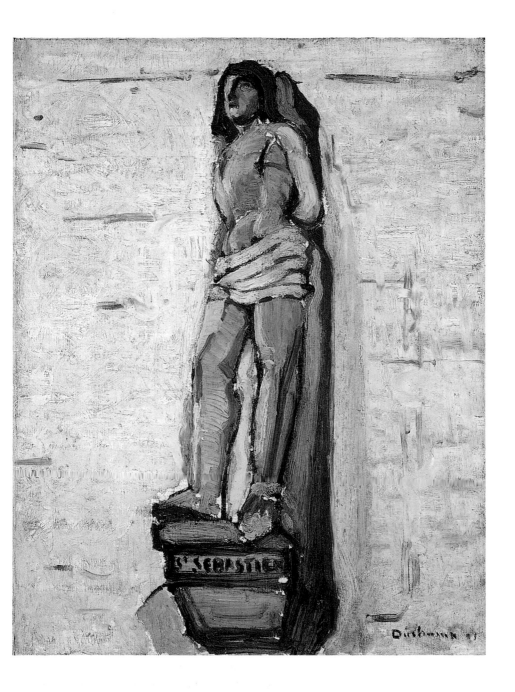

12. *Saint Sebastian*, 1909

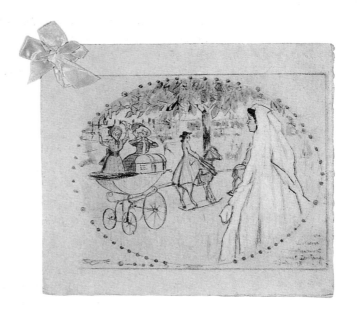

The card Duchamp made in 1909 for Simone Delacour, a family friend, on the occasion of her First Communion is a light-hearted look at the clash between the spiritual and the worldly. More importantly, though, the white dress of the young communicant prefigures the one she will later wear as a fully-fledged (but worldly) bride; she is thus an early incarnation of the Bride who will feature so prominently in later works like the *Large Glass* and function so disturbingly on both a spiritual and terrestrial plane.

From 1910 to 1911 Duchamp produced a strange sequence of paintings, with strong mystical or Hermetic connotations. They differ stylistically from earlier works in their free use of Fauve distortion, both in colour and in the treatment of the human figure, and Duchamp confirmed the Fauve influence of Matisse and Van Dongen. In his *Portrait of Dr Dumouchel* (1910), a medical student and friend, this influence is evident in the scrubby uneven patches of paint and the choice of the complementary green/pink-red hues. However, Duchamp linked the non-naturalistic use of colour with ideas of symbolic representation. A curious coloured emanation surrounds the figure's hand and his head is haloed in a deeper pink, which indicate the subject's possession of special powers. The probable source is the idea of the aura as promoted in Theosophical writings such as Annie Besant and Charles Leadbeater's *Thought Forms* (1896). Translated into French in 1908, this book included illustrations of different coloured auras indicating

14

spiritual health or state of mind. In the 1880s, Hippolyte Baraduc, a doctor, had enjoyed a certain notoriety in Paris for photographs purporting to reveal the auras emanating from the body in varying states of health. This kind of imagery could have informed Duchamp's interest in a symbolic representation of healing. Here, the two ideas, of aura and of the heightened and non-naturalistic use of colour, merge in an interesting if not wholly harmonious way. Duchamp's brief attraction to Theosophy, which brought together elements from both eastern and western religions, may well have been prompted by Frantisek Kupka, a neighbour of Duchamp's brothers in Puteaux. Kupka's paintings of the early 1890s are saturated with the Hindu and Egyptian motifs favoured by Theosophists. It is also possible to see Kupka's investigation of movement in paintings of the period as providing a stimulus for Duchamp's later interest in the theme. Duchamp's flirtation with Theosophy links him with the central abstractionists of the modern period – Mondrian, Arp, Kandinsky, as well as Kupka – all of whom benefited from its use of abstract symbols.

Dr Dumouchel makes a second appearance in *Paradise* (1910). 15 In this painting his head is enlarged in a similar way but his hand has moved downwards to conceal his sex. There is evidently a biblical reference here to Eden and the moment of original sin when Adam and Eve recognize their nakedness. His treatment of the 'paradise' theme sets Duchamp apart from Golden Age paintings like Matisse's *Bonheur de Vivre* (1905–6) or from Gauguin and his search for a tropical paradise.

Both the theme and the archaic, primitive quality of works such as *Paradise* were probably derived from a now-forgotten artist, Pierre Girieud, who was connected with the Munich-based *Neue Künstlervereinigung*. Duchamp talked to Cabanne of the 'hieratic' quality of Girieud's paintings and this word could equally apply to his own works of the time. 'Hieratic' or priestly (the opposite of demotic) implies initiation and rites, which certainly seems appropriate for *Paradise* and *The Bush*.

The Bush (1910–11) brings together initiatory rite and aura, 16 which this time completely surrounds the two female figures in blue (the Theosophical colour of peace and spiritual harmony), providing the shape that gives the painting its title. It was with this picture that the title first became of prime importance; Duchamp described adding it almost like 'an invisible colour'. *The Bush, Baptism* and *Young Man and Girl in Spring*, all painted around 17, 18 1911, could be a sequence dealing with forms of quasi-religious initiation. As the art historian John Golding has suggested, the

14. (above) *Portrait of Dr Dumouchel*, 1910 15. (above) *Paradise*, 1910

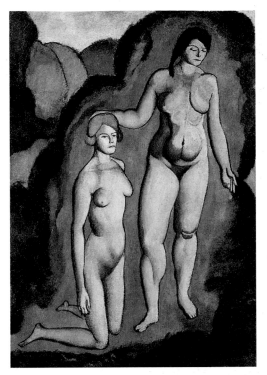

16. (above right) *The Bush*, 1910–11

17. (right) *Baptism* (also known as
Two Seated Figures), 1911

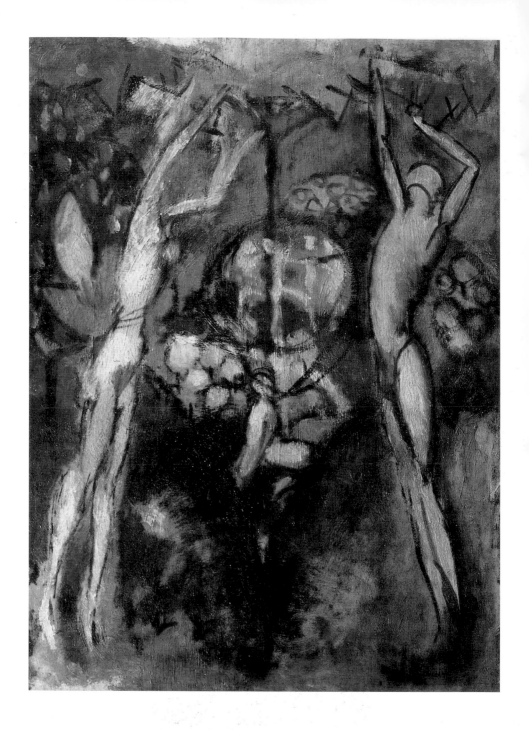

positioning of the figures echoes presentation panels from altar-pieces in which saints present the painting's donor to the divinity. However, there is a close parallel between *The Bush* and Girieud's painting *Lesbos* (1910) in their shared theme of closed female society. In both *The Bush* and *Baptism* the gestures of one of the naked women, possibly older and more experienced, suggest initiation, in a blasphemous blend of religion and eroticism. This theme is also taken up in *Two Nudes* (1910).

It is tempting to see *The Bush* as an early formulation of the theme of *Passage from Virgin to Bride* (1912) and the spiritual/sexual initiation of a woman. It also anticipates the *Large Glass*; the aura-like bush may be understood to constitute a 'blossoming', something that occurs literally as the central feature in *Young Man and Girl in Spring*. This roughly painted canvas probably again depicts the theme of Eden and is thus related to *Paradise*. Since *The Bush* prefigures later themes and images in a remarkable manner, the peculiar anatomical distortions of the right-hand figure call for closer attention. The oddly muscular, swollen torso suggests a

20

42

61

19. (right) **Pierre Girieud**, *Lesbos*, 1910

20. *Two Nudes*, 1910

superimposition of two viewpoints. A secondary outline is incorporated into the larger, frontal figure, whose clenched lower stomach could represent another figure's buttocks. The disturbing naked mannequin in the much later *Etant donnés* (see Chapter Nine) also has ambiguous bulges in the torso, a confusion of gender, although the oddly flattened, bloodless and blonde nude of that work approximates more closely to the left-hand figure in *The Bush*. Following the example of Cézanne's *Bathers*, anatomical ambiguity was a central feature of Cubism. Georges Braque's *Nude* (1908) is depicted from a double viewpoint that Duchamp may rather awkwardly be attempting to introduce here, although purely stylistic experiment is unlikely.

The mystical-religious elements in Duchamp's work, while broadly relating to the re-working of conventional Christian themes in Symbolist paintings by Edvard Munch (1863–1944) or Gauguin, are oddly joined to the nudity of the figures who take on an air of complicity in Hermetic rituals. Duchamp may here be probing the mystique of gender-specific experience. In the final analysis, *The Bush* and *Baptism* bear witness to the male fascination with female closeness and lesbianism, which is also found in Courbet, Ingres, Toulouse-Lautrec and early Picasso.

21. **Georges Braque**, *Nude*, 1908

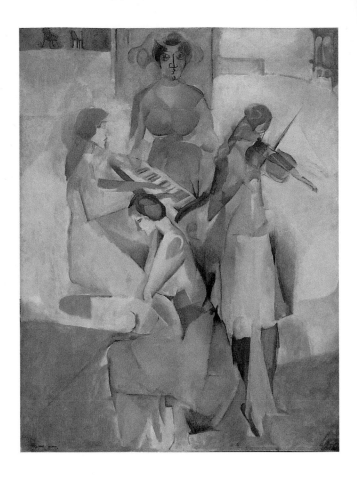

The sense of women inhabiting an exclusively female domain is seen in a more domestic setting in a series of paintings from 1911 that divide the members of Duchamp's family according to gender. The artist had three sisters: Suzanne, Yvonne and Magdeleine. All three appear with their mother in *Sonata*, while the last two are depicted in *Yvonne and Magdeleine Torn in Tatters* and Magdeleine alone in *Apropos of Little Sister*. The title *Yvonne and Magdeleine Torn in Tatters* reveals not only Duchamp's sadistic attitude towards his sisters – it is worth noting that, in one interview, Duchamp betrayed some resentment towards them, pointing out that his mother, whom he disliked, 'never denied her preference for them' – but also the new deadpan, literary element in his work.

Between late 1910 and late 1911, Duchamp, who was now living with his brothers at Puteaux, near to Neuilly on the western

23. *Yvonne and Magdeleine Torn in Tatters*, 1911

24. *Apropos of Little Sister*, 1911

outskirts of Paris, had become acquainted with what he later referred to as the 'Salon d'Automne set', namely, the Cubists: Albert Gleizes (1881–1953), Fernand Léger (1881–1955), Jean Metzinger (1883–1956) and Roger de la Fresnaye (1885–1925). Regular, lively debates at Puteaux, attended by all the Duchamp brothers, centred on 'simultaneity' and the fourth dimension. These ambitious ideas were largely deduced from the 'superior' Cubist paintings of Picasso (1881–1973) and Braque (1882–1963), who stood apart from the Salon Cubists, and supplemented by the mathematical theories of another associate, Maurice Princet, whom Duchamp later dubbed a *faux mathématicien* ('fake mathematician'). He was, indeed, by no means convinced by Princet's theoretical excesses.

Duchamp exhibited two works with the Salon d'Automne Cubists late in 1911: *Yvonne and Magdeleine Torn in Tatters* and *Dulcinea*, later known as *Portrait* (1911), having soon assimilated aspects of their style, such as the monochrome palette, spatial ambiguity and, in the latter work, the reduction of forms to interlocking planes and lines, although the handling of paint here owes as much to Cézanne as to his Cubist friends. While *Yvonne and Magdeleine Torn in Tatters* makes naive use of the multiple viewpoints favoured by the Puteaux group, paying amused attention to the family nose, its floating forms create a dream-like atmosphere suggesting that Duchamp still owed as much to the Symbolists of the 1880s and 1890s as to his immediate circle. In a later interview with James Johnson Sweeney he said that he was particularly attracted to Mallarmé's poetry at this time as well as to Laforgue's, feeling that it was 'much better to be influenced by a writer than by another painter'. While the emphasis on titles already declares his interest in words, it is also his commitment to ideas, whether concerning the enigmas of sexual initiation or of religious experience, and not just to formal experimentation, which affirmed the continuing importance of Symbolism in his work.

This conceptual dimension becomes the theme of a series of paintings dealing with his brothers playing chess, dating from 1911. Duchamp had already treated this subject in *The Chess Game* (1910), a relatively conventional, almost academic painting exhibited at the Salon d'Automne in 1910. However, by late 1911 he had adopted Cubist devices to such a degree that his brothers' heads and the chess pieces become interfused, creating an overall flat surface pattern closer to the Cubism of Picasso and Braque than to the Puteaux group, but still indebted, from a compositional point of view, to Cézanne's *Cardplayers* of the 1890s. These works fuse

the physical aspects of the chess game with the strategic cerebral moves being conceived by the players. They respond in a totally original way to the notion of simultaneous depiction of extensions in time and space and begin to test the limits of the two-dimensional canvas surface. It is interesting that in the version of *The Chess Players* (1911) at the Musée National d'Art Moderne in Paris, Duchamp has painted out the sides of the canvas to make it square, like the chessboard itself.

26

Whereas chess is entirely given over to male players, music is seen as a female domain; *Sonata* (1911) depicts Duchamp's three sisters playing musical instruments, presided over by their mother. This division of roles, male intellect versus female accomplishment and sensitivity, was fairly typical of the bourgeois household, but seems to be a particularly intense focus of interest for Duchamp and prefigures a later concern: the radical division of Bachelors and Bride in the *Large Glass*.

22

61

Dulcinea, with its rather tentative and lightly washed surface, is a deliberately free interpretation of Cubist theories. The principle in question here is again simultaneity. Whereas the Puteaux Cubists combined various views of static objects in their paintings, Duchamp deals ostensibly with a moving subject. In his conversations with Cabanne, he confirmed that the painting was based on a woman he had seen walking her dog in Neuilly, although 'it wasn't even a matter of being able to speak to her'. The woman is shown in five separate stages of undress, stripped by the artist's imagination, again prefiguring the *Large Glass*. The

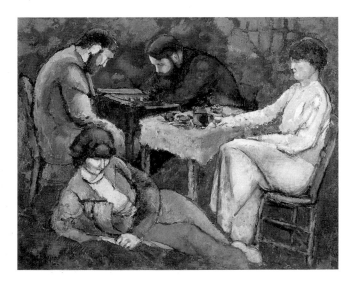

25. *The Chess Game*, 1910

movement in this picture is thus not entirely physical. As with the 'moves' in the earlier chess paintings, which had a cerebral dimension, the 'moves' here enact a psychological fantasy. The title is a reference to the idealized village girl in Cervantes' *Don Quixote* (1605) to whom the besotted hero never speaks, which gives the painting a surprising literary precedent and makes it a broader comment on the mechanisms of masculine longing.

Duchamp's interest in Symbolism fostered a highly speculative, even at times sceptical attitude to Cubism. Symbolist ideas may also help to account for the odd ovoid shape that extends from the bottom centre of the canvas to about half way up – a throwback possibly to the equally enigmatic circular shape in *Young Man and Girl in Spring*. The various progressively stripped incarnations of the woman in *Dulcinea* all stem from this ovoid shape and Duchamp said that the intention was to suggest a bouquet. Incipient here, then, may be the idea of the 'blossoming' of the Bride, also a female stripped bare, in the *Large Glass*. There is an unusual Symbolist prototype for the shape from which this

26. *The Chess Players*, 1911

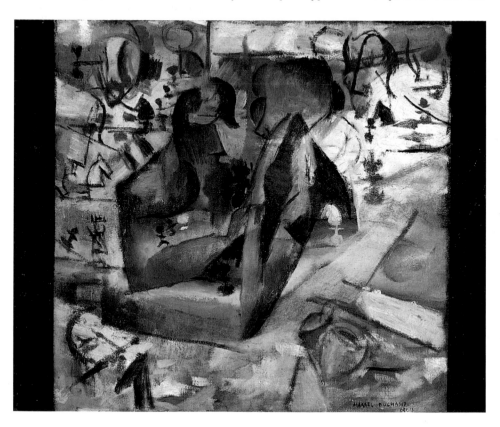

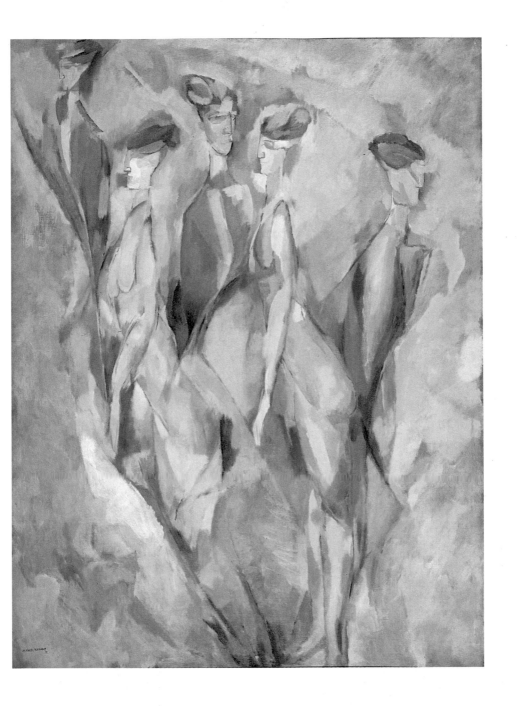

27. *Portrait (Dulcinea)*, 1911

'bouquet' blossoms. Possibly through Kupka, or perhaps through a contemporary familiar with the Symbolist milieu in Paris in the 1890s, Duchamp may have been aware of an esoteric work by the Dutch Symbolist Johannes Thorn Prikker (1868–1932), *The Bride* (1892–93). This painting, a bizarre product of Catholic mysticism, depicts a nun, a 'Bride of Christ', bound in suffering to her saviour, but simultaneously beset by sensual cravings, symbolized by the phallic tulips. The five-fold 'unfurling' of *Dulcinea* as a bouquet, though, ironically evokes the accoutrements of an earthly rather than a spiritual Bride.

The inheritance of Symbolist structures from 'Decadent' paintings of the 1890s, combining mystical and erotic elements, can be demonstrated even more powerfully by reference to a further work on the bridal theme by another Dutch Symbolist, Jan Toorop (1858–1928). His *Three Brides* (1893), which had been

28. (below) **Johannes Thorn Prikker**, *The Bride*, 1892–93

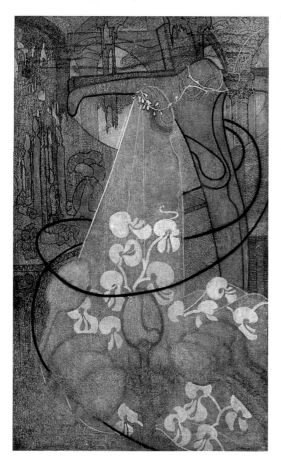

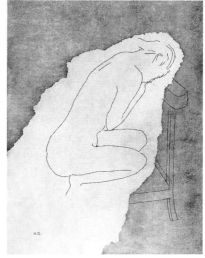

reproduced in the widely distributed English art magazine *The Studio* the same year, had a considerable reputation in Paris in the 1890s. The picture belongs to a genre within Symbolist art in which the spiritual and sexual lives of women are depicted in a threefold format. Reading from left to right, three bridal types are shown: the nun, linked with virginity and frigidity; the earthly bride, combining spirituality and sexuality; and the *femme fatale*, typically associated with death and male castration fears. Given that Duchamp's stripping of *Dulcinea* in stages led in 1912 to a painting significantly entitled *Passage from Virgin to Bride*, he could be seen as continuing this tradition.

That *Passage from Virgin to Bride* might notionally involve three stages is made clear in the notes for the *Large Glass* (known as *The Green Box*), whose Bride reveals herself nude in '2 appearances of pure virginity', which are subsequently dialectically resolved in the third bridal ' "blossoming" without causal distinction'. As well as evoking the earlier *Bush*, these ideas seem to point to the image at the centre of Toorop's painting where the Bride, symbolically 'wedding' the extremes of virginity and sensuality flanking her, is stripped beneath her veil and surrounded by blossoming roses, the emblem of the Rosicrucian movement.

Toorop's painting was a programmatic manifestation of Rosicrucian principles, as a result of the artist's brief collaboration with Sar Péladan, the leader of a faction of French Symbolists who attempted to fuse Catholic and Rosicrucian precepts in their work. Although, as far as we are aware, Duchamp had no connections with the movement, apart from a later friendship with Erik Satie who had composed music for their organization, his early use of sexual-cum-spiritual imagery would certainly make sense in this context, since Rosicrucianism had inherited from alchemy a rich Hermetic symbolism of spirituality and sexuality as linked principles, rather than separated as in the Judeo-Christian tradition. Péladan's Rosicrucianism, with its Catholic links, was also, of course, a way that the artist could continue to deal with aspects of his religious upbringing. In 1968 Duchamp produced an etching that makes a direct connection between the early First Communion card for Simone Delacour and the Bride of the *Large Glass*. Not surprisingly, she is a kneeling communicant, but as in Toorop's painting once again stripped beneath her veil.

42

29. (top left) **Jan Toorop**, *Three Brides*, 1893

30. (left) *The Bride Stripped Bare...*, 1968

Chapter 3: Passages

By late 1911 Duchamp's attention turned towards ideas about
movement and the mechanical, which influenced his experiments
with the new visual vocabulary of Cubism. At the end of 1911 he
painted the sombre, almost monochrome *Sad Young Man on a
Train*; this is more extreme formal decomposition than anything
he had previously attempted. There is a mobile, linear quality to
Duchamp's ambiguous 'figure', which is at odds with the monu-
mental, but equally monochrome grid structures, with their
delicate faceting of planes, found in Picasso and Braque's Cubist
paintings. The repeating forms also appear to recede sharply into
dark space. As in *Dulcinea*, the theme of movement is uppermost,
though several linked processes seem to be involved: the move-
ment of the train, the figure's own mental state and the sugges-
tions of the figure's swaying movement on the train, which, as
several commentators have suggested, may also be masturbatory.
The repetition of the sounds *tr* in *train* and *triste* in the French title
(*Jeune homme triste dans un train*) were intended by Duchamp to
mimic the repetitions of the figure in the painting. This figure can,
in fact, be read as Duchamp himself, naked and smoking a pipe, and
the theme apparently derived from a train journey between Paris
and Rouen. The pervasive mood of the dark-toned painting and its
title is one of melancholy and isolation, feelings evoked by
Laforgue's poetry.

The representation of 'states of mind' was a widespread
Symbolist practice, which had also been adopted by Futurist
painters like Umberto Boccioni (1882–1916). It is also possible
that ideas about the expressive meaning of specific linear direc-
tions in painting, widely disseminated in Paul Signac's treatise
D'Eugène Delacroix au néo-impressionnisme (1899) – in which he
argues, for example, that a falling diagonal line expresses sorrow –
were at the back of Duchamp's mind.

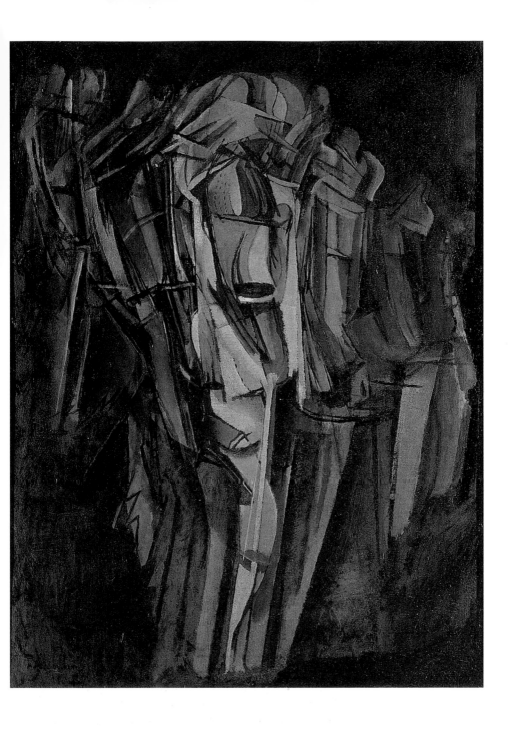

31. *Sad Young Man on a Train*, 1911

Mediocrity, one of a group of drawings from 1911 to 1912, depicts a moving train and has a subtitle in brackets '(Jules Laforgue)'. The combination of the off-hand title with its slightly mocking euphony, and the incipient 'mechanism' of the painting, sounds a different note, which may be an attempt to capture the detached and cynical wit of Laforgue's poetry in which images of futility co-exist with images of an increasingly depersonalized modern world. There are undeniable visual similarities between *Sad Young Man on a Train* and *Nude Descending a Staircase, No. 1* (1911). Another drawing from the Laforgue suite titled *Once More to This Star* (1911–12), depicting a figure ascending a staircase, clearly introduces the theme that Duchamp then reverses for the painting. The magisterial descent of the figure into darkness still creates very much a 'mood' painting; the repetition of linear elements, which Duchamp called 'elementary parallelism' in the case of the *Sad Young Man on a Train*, becomes more emphatic and dynamic in *Nude Descending a Staircase, No. 2* (1912). It serves simultaneously to construct movement and to decompose form, introducing a new elasticity into Cubist-derived dislocations. Duchamp's use of the pseudo-scientific phrase 'elementary parallelism' has some affinity with the theory of parallelism expounded in the 1890s by the Swiss Symbolist Ferdinand Hodler (1853–1918). This term described his use of repeated vertical elements across the surface of canvases such as *Eurhythmy* (1895).

A new set of ideas about the depiction of movement emerged in the little painting *Coffee Mill*, completed towards the end of 1911 for the kitchen of his brother Raymond Duchamp-Villon. This was the first time Duchamp showed his interest in machine forms and mechanical operations. The arrow indicating direction of movement, the dotted line, the handle pictured in different positions linking movement to repetition, the coffee flowing down from the grinder shown in section offer a humorous but nonetheless radical contrast to the 'impressions' of movement by the Futurists. The introduction of dry engineering techniques and diagrammatic forms to avant-garde painting, albeit here in a casual and almost private context, later had, as we shall see in the next chapter, far-reaching consequences. A few years later, Duchamp's friend Francis Picabia (1879–1953) rendered more explicitly the idea of the machine as analogue of human desires. *Coffee Mill* was reproduced in Albert Gleizes and Jean Metzinger's history of the Cubist movement, *Du cubisme* (1912).

33. *Once More to This Star*, 1911–12

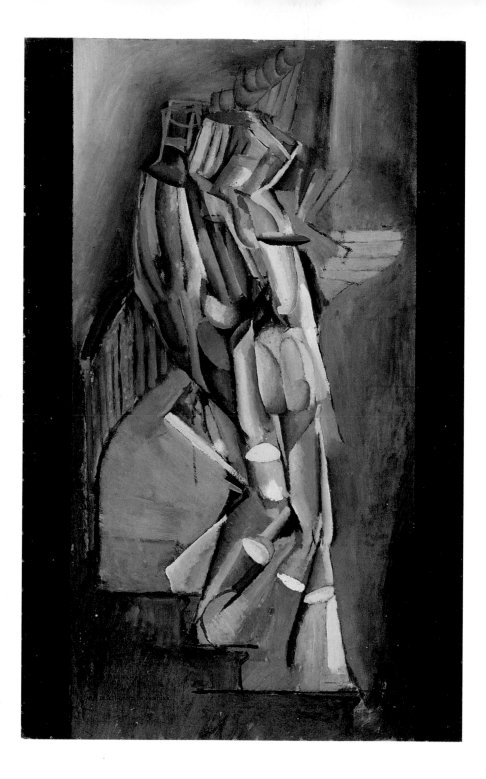

34. (opposite) *Nude Descending a Staircase, No. 1*, 1911

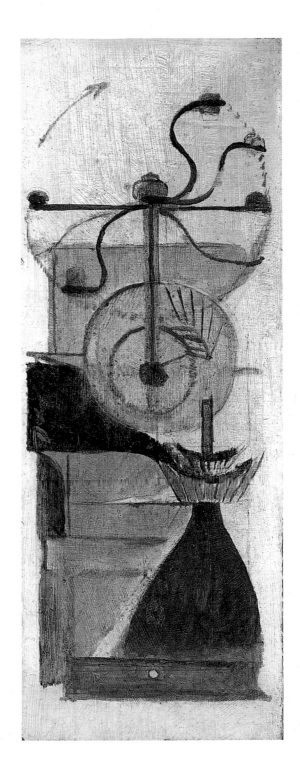

35. (right) *Coffee Mill*, 1911

36. **Etienne-Jules Marey,**
*Jump from a Height with Knees
Straight* from the series of
chronophotographs entitled
'Analysis of the Jump', 1884.

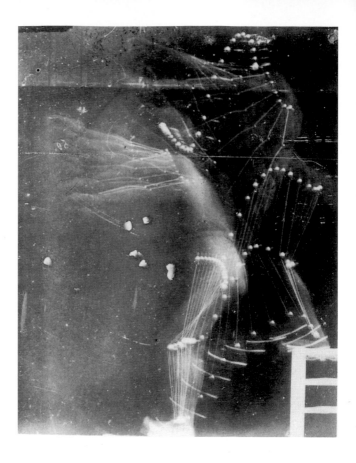

Duchamp is known to have been influenced by the experimental 'chronophotographs' made in the 1880s by the French physiologist Etienne-Jules Marey (1830–1904), a source that would also account for the diagrammatic dots at the centre of the composition. The British photographer Eadweard Muybridge (1830–1904) who worked in the United States had produced sequences of photographs showing the detailed study of movement that were much in vogue in Europe in the 1870s. His images of a woman walking downstairs may have suggested the theme to Duchamp.

While such experimentalist photographic sources for *Nude Descending a Staircase* help to account for its visual originality, they also tend to mask the fact that, as a 'mood painting', it still has roots in Symbolism. The theme of repetitive versions of a figure descending a staircase had been treated by the English Pre-Raphaelite Edward Burne-Jones (1833–98) in *The Golden Stairs*, a painting of 1872–80 that was widely circulated in France in the

form of an etching by Félix Jasinski at the turn of the century. A seemingly endless procession of young women, remarkably similar to one another, move down a spiral staircase; the scene is hypnotic and mysterious, purged of specific meaning in the interests of its psychological impact. Burne-Jones, in common with many of the Symbolists, was fascinated by abstract patterns of repetition. Despite its uncompromising 'technological' appearance, therefore, *Nude Descending a Staircase, No. 2* still drew on the literary and artistic climate of the 1890s, as well as on Cubism.

Symbolist traces may well have contributed to the unfavourable reception of the *Nude Descending a Staircase, No. 2* (1912) when Duchamp entered it for the Cubist-dominated Salon des Indépendants in March 1912. Albert Gleizes, a key figure in the Puteaux Cubist group and chairman of the hanging committee, asked Duchamp's brothers to persuade him at least to change the title. Duchamp refused to do so and withdrew the picture. Although the work was shown in October of that year at the 'Salon de la Section d'Or' exhibition in Paris, and was later the *succès de scandale* at the International Exhibition of Modern Art, known as the Armory Show, in New York in 1913, Duchamp took the rejection badly. His lack of faith in the supposed open-mindedness of the self-appointed avant-garde, which manifested itself most obviously in the 1917 *Fountain* hoax (a porcelain urinal sent as an exhibit – see Chapter Six), can be dated from this event.

The Puteaux group's objection to the title *Nude Descending a Staircase* was symptomatic of Duchamp's divergence from, and thus challenge to, their aesthetic aims. The somewhat absurd matter-of-fact descriptive title has a comic effect, leaving the connection between the title and the subject matter ambiguous. In their seminal *Du cubisme* (1912) Gleizes and Metzinger argue that 'a picture bears its pretext, the reason for its existence, within it'. The autonomy of the visual structure of the work of art was ostensibly disengaged from the implications of its subject matter, but Gleizes and Metzinger also admitted that as yet 'the reminiscence of natural forms cannot be absolutely banished'. Duchamp points unerringly to the potentially anti-humanist aspect of the residual figure. The pretext of autonomy may thus have been the butt of Duchamp's irony in presenting not a nude in his painting, but an automaton or machine. Moreover, this automaton, which, according to the title, might be assumed to be female, in fact bears no signs of gender according to the conventions of both academic and avant-garde Salon painting.

38

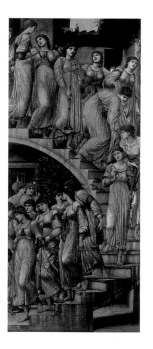

37. **Edward Burne-Jones**, *The Golden Stairs*, 1872–80

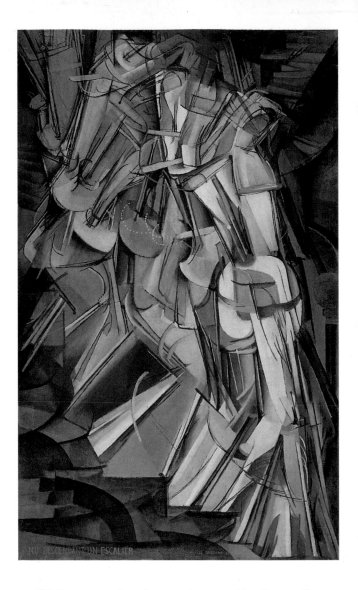

While attempts have been made to provide a literary lineage for Duchamp's mechanized woman – most notably Villier de l'Isle Adam's *L'Eve future* of 1886 – the overall proportions of the figure and the treatment of the chest region suggest that it is, if anything, masculine. There is also the possibility of an effeminate male or a male in drag, given the suggestion of a long skirt or dress and Duchamp's later female incarnation as Rrose Sélavy, his female alter ego photographed by Man Ray (1890–1976), who also 'signed' some works and produced puns and word games (see

Chapter Six). Certainly, Duchamp's Puteaux associates would have considered their high-minded aesthetic aspirations jeopardized by such conceptual conundrums and visible ambiguities, as well as by its Futurist affinities.

The yoking of the 'nude' to the representation of movement might also have been a tongue-in-cheek response to the dictum in the 'Technical Manifesto of Futurist Painting' (1910) that the nude be banished from art for ten years. A few weeks prior to the Salon des Indépendants an important Futurist exhibition opened at the Galerie Bernheim-Jeune, in an evident attempt to claim avant-garde supremacy. Although Duchamp's painting, as we have already shown, cannot have been influenced directly by the Italian Futurists' attempts to depict motion illusionistically, there were undoubted analogies between them, and such was the rivalry between avant-garde groups at the time that the similarity between Duchamp's work and the Futurists, rather than between

39. *The King and Queen Surrounded by Swift Nudes,* 1912

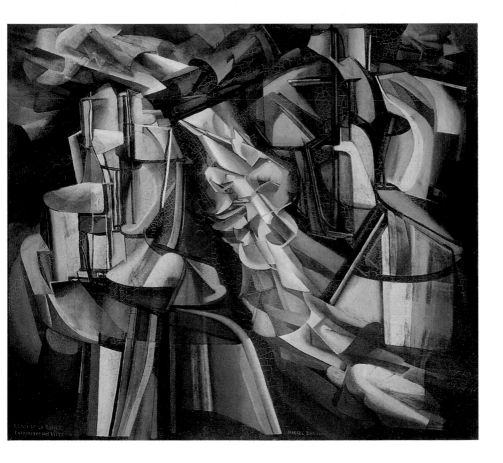

his work and the Puteaux group's notion of conceptual simultaneity, must have contributed to the criticism his work aroused.

Intriguing though the analogies are between Duchamp and the Futurists, he had none of their unreflective optimism in machines and the modern world and scorned their 'urban Impressionism'. In his interviews with Pierre Cabanne, Duchamp tentatively acknowledged that a further exploration of movement, produced in May 1912, *The King and Queen Surrounded by Swift Nudes*, may have been affected by the Futurists' Paris exhibition. This work indeed shows strong formal affinities with two panels from Boccioni's *States of Mind* triptych (1911) displayed at the Galerie Bernheim-Jeune, Paris. *The King and Queen Surrounded by Swift Nudes* fuses the themes of machines, gender and chess. Movement conceived from a conceptual standpoint is connected with the highly systematized and strategically motivated moves of chess as a physical-cum-intellectual game.

In July 1912 Duchamp decided to leave Paris and withdrew to Munich for the summer, possibly in order to detach himself from Cubist circles and from an avant-garde who seemed to him to take a very narrow view of a new visual language. In Munich, which he

40. **Umberto Boccioni**, *States of Mind 1: Those Who Go*, 1911

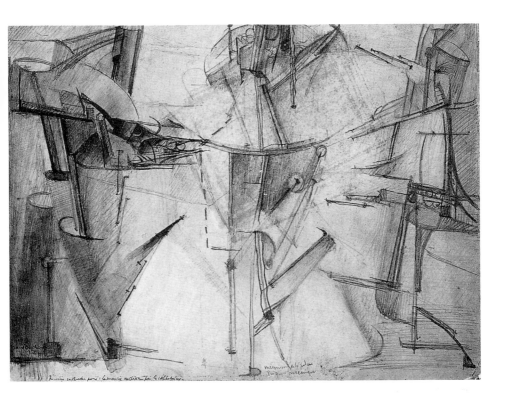

41. *The Bride Stripped Bare by the Bachelors*, 1912

called the 'scene of my complete liberation', he produced impor-
tant works that continued to deal explicitly with the themes of
physical/conceptual movement and sexuality that had unnerved
his Cubist colleagues.

The first of the Munich works, the drawing of *The Bride
Stripped Bare by the Bachelors* (1912), implies a link between the
rituals of courtship or sexual congress and the 'moves' of chess,
transposing the mechanical characteristics of the previous King,
Queen and nudes on to a central robotic 'Bride' who is apparently
menaced by two highly aggressive 'Bachelors' with phallic
weapons. More than any previous works, this drawing has a cold,
diagrammatic quality betraying a growing distrust of expressive
handling, to say nothing of implied ambivalence towards the sex
act.

The rest of the Munich paintings concentrate exclusively on
the 'Bride' figure from this drawing, implicitly charting her inner
'movements' from an earlier 'virgin' state; it is not until *The Bride
Stripped Bare by Her Bachelors, Even* (the *Large Glass*) that the
chess/mating game analogy appears to be taken up again. The

61

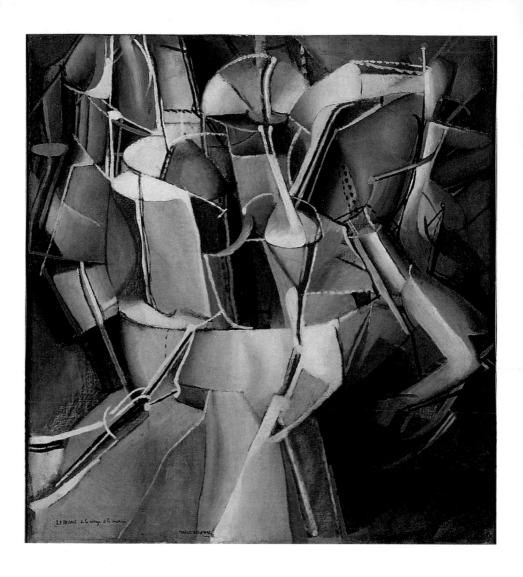

42. *Passage from Virgin to Bride*, 1912

aggression expressed in the drawing of *The Bride Stripped Bare by the Bachelors* seems to have been repressed, for there is nothing comparable in the rest of Duchamp's work. It is rather the initiatory and sexual implications of earlier paintings such as *The Bush* that are explicitly annexed to the machine theme in the subsequent Munich paintings.

The first of the Munich paintings was *Passage from Virgin to Bride*, a picture preceded by two very elegant drawings entitled *Virgin, No. 1* and *Virgin, No. 2* (all 1912). The works develop a 43, 44 complex 'anatomy' for a female mechanomorph (a creature made of shapes based on mechanical forms), elements of which are transferred to the painting. This interest in reinventing anatomy probably derived from an experience directly preceding the Munich trip: a visit, sometime before its final performance on 12 June 1912, to see Raymond Roussel's *Impressions d'Afrique*, in the company of Francis Picabia and Guillaume Apollinaire (1880–1918). Roussel's play, which concerned the adventures of a group of characters flung together after a shipwreck on the African coast, contained a number of bizarre proto-Surreal episodes surrounding peculiar 'inventions' whose linguistic origins Duchamp was quick to penetrate. Several of these result in biological-mechanical hybrids, such as the character whose lungs are replaced by a system of tubes connected to her clothing; such human-machine analogies may well have stimulated Duchamp's successive realizations of the Virgin and the Bride. Before the end of the year, Duchamp began to explore the generative possibilities of puns, as we shall see in the notes for the *Large Glass* (see Chapter Five). Another possible source for Duchamp's 'gynaecological' ideas is a famous drawing by Leonardo da Vinci of the dissection of the female torso, frequently reproduced in the early twentieth century, which bears striking similarities to *Bride*.

The title of *Passage from Virgin to Bride* produces immediate associations. The overriding implication is that of initiation, which may be interpreted as grossly sexual or religious/mystical; the 'passage' may literally be the anatomical route by which the virgin's state is altered or it may designate an inner transformation whereby femininity enters a new experiential mode. The physical appearance of the painting, with its confusing amalgamation of mechanical elements and abstract planes, which themselves appear to be in motion from left to right, has Cubist and Futurist affiliations, and it is quite possible that, in running spatially discontinuous planes together within the picture Duchamp was parodying Cubist 'passage'.

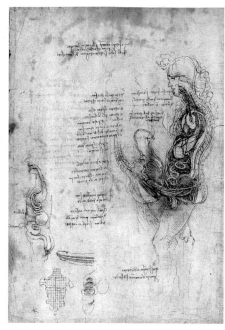

45. (above) **Leonardo da Vinci,**
Coition of Hemisected Man and Woman
(detail) from *Quaderni d'Anatomia 111*,
folio 3v. While *Bride* bears a
resemblance to Leonardo's dissected
female anatomies, the idea of passage
in the organic dynamism of *Virgin,
No. 1* recalls this section drawing of
copulation. Leonardo's 'asentImental
speculation' here anticipates the sexual
encounter of the *Large Glass*.

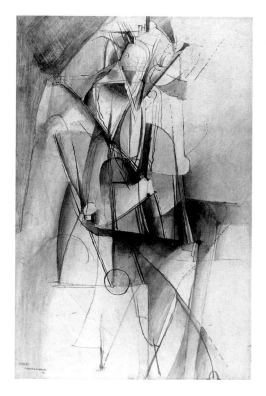

43. (top left) *Virgin, No. 1*, 1912

44. (left) *Virgin, No. 2*, 1912

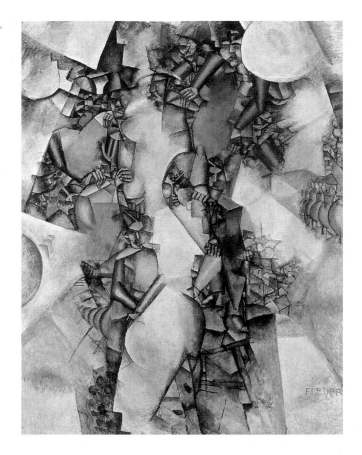

There is also a rather literal way in which the picture can be viewed: namely, as an abstract interpretation of a young woman's movement along the aisle where she will metamorphose into a bride. In this sense the work could be a riposte to Fernand Léger's *The Wedding* (1911–12), which, unlike *Nude Descending a Staircase, No. 2* had been allotted a place in the Salon des Indépendants earlier in the year. *The Wedding* also deals with movement, a wedding procession moving down the canvas through a landscape. Léger, like the other Puteaux Cubists, was interested in Bergson's philosophical notion of *la durée*, the psychological time of lived and remembered experience, which is opposed to the scientific construction of measurable time. Duchamp might thus have intended to outdo Léger in the realm of 'psychological' painting, concentrating on the mind of the bridal initiate herself rather than an overview of the entire ceremony.

Passage from Virgin to Bride anticipates *Bride*, the extraordinary painting completed in Munich in August 1912. The wedding 'contract' in question might be the wedding of the conceptual and pictorial elements that Duchamp later pointed to as his overriding concern at this period. In an interview with George H. Hamilton and Richard Hamilton in 1959 he talked of the intellectual element of a work functioning as part of its material fabric, saying, for instance, that the notion of eroticism should be injected into an art work 'as you would use a tube of paint'. Such an eroticized fusion of poetic ideas and pictorial elements logically adds up to the Bride.

Some detect a certain degree of misogyny in *Bride*, and the indications of an apprehensive male attitude to the female is underscored by Duchamp's admission to the critic Lawrence Steefel, 'I did not really love the machine,' adding, with regard to the paintings of 1912, that 'it was better to do it to machines than to people'. Cabanne pursued this issue, pointing to Duchamp's well-known 'anti-feminist attitude' at certain points in his career, only to be rebuked by Duchamp, who replied: 'No, anti-marriage, but not anti-feminist.'

One of the few sources for *Bride* that Duchamp acknowledged was the game at country fairs where spectators were invited to throw balls at the heads of puppets depicting the bride, bridegroom and guests at a wedding party. In some versions of this game a direct hit would cause the bride to tumble naked out of bed. The blatant mixture of aggression and voyeurism seems to have appealed to Duchamp. Yet there was also an artistic precedent for this theme: Georges Rouault's *The Bride* (1907), a depiction of exactly this kind of puppet, exhibited at the Salon d'Automne of

48. (right) **Georges Rouault**, *The Bride*, 1907

1907 and probably seen by Duchamp. Something of Rouault's disgust informs Duchamp's approach to *Bride.* According to an anecdote recounted later in his life, Duchamp returned home drunk one night, while he was in Munich. *Bride* stood unfinished by his bed. In a sinister dream the Bride metamorphosed into a beetle that tortured him with its wings. Echoes of insect forms remain visible in the final painting. They were preserved when Duchamp transferred its central section on to the *Large Glass;* in the notes for it, *The Green Box,* he referred to this 'sex cylinder' as the 'wasp'.

However, there is a danger of taking too narrow an interpretation of Duchamp, an artist who was capable of adopting a strongly ironic attitude to himself and to life. Taken in conjunction with Duchamp's later explorations of female identity, for instance in his alter ego Rrose Sélavy, and given his many close female friends and lovers during his life, it is possible to argue that *Bride* in fact consciously seeks to satirize male attitudes towards women on both narrowly artistic and broadly social and cultural fronts.

On the artistic level, this work again addresses Cubism's unwitting savagery at the expense of the female form. Apollinaire had used metaphors of dissection to discuss Picasso in *Les Peintres cubistes: méditations esthétiques* (1913), saying a man like Picasso studies an object as a surgeon dissects a cadaver. Given Duchamp's friendship with Apollinaire during 1912, it is likely that his 'dissected' Bride wittily alludes to such ideas. The work may even be regarded as a kind of 'abstraction machine', the Bride's organs

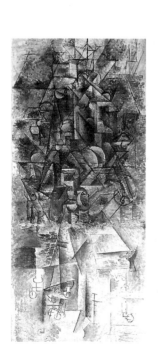

being linked by pipes and tubes just as the signifying elements in Cubist paintings, such as Picasso's *Man with a Mandolin* (1911), are part of an overall abstract superstructure. A burning theoretical issue at the time among the Cubists was the problem of 'abstraction'; while he was in Munich, Duchamp bought a copy of a manifesto of abstraction coming from a very different set of ideas and linking abstraction to 'inner necessity', Kandinsky's *On the Spiritual in Art,* which was published in 1912. He later said to Cabanne: 'A canvas like *The Bride* is abstract, since there isn't any figuration. But it isn't abstract in the narrow sense of the word. It's visceral so to speak.' This comment suggests that he could have been playing on this new set of ideas about an 'inner' meaning. He obviously relished the confusion set up between the 'human' and the 'non-figurative' aspects of the work, a confusion that is borne out in the technical handling, ranging from a diagrammatic precision to a sensuous painterliness reminiscent of areas of *Passage from Virgin to Bride.* The indeterminate identity of the actual forms

in the work – whether mechanical, human, vegetable or insect – further compounds the disorientation.

On a broader cultural level, *Bride* may be seen as commenting on scientific method, which has been traditionally linked to a (male) desire to probe (female) nature's inner secrets. The work can be viewed as 'nature' exposed or stripped bare by the scientific male gaze; this of course looks back to the voyeuristic theme of *Dulcinea*, but, more importantly, anticipates the *Large Glass* as, literally, the Bride stripped bare by her Bachelors. Duchamp later voiced his distrust of science to Cabanne when discussing the *Large Glass*: 'It wasn't for love of science that I did this; on the contrary, it was rather in order to discredit it.'

If part of Duchamp's aim was indeed to discredit scientific thought on a broad level, it is likely that he had in mind the French philosopher who would have figured prominently in his early education, namely, René Descartes (1596–1650). Duchamp often alluded ironically to Descartes in interviews, remarking that he was attracted to the philosopher's 'close mathematical thinking', but that, simultaneously, he sought to escape it; he was, he said, a 'defrocked Cartesian'. Asked by William Seitz which adjective he would use to describe his work, he replied: 'Metaphysical if any. And even that is a dubious term. Anything is dubious. It's pushing the idea of doubt in Descartes…to a much further point than they ever did in the school of Cartesianism: doubt in myself, doubt in everything…in the end it comes to doubt the verb "to be".' This comment suggests that Duchamp's intellectually rigorous form of Dada owed as much to this arch-rationalist as to any other source, even if part of Duchamp's mission was to 'outdoubt' Descartes, whose famous method was, after all, primarily aimed at securing a sense of certainty.

It is in his conception of the body and its motion, however, that Duchamp comes closest to the philosopher. Departing from the metaphysics established in the classical world, Descartes argued that the body could be viewed as a mechanism. The soul that it contained could not be derived from the 'potentiality' of 'matter', but was in fact a non-material entity placed in each body by God. Such an argument, in which spirit or mind is regarded as an entirely separate entity from the body, resulted in the Cartesian mind-body dualism. It also served as a philosophical basis for modern biological inquiry by implying that the human nervous system could be investigated dispassionately without recourse to metaphysics, as though it were a machine. In his *Description of the Human Body*, Descartes actually assumes an identity between the human body

and the machine, writing: 'The veins are pipes which conduct the blood from all parts of the body towards the heart where it serves to fuel the heat there. The stomach and the intestines are another much larger pipe perforated with many little holes through which the juices from the food ingested run into the veins.' In Duchamp's *Bride*, the merging of visceral and mechanical elements, along with the overall allusion to dissection, ironically responds to this kind of philosophical position.

Duchamp's running argument with the Cubists is again relevant. His appeal to one of the giants of French philosophy would have appeared wilfully anachronistic to Gleizes and Metzinger who were at the time much more influenced by Nietzsche's rhetoric about the superior, transforming 'will' of the artist and whose interests in 'simultaneity' owed more to the sophisticated psychology of the fashionable French philosopher Bergson than to the rationalist thought of Descartes. Duchamp thus deliberately sets himself apart, stubbornly returning to philosophical basics to tease out the implications of Cubism's dissection of the nude in the service of pictorial autonomy.

There was another aspect of contemporary interest in Bergson to which Duchamp's Munich works may have responded. Contrary to his own thinking, Bergson's philosophy was interpreted by influential young intellectuals at the time in France as endorsing a move towards the right in politics and, more significantly, a return to traditional Catholicism. It is this Catholic revival that provides a context for yet another level of irony in Duchamp's Munich works. Given the Rosicrucian/Catholic and Symbolist themes discussed in the last chapter, *Passage from Virgin to Bride* can be interpreted as alluding to a mystical Bride. Without returning to the notion of the threefold Bride of the *Large Glass*, this Bride might be a communicant or a nun. Both of these 'Brides' are, of course, simultaneously 'Virgins' and their exemplar within Catholicism is the Virgin Mary herself. The possibility that it is indeed the Virgin of whom Duchamp is thinking is reinforced by another clue. Amongst the mixture of organic, insect-like and mechanical elements that make up the creature there is a form, just right of centre, that looks like some kind of chemical (or possibly alchemical) apparatus, the Bride's 'sex cylinder'. At the top the cylinder narrows and forks in two producing a shape that derives from the stigma and style or reproductive organs of a plant. This curious yoking of human and insect or plant reference was a feature of works – such as the *Tête humaine (Human Head)* from *Homage to Goya* (1885) – by Odilon Redon

(1840–1916), an artist whose influence Duchamp acknowledged. These plant references in the sex cylinder might connote an imminent 'blossoming' according to Rosicrucian ideas. While the resultant rose might have Rosicrucian connections, it has also been traditionally associated with the Virgin Mary. The first appearance of this 'sex cylinder' is, in fact, in *Passage from Virgin to Bride*, and, given the crudely sexual interpretation of the title, it is perfectly feasible that the picture's theme is the ineffable moment of divine impregnation. The 'passage', as suggested earlier, is thus even more blatantly an imponderable fusion of the spiritual and the physical.

This interpretation conveys the full force of Duchamp's blasphemy at a time of Catholic resurgence. As a depiction of the moment of virgin conception, *Bride* significantly eschews the attempt to depict physical motion of earlier paintings; movement is now very much 'hidden'. It occurs mysteriously in the tubes and

50. **Odilon Redon**, *Tête humaine (Human Head)* from *Homage to Goya*, plate 2, 1885

viscera of what is a profoundly hermetic organism. If, then, in polemical terms, *Bride* was simultaneously aimed at two contemporary targets – Cubism and Catholic resurgence – we should not ignore the *gravitas* or poignancy of the image.

To pursue this last point, a final association of the image of the 'sex cylinder' needs to be added: namely, its similarity to the kind of apparatus used in alchemy, as depicted, for instance, by Wright of Derby (1734–97). The art historians Arturo Schwarz and Maurizio Calvesi have constructed intricate theories surrounding Duchamp's possible interest in alchemy, particularly in relation to the *Large Glass*. For the purposes of this discussion we may focus on the peculiar mingling of the mechanistic, the spiritual and the sexual that is such a marked feature of this tradition. Although the alchemists used scientific paraphernalia, their ultimate aim was an esoteric fusion of opposed elements (sulphur and mercury initially), which, symbolically, united sexual and spiritual principles

51. **Wright of Derby,**
The Alchemist, 1771

(male and female, Bride and Bridegroom, etc.). Through such dialectical operations they attempted to undermine the mind-body dualism endemic to mainstream western thought and taken to its logical conclusion by Descartes. As noted earlier, a residue of this alchemical tradition survives in the symbolism of Rosicrucianism. Historically, it was the rationalist mechanics of Descartes that succeeded in banishing such elaborate symbolic structures from the western world-view, and this is, ultimately, why Duchamp's work implicitly ironizes Descartes, as it mocks so many other cultural and artistic institutions. *Bride* is at one and the same time a stripped-down victim of scientific reductionism – the objectified 'other' of the male gaze – and a mysterious, self-contained organism, inwardly generating sexual/spiritual processes of a unique kind. Something of Duchamp's dismay as his ingrained mystical archetype of femininity meets the ideological positioning of males and females in their social domains is surely enacted here. The mask, to some extent, slips.

Bride is the culmination of the Munich period. After painting it, Duchamp returned to Paris via Prague, Vienna, Dresden and Berlin. Later on he transferred parts of the image to the *Large Glass*, rethinking elements of the Bride's workings as a 'motor' in *The Green Box*. These notes leave us in no doubt about a religious dimension to the Bride: she is called an 'apotheosis of virginity', and the 'blossoming' she produces at the top of the *Large Glass* is described as her 'halo'. Whatever his subsequent artistic and intellectual interests over the next few years, Duchamp preserved this crucial symbol, allowing it to be interrogated and assailed by other belief-systems and his own constant scepticism, but not to disappear. The Bride's final embodied incarnation in *Etant donnés* 151 testifies to this attitude.

Chapter 4: Dry Art, the 'Retinal Shudder' and the Planning of the Large Glass

In pursuing a metaphorical link between the body and the machine Duchamp had had recourse to mechanically derived visual images (photography). In the 1911 painting of the *Coffee Mill* he had referred, though still in a loose if rudimentary painterly manner, to a diagrammatic mode of representing its mechanical action. A much more radical rejection of the aesthetics of his modernist colleagues followed in 1913, although its implications were delayed for some years. However, the critical responses to Duchamp's work after his return to Paris in October 1912 show the beginnings of significant differences between Duchamp and the other Cubists, even if their exact nature was not apparent. In October 1912 Duchamp exhibited one of the Munich *Virgin* drawings at the Salon d'Automne, and, more importantly, was well represented at the famous 'Salon de la Section d'Or' exhibition at the Galerie de la Boëtie, principally organized by the Puteaux group of Cubists – perhaps in compensation for his rough treatment over *Nude Descending a Staircase, No. 2* in the spring. Six works by Duchamp were exhibited, of which four are identifiable: apart from *Nude Descending a Staircase, No. 2*, the canvases that link the themes of the nude and chess are *The King and Queen Surrounded by Swift Nudes* (1912), the watercolour *The King and Queen Traversed by Nudes at High Speed* (1912) and *Portrait of Chess Players* (1911).

Apollinaire was one of the critics who noticed that the show lacked stylistic unity. The poet, whose views Duchamp later regarded with suspicion, recognized that Duchamp and his friend Picabia were pursuing a different approach to the Salon Cubists, although he had difficulty in defining it. In an article responding to a survey in *Le Temps*, Apollinaire wrote: 'Picabia abandoned the conceptual formula [of Cubism] at the same time as Marcel Duchamp and began to practise an art governed by no rules whatsoever. Delaunay, for his part, silently invented an art of pure colour. Thus, we are evolving towards an entirely new art that will be to painting, as it has hitherto been envisaged, what music is to poetry. It will be an art of pure painting.' Apollinaire's *Les Peintres cubistes* was a polemical tract backing this new school of painting.

Published in 1913, it was almost certainly the subject of discussion during a visit Apollinaire, Duchamp and Picabia paid to the Jura Mountains late in October 1912, to stay with Gabrielle Buffet-Picabia at her mother's house. Here Apollinaire first read his poem *Zone*, which opened with the line: 'In the end, you're bored with the old world.' It celebrated a modern world of factories, aircraft hangars, newspapers, posters, in language that alternates between a flat conversational tone and a kind of stripped and modernized lyricism.

Of the painters whom Apollinaire discusses in *Les Peintres cubistes*, Delaunay perhaps comes closest to the poet's sense of the popular, ephemeral, transient, shifting, urban scene. He became the most purely abstract painter. The categories into which Apollinaire divided Cubism, which he defined as no longer 'an art of imitation but an art of conception which tends to rise to creation', have not stood the test of time; scientific Cubism, physical Cubism, orphic Cubism and instinctive Cubism are now not clearly distinguishable from one another, although they do respond to the different ways an artist might 'construct' rather than imitate, and the possibilities that 'pure' painting might dispense with or become its own subject. Unlike Gleizes and Metzinger's *Du cubisme*, though, this text is a critical defence rather than a manifesto and its central part is a series of short chapters on individual artists, some of which had previously been published.

The short but grandiose essay on Duchamp, the youngest and least known of the artists discussed, who, Apollinaire felt, had produced too few works to form a clear impression of the direction he was taking, nonetheless contains three striking insights into the artist's work. Firstly, it pointed to the significance of titles. Apollinaire saw that Duchamp used titles (as has been argued earlier) as an independent element and made a deliberate contrast between 'an extremely intellectual title' and the 'concrete composition' of his painting. By writing its title on the painting, 'the literature which few painters are able to dispense with disappears from his art, but not the poetry'. This obscure remark probably alluded to the practice of inventing mundane stories about an image or recognizing a literary or historical subject. Apollinaire suggested that this custom is frustrated by Duchamp's mysterious (poetic) titles, by which he willingly ran the risk of being accused of producing an 'esoteric' painting. Over and above the casual reference here to Hermetic or alchemical aspects of the paintings, Apollinaire recognized Duchamp's willingness to obstruct easy understanding, a tendency that later became more pronounced.

Secondly, Apollinaire noted that Duchamp seemed to be the only modern painter who was still concerned with the nude. Thirdly, he sensed that Duchamp's painting shared something with the industrial world.

In attempting to draw an analogy between Duchamp's paintings and music, a popular approach in their small group to subjectless painting – Gabrielle Buffet-Picabia, Picabia's wife, was a gifted musician and contributed to their debates about abstraction – Apollinaire noted Duchamp's avoidance of a generalized aesthetic of colour and form in favour of odd scratchings and a small number of energetic lines:

This technique can produce works of a strength so far undreamed of. It may even play a social role.

Just as Cimabue's pictures were paraded through the streets, our century has seen the airplane of Blériot, laden with the efforts of humanity made for the past thousand years, escorted in glory to the Arts et Métiers. *Perhaps it will be the task of an artist as detached from aesthetic preoccupations, and as intent on the energetic as* Marcel Duchamp, *to reconcile art and the people.*

Perhaps Apollinaire was only trying to avoid saying that Duchamp showed 'Futurist' leanings. Yet this remarkable text, which substitutes public awe at the functional aeroplane for the social significance of religious art in past centuries, also contains a plea for an art that is at once democratic, appropriate to the modern world, and still the equal of the Cimabue Madonna. This mission to reconcile art and the people is not one that is normally associated with Duchamp, but it does point to a strand in his future activities that was eminently democratic: his debunking of 'pure' painting and mistrust of the Cubists' claims to be the avatars of a new 'language' of art.

Probably his last work before abandoning the Cubist avant-garde was, significantly, the baffling wash drawing *Aeroplane* (1912), a delicate Munich work that seems to refer obscurely but with paradoxical precision to instruments (perhaps of a plane) as well as to flight, propellers, perhaps a window, but also persistently to the visceral forms of the Bride. In the outlines at the base of this drawing of a tubular apparatus there is already evidence of precise technological drawing, which is again fleetingly found in the 'stand' in the *Portrait of Gustave Candel's Mother*. Although the bust itself was probably painted in Neuilly between 1911 and 1912, it is inscribed to Madame Candel in 1913, when it is reasonable to suppose Duchamp added the ruler-drawn, carefully shaded

base, which is clearly related to the *Cemetery of Uniforms and Liveries, No. 1* drawing of that year.

The dissatisfaction and unease Duchamp appears to have experienced at this time is conveyed in an incident reported in a later interview. Sometime in the autumn of 1912 Duchamp visited the Salon de la Locomotion Aérienne together with the painter Fernand Léger and the sculptor Constantin Brancusi (1876–1957); Duchamp paused in front of a propeller, perhaps of the kind Picabia later re-christened *Ass* for his Dada review *391* and said to Brancusi: 'Painting is finished. Who can do better than that propeller? Tell me, can you do that?' The accidental formal beauty of the industrial product beat art and sculpture at their own aesthetic game. This realization may have exacerbated the crisis that led Duchamp, after the Jura trip, to ask Picabia to find him an undemanding job as a librarian at the Bibliothèque Sainte Geneviève on the Place du Panthéon in Paris. As Duchamp later confessed, he was completely disenchanted with the art scene. He had been profoundly disillusioned by the rejection of his *Nude Descending a Staircase, No. 2* at the Salon des Indépendants exhibition in 1912 and in a television interview of 1956 recalled saying to himself: 'Marcel no more painting, go get a job.'

75

54

His sceptical mind was irritated by the path being taken by avant-garde art and by the justifications of Cubism and the various forms of 'abstraction'. He particularly disliked the continual references among the Cubist critics to the 'conceptual' aspects of this art, a notion that Duchamp turned in a very different direction. Discussion of the conceptual did not hide, for Duchamp, the continuing emphasis on the purely visual in the painting of his contemporaries. A key statement to Cabanne sets out Duchamp's rejection of abstraction:

Since Courbet, it's been believed that painting is addressed to the retina. That was everyone's error. The retinal shudder! Before, painting had other functions: it could be religious, philosophical, moral. If I had the chance to take an anti-retinal attitude, it unfortunately hasn't changed much; our whole century is completely retinal, except for the Surrealists, who tried to go outside it somewhat. And still, they didn't go so far! In spite of the fact that Breton says he believes in judging from a Surrealist point of view, down deep he's still really interested in painting in the retinal sense. It's absolutely ridiculous. It has to change; it hasn't always been like this.

N° V.1

ANE

391

41

54. **Francis Picabia**, *Ass*, cover of *391*, June 1917 (no. 5). This first New York issue of the review Picabia founded in Barcelona in January 1917 appeared just after *The Blind Man/Fountain* scandal (see Chapter Six). *391* was important in spreading the 'machine style' initiated by Duchamp and later was closely associated with Dada. Here Picabia gives a new meaning to the 'readymade' through its title.

Duchamp rejected the common phrase 'stupid as a painter': 'By the retinal approach', he explained in a panel discussion at the Philadelphia College of Art in 1961, 'I mean that the aesthetic delectation depends almost exclusively upon the sensitivity of the retina without any auxiliary interpretation.' Retinal art destroyed art's close ties with society, because in his view it had excluded the religious, philosophical and moral content that had once bonded the two together. At one level, Duchamp's hostility towards 'retinal art' was based upon a philosophical scepticism about the circularity of its pseudo-theoretical premises. Its greatest spokesman in France at the time was Matisse, whose *Notes d'un peintre* of 1908 gave an account of art in terms of 'expression', but insisted that the painter followed rules that could only derive from feeling. Expression thus became a highly subjective phenomenon and theoretically at least the viewer could not easily make judgments about the truth of what was expressed. The absence of intellectual content, reflected in the theoretical vacuity of the notion of 'expression', set a disastrous course for art. Duchamp had a consistently ambivalent attitude to Matisse's painting: 'It was a good thing to have had Matisse's work for the beauty it provided. Still, it created a new wave of physical painting in this century.' Duchamp's attitude to the physicality of sensuous, retinal art is underpinned by his own preoccupation with sexual pleasure and the unthinking and unspoken elision of the two. The ever narrowing gap between what in Duchamp's view was a fantasy of perfect coition and the claims made for the aesthetic experience of retinal art seemed to him to bring art even closer to an unthinking, solitary, animal paroxysm. As Duchamp put it in a cutting aphorism: 'The ultimate for/a collector/is to take Aspirin/for his Henri Matisses.' Later in his life, and true to his desire to 'include [him]self in the joke', Duchamp spoke of the fantasy of perfect coition as a common origin of all art, even his own supposedly intellectual efforts: 'We have created [Art] in thinking about ourselves, about our own satisfaction. We created it for our sole and unique use; it's a little like masturbation.' To reconcile this perception with his rejection of the 'retinal' was, as we shall see, one of the motives of the *Large Glass*.

The creation of the *Chocolate Grinder*, together with the many drawings for the details of the *Large Glass*, is accompanied by a marked change in technique equally removed from Cubism and the 'expressive fallacy'. Duchamp commented on this change in a lecture given in St Louis, Missouri, in 1964:

BROYEUSE DE CHOCOLAT - 1913

55. *Chocolate Grinder, No. 1*, 1913

BROYEUSE DE CHOCOLAT - 1914

56. *Chocolate Grinder, No. 2*, 1914

From 1913 on, I concentrated all my activities on the planning of the
Large Glass *and made a study of every detail, like this oil painting*
which is called Chocolate Grinder, [No. 2] *1914. It was actually*
suggested by a chocolate grinding machine I saw in the window of a
confectionery shop in Rouen. Through the introduction of straight
perspective and a very geometrical design of a definite grinding
machine like this one, I felt definitely out of the Cubist straightjacket.

Mechanical drawing techniques, Duchamp held, lay outside
pictorial conventions, were not subject to aesthetic considerations
and avoided the operations of taste, which were no more than
habit. Objects would be represented in plan or elevation, as a blue-
print for production, while diagrams could represent movement.
This new direction recalled the French schoolboy's education in
technical drawing. The introduction of drawing techniques
directly related to industrial production was, as the art historian
Molly Nesbit has shown, an important part of standardized educa-
tional reform in late nineteenth-century France. This drawing
technique renounced light, texture and any sign of vital
spontaneity or expression. The interest in the mechanical and the
mechanomorphic led Duchamp to a literal application of its
representational values, which functioned effectively as a rejection
of the 'retinal'. There was thus a perfect match between the
mechanical drawing technique and Duchamp's theoretical
distaste for the retinal. However, Duchamp's simultaneous revival
of perspective, another feature of his early training in industrial
drawing, opened the way for more speculation, this time returning
an intellectual dimension to the retinal.

The meticulous shadows and perspective of *Chocolate Grinder*,
No. 1 (1913) recall the shadowy universe and false perspectives of
his contemporary Giorgio de Chirico (1888–1974). This first ver-
sion of the *Chocolate Grinder* has a strong sense of perspective; in
an interview with Dorothy Norman in 1953 Duchamp said noth-
ing like it was being painted at the time, but also: 'The spirit of my
work was close to the cubist idea of what I would call "dismant-
ling". But in form it was quite different.' The machine Duchamp
saw, powered by a steam engine, had two rollers that ground to a
fine texture a coarse blend of cocoa and sugar. Duchamp added
another roller, redesigning or simply misremembering its
mechanics, and completed it with an elegant infrastructure, which
he called a 'Louis XV' chassis. Its finely curved legs, ornamented
with a rolling caster, were the subject of several drawings. Too
light for its burden, this chassis is like an ironic Rococo reminder of

the first great mechanical age immortalized in the standard drawings of functional objects in Diderot's *Encyclopédie*. The machine, though, is stripped down to one basic gyratory function, a turning and grinding of gears that Duchamp associated symbolically with masturbation: 'Always there has been a necessity for circles in my life, for, how do you say, rotation. It is a kind of onanism. The machine goes round, and by some miraculous process I have always found fascinating, produces chocolate.'

In *Chocolate Grinder, No. 2* of February 1914, Duchamp gave expression to his desire to 'avoid all formal lyricism'. Shadows are eliminated as the adjunct of perspective, light and viewpoint, and the fine grooves on the roller are stitched on to the canvas with thread, while black lead has been used for the pigmentation. At the lower left of the work the title and date are inscribed in gold letters on black ribbon, combining a luxury nametape on a commodity item and the inscription on a sacred icon. This is no longer a functional machine; its grotesque embroidered rollers could not possibly turn. 56

57. (below left) *Study for the Chocolate Grinder's Leg*, 1914

58. (below right) A water mill from Diderot and d'Alembert, *Encyclopédie*, 1762.

Agriculture, Œconomie Rustique,
Moulin à Eau.

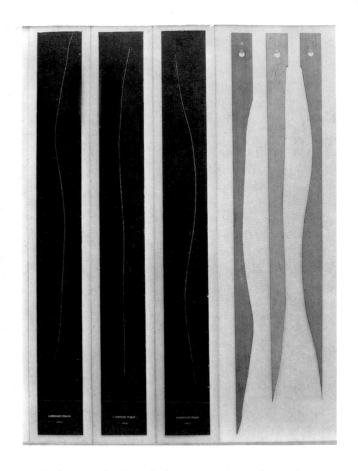

Duchamp's adoption of a dry engineering style was, however, no celebration of science. Nowhere is this fact more clearly demonstrated than in his introduction of chance into the science of measurement, which produced one of his most technically bizarre works, the *3 Stoppages Etalon (3 Standard Stoppages)* of 1913 to 1914. This work, which combined his critique of retinal art with that of anthropocentric science, recalls the Pataphysics, or 'science of imaginary solutions' invented by Alfred Jarry. His 'neo-scientific' novel, *Gestes et opinions du docteur Faustroll, pataphysicien*, was written in 1898 but not published in full until 1911, when it was immediately lauded by Apollinaire. Jarry's Pataphysics mixed science, theology and art in an irrational, hilarious and proto-Surrealist version of faith in human technology: 'Pataphysics', Jarry wrote, 'will be the science of the particular, despite the common opinion that the only science is of the general. Pataphysics will examine the laws governing exceptions, and will explain the

universe parallel to this one.' A contemporary note by Duchamp published in *The Box of 1914* describes the idea of the fabrication in the *3 Standard Stoppages*: 'If a straight horizontal thread one meter long falls from a height of one meter onto a horizontal plane distorting itself *as it pleases* and creates a new shape of the measure of length.'

Duchamp took three one-metre lengths of string and dropped them from a height of one metre on to a canvas. He then stuck the threads down and thereby fixed the new lengths that chance, gravity and the 'whims' of the threads had created. He consistently emphasized that he was not personally responsible for the deformations of these lines (unlike the way Matisse, say, needed to be completely responsible for his). Rather, Duchamp had, in his phrase to Cabanne, 'canned chance'. The term *stoppages* – a French word meaning the invisible mending of a garment – which he had glimpsed on a shop sign, seemed appropriate for his impersonal threading; when he rendered the title into English, however, he used the same word, which thus takes on new connotations. Duchamp then proceeded to make three 'rulers' that followed the exact contours of the threads and went on to box them like technical instruments (but in a wooden box resembling a case for croquet sets).

Duchamp mocked the human pretension of measuring nature, calibrating it by a scheme that is always arbitrary, making sense of it with rules and laws that depend entirely upon a human perspective. He almost certainly had in mind the French standard metre, which was preserved in the form of a platinum-iridium bar kept in a deluxe tube in the Pavillon de Breteuil, Sèvres. It was supposed to verify the precise length of the metre, but was based upon a mistaken measurement of the globe itself.

In a 1963 interview with the critic Francis Roberts published just after Duchamp's death five years later, he said: 'If I do propose to strain a little bit the laws of physics and chemistry and so forth, it is because I would like you to think them unstable to a degree. Even gravity is a form of coincidence or politeness since it is only by condescension that a weight is heavier when it descends than when it rises.' The notion of making three, not one, personal 'standard' units of measurement underlined the arbitrary nature of measurement and the fetishistic absurdity of anything but a mathematical definition. Duchamp called his lovingly boxed rulers 'the meter diminished' and used them, each repeated three times, in his *Network of Stoppages* (1914) as the templates of a plan for the disposition of the Bachelors or the Nine Malic Moulds in the *Large*

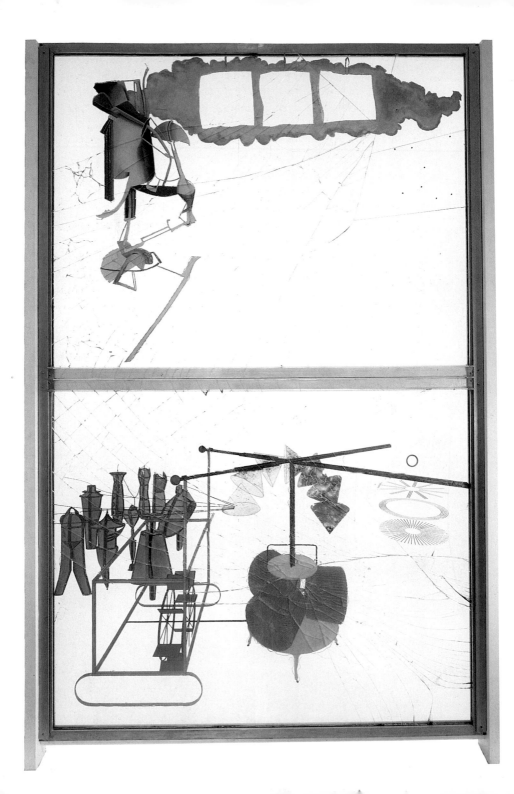

61. (opposite) *La Mariée mise à nu par ses célibataires, même (The Bride Stripped Bare by Her Bachelors, Even*, known as the *Large Glass*), 1915–23

Glass. Each of the nine Bachelors, marked by a circle, is positioned along one of the curved lines, thus notionally locating them in space, as one can see from the 'perspective' drawing *Cemetery of Uniforms and Liveries, No. 2. Network of Stoppages* consists of three superimposed works, whose connections with each other may not be purely fortuitous. The earliest is an enlarged, unfinished version of *Young Man and Girl in Spring*, probably dating from 1911. Its sides were then painted over with black bands to produce the dimensions of the *Large Glass*, in which he drew a half-scale plan, consisting largely of measurements. The uppermost layer is the 'network of stoppages' itself, almost certainly undertaken in 1914. Chance, then, in the guise of the *3 Standard Stoppages*, equipped Duchamp with drawing instruments for the *Large Glass.*

Duchamp recognized that technology, science, art and the human body, once so closely allied, had grown so far apart that they might now collide. His dry mechanical art was the first spark that flew from this collision; the readymades (see Chapter Seven) were the second. However, the most complex manifestation of the fractures of modern life and their representations was the huge construction known as *The Bride Stripped Bare by Her Bachelors, Even* (the *Large Glass*).

76
59

62. Diagram based on Duchamp's etching entitled *The Large Glass Completed*, 1965

Key to the *Large Glass*
Elements planned but not executed on the original *Glass* are indicated*

1. Bride, *pendu femelle*
1a. Wasp or Sex Cylinder

2. Milky Way or Top Inscription

3. Draught Pistons

4. Nine Shots

5. Bride's garment*

6. Horizon

7. Region of the Wilson-Lincoln effect*

8. Handler or Juggler of Gravity*
 (also Tender of Gravity)
8a. Handler of Gravity's leg*

9a. Priest
9b. Department store delivery boy
9c. Gendarme
9d. Cuirassier
9e. Flunky (liveried servant)
9f. Undertaker
9g. Stationmaster
9h. Busboy / Waiter's assistant
9i. Policeman

10. Glider, Chariot or Sleigh
10a. Water Mill Wheel
10b. Runners
10c. Sandow*
10d. Revolution of the Bottle of Benedictine*

11. Capillary Tubes

12. Chocolate Grinder
12a. Louis XV Chassis
12b. Bayonet
12c. Necktie
12d. Scissors

13. Sieves or Parasols

14. Region of the Waterfall*

15. Oculist Witnesses (Oculist Charts)

16. Region of the Butterfly Pump*

17. Toboggan, or Corkscrew, or Planes /
 Slopes of Flow

18. Region of 3 Crashes or Splashes*

19. Weight with Nine Holes*

20. Magnifying Glass

21. Boxing Match*

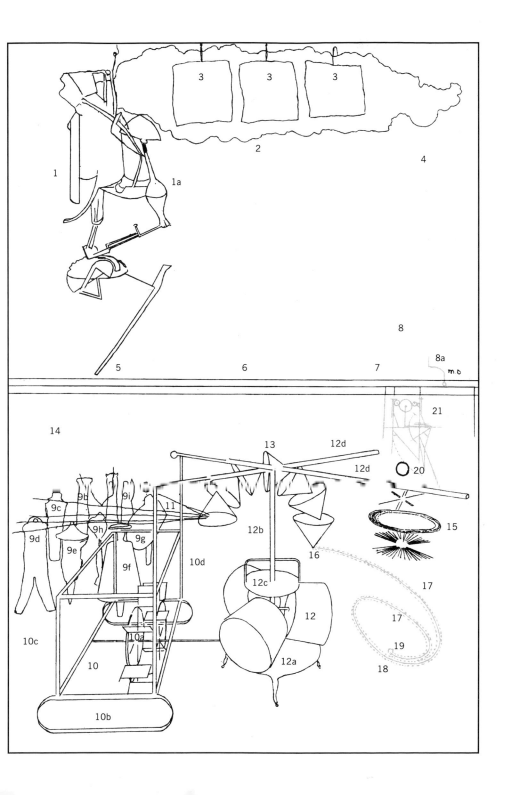

Chapter 5: The Bride Stripped Bare by Her Bachelors, Even (the Large Glass)

Twice in his life Duchamp concentrated his energies on a 'major' work: *The Bride Stripped Bare by Her Bachelors, Even* (the *Large Glass*) of 1915 to 1923 and *Etant donnés: 1. La chute d'eau 2. Le gaz d'éclairage (Given: 1. The Waterfall 2. The Illuminating Gas)* of 1946 to 1966. They were 'major' works in the sense that they were executed on a grand scale and they summed up and gave a focus to ideas developed over long periods. These works are not, however, 'major' in the conventional sense of aiming to be a public statement, an aesthetic manifesto. Indeed, the *Large Glass* was conceived more or less simultaneously with his rejection of a conventional artistic career and embodies this rejection as much as the readymades, though in a more paradoxical way, while *Etant donnés* was produced in total secrecy, its existence revealed only after his death in 1968. In many ways *Etant donnés* was, as we shall see, a counterpart of the *Large Glass*, its origins lying in the same notes and plans. Both take eroticism and desire as central themes and both embody the idea of delay, of the deferral of gratification (including that of artistic recognition).

In 1915 Duchamp, exempt from military service because of his health, left war-torn Europe for New York, where he began the construction of the *Large Glass*. Although he preserved an icy detachment from the conflict of the European nations, a note in *The Box of 1914* does extend the human/machine metaphor to satirize military activity: 'Against compulsory military service: a *"deferment"* of each limb, of the heart and the other anatomical parts; each soldier being already unable to put his uniform on again, his heart feeding *telephonically*, a deferred arm, etc.'

The Box of 1914 was the first in a long history of facsimile publications of Duchamp's notes. A minute edition (five only) assembled sixteen photographic facsimiles of manuscript notes and the drawing *To Have the Apprentice in the Sun* of 1914 in a commercial box for photographic paper. The more extensive collection of notes and sketches that related closely to *The Bride Stripped Bare by Her Bachelors, Even*, which bore the same title (though it was popularly known as *The Green Box*), was not published until 1934.

63, 64. (opposite)
The Box of 1914, 1913–14

These notes and drawings, however, had accumulated since 1912, and by the time Duchamp started work on the *Large Glass* in 1915 it was already meticulously planned. Most of its elements already existed, either as independent paintings like *Bride* and *Chocolate Grinder, No. 2* or in full-scale studies on glass like the *Nine Malic Moulds* (1914–15) or the *Glider Containing a Water Mill in Neighbouring Metals* (1913–15). A few things were to be left to chance – the results unpredictable, the operation precisely planned. Duchamp worked on the *Large Glass* daily in his studio – not for long at a time – copying the figures as painstakingly as a watchmaker, 'as though fulfilling a vow'. Having rejected the purely retinal in favour of a conceptual approach, he was now dedicated to its manual realization. 'Being a painter,' he said, 'one is always a kind of artisan.' The *Large Glass* was, then, the very antithesis of the readymades, the only other works in his studio at the time (see Chapter Seven). The snow shovel, hat rack, coat rack and others suspended from the ceiling or fastened to the floor were, once the choice had been made, produced as instantaneously as a photograph. Unlike the *Large Glass*, they represented the withdrawal rather than expenditure of time and labour.

Progress was leisurely. There was no pressure to finish the *Large Glass*, for Duchamp had taken the decision not to paint for a living. Usually he gave his works away or exchanged them.

65. (opposite)
Nine Malic Moulds, 1914–15

Occasionally he raised funds for specific projects, engaged in a little dealing, gave French lessons. In New York he had the support of Katherine Dreier, the first owner of the *Large Glass*, and of Walter C. Arensberg, who built up the largest collection of works by Duchamp, now gathered at the Philadelphia Museum of Art. Arensberg, who devoted much of his considerable wealth to proving that Francis Bacon wrote Shakespeare's plays, was a generous host and his apartment where Duchamp spent much of his time playing chess became the centre of social and artistic life. Duchamp's circle – which included not only fellow refugees like Picabia, the composer Edgar Varèse, the writer Henri-Pierre Roché, the poet Mina Loy and her husband the poet and boxer Arthur Cravan, and the eccentric Elsa von Freytag-Loringhoven but also American artists like Alfred Stieglitz, Joseph Stella, Beatrice Wood and Man Ray – created an iconoclastic, proto-Dada atmosphere.

66. (right) *Glider Containing a Water Mill in Neighbouring Metals*, 1913–15

When the United States entered the war in 1918, Duchamp moved to Buenos Aires, returning to Paris in 1919. The *Large Glass* remained in his studio in the Lincoln Arcade Building, and for the next few years Duchamp returned for extended periods to New York, where in 1920 his female alter ego Rrose Sélavy was born. In 1923 Duchamp stopped work on the *Glass*, declaring it 'definitively unfinished'.

♕ ♕ ♕

What exactly is *The Bride Stripped Bare by Her Bachelors, Even*? There is the construction of that title: two glass panels set one above the other, over nine feet (2.75 metres) tall, and freestanding. Impressive in scale, it is at first sight baffling in iconography and unclassifiable in style. Yet this glass construction is not a discrete whole; *The Bride Stripped Bare by Her Bachelors, Even* is also the title given to *The Green Box* notes. Duchamp intended the *Large Glass* to be accompanied by a book, in order to prevent purely visual responses to it. He explained his attitude to Pierre Cabanne, while referring to *The Box of 1914*: 'I wanted that album to go with the [*Large*] *Glass*, and to be consulted when seeing the *Glass* because, as I see it, it must not be "looked at" in the aesthetic sense of the word. One must consult the book, and see the two together. The conjunction of the two things entirely removes the retinal aspect that I don't like. It was very logical.'

The Box of 1914 was actually published while Duchamp was in the final stages of preparation for the *Large Glass* and had already produced two half-scale studies for it on glass; although less obviously concerned with the iconography and narrative of the *Large Glass* than *The Green Box* notes of 1934, it shares the same kinds of preoccupations with, for instance, chance, machines and sex. His purpose, in any case, is clear: the conjunction of glass and *a book* was meant to challenge a purely retinal, or visual, approach to the painting, the habit of looking unaccompanied by thought.

In terms of their actual published form, Duchamp's various selections from his numerous notes never reached that 'definitive' state implied by the word 'book'; perhaps they were never intended to. In their meticulous preparation, with templates cut to the size and shape of the originals, they preserve the provisional character of jottings, scraps, sketches, fragments. Among the posthumously published notes are indications for a book (to go with the glass) that would be circular in form (on a spiral binding, for example): 'make a round book i.e. without beginning or end', or that might

follow an order by ending and starting pages with the same word. The collections of notes published loose in boxes have indeed no predetermined order. They recall Stéphane Mallarmé's idea of a book that would be the 'Orphic' explanation of the world, taking the form of a loose-leaf album of some 960 pages, which would be recited or performed at regular intervals, while the leaves would be shuffled as part of the ritual.

Duchamp's numerous notes, many unpublished in his lifetime, are among the richest and least classifiable of any artist's writings. Many are highly speculative, concerning linguistic, scientific and mathematical ideas, as well the medium and iconography of specific works. However, his comment to Cabanne seems to minimize the interpretative significance of the published notes for the *Large Glass*: 'I don't have any [interpretation of it] because I made it without an idea. There were things that came along as I worked. The idea of the ensemble was purely and simply the execution, [plus] descriptions of each part in the matter of the catalogue of the *Arms of Saint-Etienne*. It was a renunciation of all aesthetics, in the ordinary sense of the word…not [to make] another manifesto of new painting.' This is a slightly different and more reductive model of the glass/book relationship: image and words that relate to one another like the pages of a mail-order catalogue. 'Avoid all formal lyricism/let the whole text be a catalogue.' This certainly serves to distance the notes from the idea of a text with aesthetic purposes. They are intended as description rather than hermeneutics. When Duchamp said he made the *Large Glass* without an idea, he spoke with his habitual precision, for he was referring to the actual process of its construction. By the time he came to make it, most of its composition and imagery had already been worked out in detail. He was also enacting for himself the original meaning of 'art', which was 'to make'.

In the making of the *Large Glass*, as in its iconic quality, there is an echo of the quattrocento craftsman working his precious materials and applying them to wood panels. Duchamp's above remark can be understood to mean that the execution of the work was in itself part of the idea. The ways in which technical difficulties resulting from the unusual materials were solved, alternatives sought where necessary, were at this stage integral to the whole concept. He had, for instance, planned to transfer the image of the Bride from the 1912 painting by photographic means. This was not only a practical short cut but also a way of drawing out the notion of the the *Large Glass* itself as a photographic analogue, its panes like the plates in a camera, to be imprinted with readymade

images. When it proved impossible to reproduce the Bride on the *Large Glass* photographically, he painted her in black and white, as though she were a photograph; the imitation of photography was to be 'noticeable'.

There were various indications initially for the medium of this new work. In the first recorded notes relating to it, which date from a trip in October 1912 to the Jura Mountains with Picabia and Apollinaire, in one of Picabia's powerful cars, he writes: 'The pictorial matter of this Jura-Paris road will be *wood*'. The 'head-light child could, graphically, be a comet, which would have its tail in front, this tail being an appendage of the headlight child appendage which absorbs by crushing (gold dust, graphically) this Jura-Paris road'. Another note describes the final compositional structure of the *Large Glass*, although now naming canvas as its support:

2 principal elements: 1. Bride
2. Bachelors
Graphic arrangement.
a long canvas, upright.
Bride above – bachelors below.

He probably decided to use glass as the medium at some point in 1913. An important note, not included in *The Green Box*, was written following a holiday with his sister at Herne Bay in England in 1913: 'Paint the definitive picture *sur glace sans tain* [two-way mirror] (thick).' To begin with he still appeared to be thinking in terms of canvas for his new work, mentioning riddling the canvas with lead shot in all its unused areas. He writes: 'As a background, perhaps: An electric fête recalling the decorative lighting of Magic City or Luna Park or the Pier Pavilion at Herne Bay. – garlands of lights against a black background (or a background of the sea, Prussian blue and sepia). Arc lights. Figuratively a fireworks. – In short a magical (distant) backdrop in front of which is presented [the Bride, crossed out] the agricultural instrument.' This idea of a black background against which only the lights stood out goes some way towards the background's eventual elimination altogether. A pre-war popular spectacle was artificial lighting in the form of decorative lanterns, and the glass of the lanterns may have contributed to the 'solution' of using glass. In the end, the 'garlands of lights' became the Malic Moulds. Novelty lights could be of different shapes (note, for instance, the Chinese lantern effect in the central foreground Malic Mould) but

could also have the remarkable property of turning different colours when the gas was heated.

In *The Green Box* notes he gives a

Kind of Subtitle
Delay in Glass

Use 'delay' instead of picture or painting; picture on glass becomes delay in glass — but delay in glass does not mean picture on glass —

It's merely a way of succeeding in no longer thinking that the thing in question is a picture... a delay in glass as you would say a poem in prose or a spittoon in silver.

67. **Man Ray**, *Dust Breeding*, 1920. Reproduced in the special issue of *Littérature* (1 October 1922) devoted to Duchamp's female persona Rrose Sélavy, with the caption: 'This is the domain of Rrose Sélavy/How arid it is – how fertile it is – how joyous it is – how sad it is/View taken from a aeroplane by Man Ray – 1921 [sic].'

'Delay' was eventually figured literally in the dust that gathered on the glass in his New York studio, which was photographed by Man Ray in 1920, and eventually wiped from all but the Sieves, where it was fixed with spray adhesive. Dust registered the passage of time as inactivity rather than activity: chance accumulations of secretions and dissolutions.

68. The *Large Glass*
in Katherine S. Dreier's library,
after Duchamp had mended
it in 1936. The specially
commissioned *Tu m'* (1918)
is visible framed in a bookcase
that appears to be free-standing.

Duchamp told Pierre Cabanne that the idea of using glass derived from the glass palette he habitually employed. He may also have been familiar with the minor art of painting on glass, which was particularly popular in Bavaria, where he had spent the summer of 1912. One note also refers to glass as a good base for 'cutting out – on smooth surface. preferably hard – (glass – ½ centim. thick)'. While this seems to be a purely technical note (probably to do with the stencils that were to be an important means of transferring completed images on to the final work), there is constant overlap and intersection between the technical and the conceptual in the notes; ideas both derive from, and are generated by, the medium itself, in literal or metaphorical extensions. So glass as a base for 'cutting out' could be linked to his comments about the cutting and moulding of the 'gas' produced by the Bachelors. The glass is regarded at various times as window, camera lens and photographic glass negative, as mirror and device in the construction of perspective. One note suggests encasing the Bride in a transparent glass box, hinting at a natural history display case, pointing up her insect qualities.

Glass as a substance is also, however, pictorially speaking, absence, its transparency purely negative. This was an important consideration for Duchamp, and a justification for 'no longer thinking that the thing in question is a picture', for it enabled him to dispense with landscape, background or setting: 'All that background on the canvas that had to be thought about, tactile space like wallpaper, all that garbage.... I wanted to sweep it away. With the glass you can concentrate on the figure if you want and you can change the background if you want by moving the glass. The transparency of the glass plays for you.' Glass has the property of a window in that it automatically and involuntarily includes what is seen through it, but unlike a window the position of the *Large Glass* can be changed to look out onto a different prospect, a different setting for the figures.

In 1927 both panes of glass shattered while in transit from an exhibition in Brooklyn. When its owner Katherine Dreier brought herself to tell Duchamp of the disaster, he accepted the breakage as a kind of 'chance completion', and in 1936 spent some months patiently mending it, finally encasing each panel in two further glass panels, mounted in a wood and steel frame.

70. *Draught Piston*, 1914. One of three photographs of gauze made to determine the irregular chance shapes of the Draught Pistons in the Milky Way on the *Large Glass*.

In the figures depicted on the *Large Glass*, an erotic-mechanical aspect is undoubtedly most prominent. Its curiously detached character is captured by the Surrealist leader André Breton (1896–1966), in his essay of 1935, 'Lighthouse of the Bride'. Breton summarized the *Large Glass* as a 'mechanistic, cynical interpretation of the phenomenon of love: the passage of woman from the state of virginity to the state of non-virginity taken as the theme of an asentimental speculation – one might say an extra-terrestrial being applying itself to imagine that type of operation'. It is not just the fact that machines and mechanical operations symbolize love, but that they are portrayed with what appears to be cold and speculative logic.

The Bride, who, in the 1912 painting, already possessed a partially mechanized form, is now situated in an aerial environment in the upper half of the *Large Glass*. A thread-like shape trails up from her 'body' towards the top of the glass, where it is hooked to the top 'bar'. The long 'feeler' stretching downwards does not touch the dividing barrier between her domain and that of the Bachelors. She is described as *Pendu femelle* (the 'Hanged Man' of the Tarot cards rendered female). Another component was sketched but not finally realized: a suspended filament of a gas lamp, to be linked to the Sex Cylinder (Wasp). Part of this moved in air currents, which connects it with the Draught Pistons. These Draught Pistons were generated by chance; in the final work, they are the 'empty' distorted squares enclosed in what Duchamp described as a 'kind of milky way *flesh colour*', which emanates like plasma from the Bride. The shapes were obtained by photographing three squares of gauze

hung in the draught from an open window (or according to another account, in the rising current of air from a radiator); Duchamp had originally intended to glue the pieces of gauze in the shapes randomly created by the wind, which he photographed, directly to the glass, but this was not feasible. The black-dotted gauze visible in the photographs is probably the sort of material used as veils on women's hats, a form of fashionable trimming, but disturbing in this context in that a bride's veil would usually be white.

The Milky Way is firmly attached to the top bar of the glass by three hooks, making an illusionistic link between the physical frame of the glass and the image on it. There is something paradoxical about this 'anchoring' in the sky – a limitless realm, but the visual effect convincingly suspends the whole 'figure' of Bride and Milky Way as it were in space, to make them appear real, just as Duchamp does by different methods with the Bachelor Apparatus.

An allegory of fertility may also lurk in the name Milky Way; although it *looks* like the clouds of a Renaissance heavenly scene, the name refers to the thick band of stars across the ecliptic, whose resemblance to a stream of milk is graphically represented by a goddess suckling a child in Tintoretto's *Origin of the Milky Way* (1577–78). *The Green Box* notes also mention that the Bride is an 'agricultural machine', or 'apparatus/instrument for farming', an allegorical shorthand for the idea of female (productive) nature harnessed by male industry.

The final element executed in the Bride's Domain are the Nine Shots: nine matchsticks dipped in paint were fired from a toy cannon, three at each of three 'targets', though only one succeeds in reaching a target (the edge of the Milky Way). The 'one-dimensional' target, 'the vanishing point (in perspective)', was thus, in Duchamp's term, 'demultiplied'. At the spots marked by chance by the paint, holes were neatly drilled through the glass.

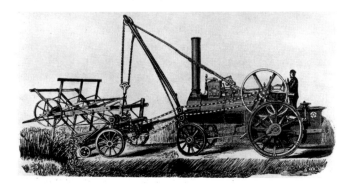

71. Agricultural machine, 1876

72. *Le Célibat broie son chocolat lui-même (The Bachelor Grinds His Chocolate Himself)*, 1913

The lower panel of the *Large Glass* contains the Bachelor Apparatus, to which the majority of the notes and sketches from 1912 to 1915 are devoted. This is a visibly mechanical world, and one that seems contained by circular movement and frustration. Not only does this male section of the the *Large Glass* multiply in terms of figures, but it is also the subject of intensive exploration of mechanical power and motion. The Bachelors were identified with a machine for grinding cocoa beans; a sketch of a chocolate grinder seen through the window of a confectioner's shop in Rouen is inscribed 'The bachelor grinds his chocolate himself'. This was soon followed by a sketch detailing the different pigments that will constitute the tones and hues of the chocolate, reinforcing the intimate interaction in the elaboration of the *Large Glass* between medium and idea. The metal shaft and its bell-like head become a 'necktie', the chocolate grinder acquires a third roller, and is mounted on a nickel-plated Louis XV chassis. A large-scale drawing entitled *Celibate Utensil* was exhibited in New York in 1916. *Chocolate Grinder, No. 2*, Duchamp's last oil painting on canvas (with the exception of *Tu m'* of 1918), was the model he used for the *Large Glass*, and differs in several significant details from the first version. Although perspective is retained, there is no delineation of space in the background. After testing the effect of different curves for the legs of the 'chassis' in a number of sketches, Duchamp added castors to suggest mobility. Finally, the lines on the rollers in the *Large Glass* are made of lead wires fixed to the surface.

There are several other motifs in the Bachelors' Domain as it was finally realized: the Chocolate Grinder acquired more attributes and accoutrements: necktie, scissors, bayonet; the

Glider containing a Water Mill; the Nine Malic Moulds forming the *Cemetery of Uniforms and Liveries*; the Sieves; and finally the Oculist Witnesses. A number of other motifs and ideas feature only in the notes. The Boxing Match, whose position is indicated in Duchamp's 1965 etching of the 'completed' work to the upper right in the Bachelors' Domain, is one of the most abstractly geometrical, with arcs and circles presumably matching punches and swings. Others included the Butterfly Pump, the Juggler or Handler of Gravity (in the Bride's Domain), the Churn, Drainage Slopes, the Buffer of Life and the Waterfall (omitted

73. *The Large Glass Completed*, 1965

74. *Buffer of Life*, 1913–15.
Study for the *Glider* (ill. 66). The
inscription reads: 'Buffer of life,
stopping the momentum, not by
brutal opposition, but by extended
springs which return more slowly
to their first position… The
carriage supported by runners
which slide (oil etc.) in a channel'.

75. (opposite top) *Cemetery of
Uniforms and Liveries, No. 1*,
1913

76. (opposite below) *Cemetery
of Uniforms and Liveries, No. 2*,
1914. Working drawing, life
size, for the Nine Malic Moulds,
reversed in order to be applied
to the back of the *Glass*.

because it raised the problem of 'landscape'). Whether these were
left off the *Large Glass* deliberately or were the casualties of its
unfinished state, they are nonetheless part of Duchamp's specula-
tions about the erotic machinations of his principal forms, mediat-
ed through pseudo-scientific and technological cause and effect.
The Buffer of Life, for example, attached to the end of the Glider
containing a Water Mill, is described as 'stopping the momentum,
not by brutal opposition, but by extended springs which return
more slowly to their first position'. It resembles the buffers
between carriages or the carriage and engine of early twentieth-
century steam trains, cushioning life's bumps.

The *Cemetery of Uniforms and Liveries*, later known as the Nine
Malic Moulds, originally consisted of eight figures, whose shapes
seemed to derive from various sketches combining dressmaker's
models and decorative glass lanterns. These two sources connect
the themes of gravity and weight in the lower part of the *Large*

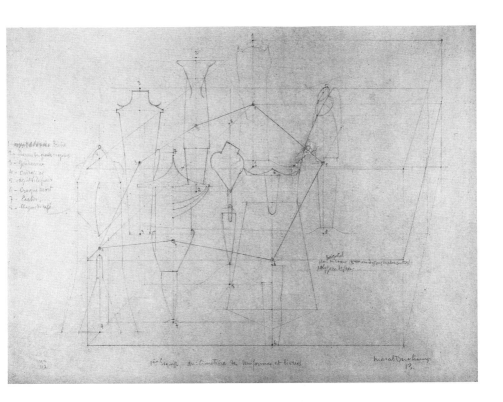

Glass: while the lanterns hang downwards, the busts are erected upwards from a ground support. They were named after uniformed characters: priest; department store delivery boy; gendarme; cuirassier; policeman; undertaker; flunky; busboy; the ninth, the stationmaster, was added later. They are not so much actual personages as 'hollow liveries', waiting to be filled, as their final title *Nine Malic Moulds (moules malics,* male-ish moulds) suggests. They were the subject of Duchamp's second complete study on glass, with lead wire encasing the shapes, like the metal frame of a glass lantern, their 'colour' provided by sheet lead, of a reddish colour, which Duchamp intended as 'provisional', like an undercoat.

The first scale drawing of the overall composition of *The Bride Stripped Bare by Her Bachelors, Even,* dating from 1913, puts in position in the lower half a perspectival study of the Glider, the upper section of the Chocolate Grinder, the Sieves and a spiral spinning from the last Sieve, which possibly represented the final form of the Illuminating Gas that had been cut into bits by the Sieves and finally liquified. In the upper half, a rough sketch of the Bride, together with the tip of the Milky Way and a rectangle that was to contain the Nine Holes.

78. (opposite) *The Bride Stripped Bare by Her Bachelors, Even (Study)*, 1913

170.

129,5

36
24

6'

31

6

137

109.

3,5 71,3 F 71,3 3,5

48,2

15

26

148 48,6

97 73

48,5 faits

170.

marcel Duchamp 1913

79. The lower panel of the *Large Glass*, the Bachelors' Domain, in Duchamp's New York studio (33 West 67th Street), 1918.

In October 1913 Duchamp made a full-scale working drawing on the freshly plastered wall of his new Paris studio at 23 Rue Saint-Hippolyte, which his friend the writer Robert Lebel describes as being based on the half-scale sketch under the *Network of Stoppages*. Missing from these sketches, and also from a photograph of the lower panel of the *Large Glass* taken in Duchamp's New York studio in early 1918 are the *Oculist Witnesses*, which thus represent the last element of the Bachelors' Domain, and the final fragmentation of the 'Bachelor Apparatus'. These 'peeping toms' were added to a silvered section in the lower right-hand part of the glass surface that was meticulously scraped away around the edges to produce the elliptical forms. This silvering may be a passing reference not only to the idea that the Bachelors are reflected back on themselves 'onanistically', but also to the silvering of photographic negative glass plates.

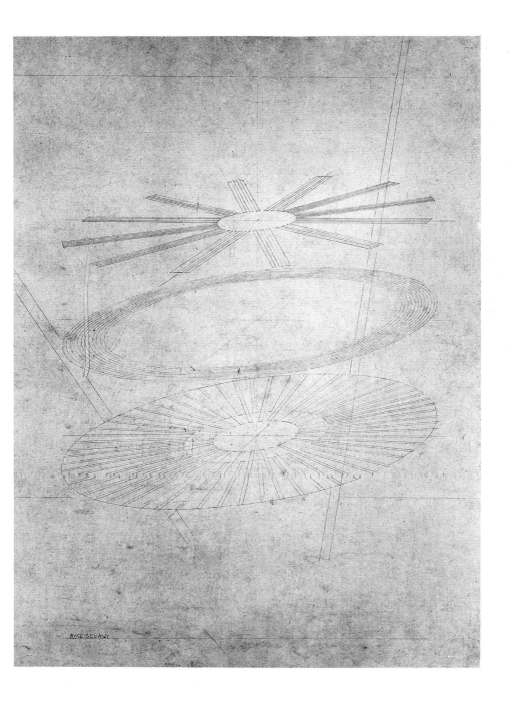

80. *Oculist Witnesses*, 1920

The Bride and the Bachelor Apparatus produce and expend erotic energy (desire, libido) in terms of natural and mechanical power and motion. How far this is mutual – what kind of interaction is expressed – remains ambiguous. The forces of electricity, gas, steam, water, gasoline propel into action various types of machine, or as Duchamp preferred to say, 'apparatus'.

Extracts from *The Green Box* notes give an idea of the interwoven emotional/physical, mechanical/sexual sources of energy. The whole passage runs through every possible (known) type of technological propulsion, referring at the same time to the notion of 'blossoming'.

The Bride basically is a motor. But before being a motor which transmits her timid-power. – she is this very timid-power – This timid-power is a sort of automobiline, love gasoline, that, distributed to the quite feeble cylinders, within reach of the sparks of her constant life, is used for the blossoming of this virgin who has reached the goal of her desire....

The whole graphic significance is for this cinematic blossoming....

Hence, this motor with quite feeble cylinders has 2 strokes. The 1st stroke (sparks of the desire-magneto) controls the immobile arbor type. This arbor-type is a kind of spinal column and should be the support for the blossoming into the bride's voluntary stripping. The 2nd stroke (artificial sparks of the electrical stripping) controls the clockwork machinery, graphic translation of the blossoming into stripping by the bachelors. (expressing the throbbing jerk of the minute hand on electric clocks.)

While implicated in this 'stripping' and 'blossoming', the Bachelors have their own multiple and self-contained stimulations and emissions: the Illuminating Gas passes from the top of each Malic Mould through the Sieves, turning imperceptibly into 'spangles *lighter than air, of a certain length, of elemental* thickness with a determination *to rise*, into: a liquid elemental scattering, seeking no direction'. The Illuminating Gas is to fill the Malic Moulds:

By eros' matrix, we understand the group of 8 uniforms or hollow liveries destined to receive/give to the illuminating gas which takes 8 malic forms (gendarme, cuirassier etc.)

The gas castings so obtained, would hear the litanies sung by the chariot, refrain of the whole celibate machine.

The meeting of the Bride and the Bachelors, which we learn is desired by both parties, is not represented and never takes place. The *Large Glass* is an 'inventory of the elements of this blossoming, elements of the sexual life imagined by her the bride-desiring'. The action is reciprocal but independent: 'The bride stripped bare by **her** bachelors, even.... **The bride possesses her partner and the bachelors strip bare their bride.**' As in the science fiction movie *Barbarella* (1967), the heroine reaches orgasm without contact with the Bachelors. By contrast with the Bride's blossoming, the Bachelors are a lugubrious group, grinding their own chocolate and listening to a litany of onanism. They are also neurasthenic, dizzy, dissipating energy and losing momentum.

Attempts have been made to construct a narrative of the implied mechanical functioning of the upper and lower halves of the *Glass*: to make visible the 'cinematic blossoming', as Duchamp put it, of the Bride and her interaction with the Bachelors. However, to succeed, these attempts would require the application of a consistent logic to operations that remain notional, inconsistent or at least multiply determined. The erotic is not rational. It is, perhaps, only a sexual encounter in the terms in which Breton saw it, as an extra-terrestrial observation of the inconsistencies, non-reciprocities and ambiguities of human sexuality.

The fascination with kinetic energy and 'fields of force' in both visual and linguistic terms runs throughout the *Large Glass* and the notes, which together form a fantastic catalogue of forms of propulsion and motion, and of the more invisible sources of energy and modes of communication. For instance, the Bachelor Machine is powered by steam and is also an internal combustion engine; it includes gas and a waterfall, springs and buffers and a hook made of a substance of 'oscillating density'. This was, Duchamp noted, a 'sandow', initially the name of a gymnastic apparatus made of extendable rubber, and by analogy a plane or glider launcher. The Bride runs on 'love gasoline'; she is a car moving in slow gear; her stripping produces sparks; she is a 1-stroke engine, 'desire-magneto'; the 2nd stroke controls the clockwork machinery (like 'the throbbing jerk of the minute hand on electric clocks').

Invisible forms of power, such as Hertz's discovery around 1886 of the identity of transmission between electricity, light and heat radiation and electro-magnetic waves, which opened the way for the invention of wireless transmission, were especially suggestive. In *The Box of 1914* Duchamp noted: 'Make a painting of *frequency*.' The multiple meanings of the term fascinated him: in

French, as in English, they stretch from a commonplace experience of time (short gaps between events), to the rate of recurrence of a vibration, to, in electricity, the number of complete cycles per second of an alternating current, and in statistics, to the ratio of the actual to the number of possible occurrences of an event. All these easily take on erotic connotations – although this was not the sole purpose to Duchamp's lengthy calculations and propositions related to science.

In their unique abbreviation Duchamp's various notes and sketches convey the different modes and moods of contemporary science, whether experimental or popular, commercial or domestic. For example, on new apartment blocks in Paris at the turn of the century, a blue plaque was fixed promising the modern conveniences of *eau et gaz à tous etages* ('water and gas on every floor'). In one of *The Green Box* notes Duchamp writes:

Notice

Given: *1st the waterfall...*
 2nd the illuminating gas,

which was to become the title of Duchamp's last work.

The mechanistic universe of the *Glass* is governed in rational and irrational ways by physical laws, especially gravity. Weight and weightlessness, falling, horizontality and verticality have their human and their abstract mechanical dimensions. There are hints in this fragmentary world of two interlocking systems that may both be described mechanistically: the universe itself and the human body. While there is no Prime Mover, the Enlightenment equivalent of God, visible in the *Large Glass*, the Juggler or Handler of Gravity has some of His characteristics, and there are other ironic echoes of Enlightenment descriptions of the universe as a great machine, as we saw earlier in relation to the Bride. In spite of the vivid expressions of generative power animating the Bride and the Bachelors, there are also suggestions in the *Large Glass* that this machine is running down. It gathers dust and rusts, as though Duchamp were pondering the second law of thermodynamics in relation to the loss of desire.

Duchamp's anti-retinal attitude can be explored in several directions in the *Large Glass* and its 'book'. Firstly, there are the language games. *The Green Box* notes contain a mass of puns, including the title of the work itself. There is a crucial pun in the final adverb which confers a meaning lost in translation: *La Mariée mise à nu par ses célibataires, même: même*, 'even', is homophonous with *m'aime*: 'loves me'. This adverbial pun completes the title that already existed, inscribed on the Munich drawing of 1912 'The bride stripped bare by the bachelors *loves me*'. A note dated 1912 reads: 'The machine with 5 hearts, the pure child, of nickel and platinum, must dominate the Jura-Paris road' and refers to the 'head-light child'. The text in French is a succession of puns: *La machine à cinq coeurs (5 heures)* and *l'enfant-phare (en fanfare)*. Duchamp must have penetrated the bizarre method of linguistic invention used by Raymond Roussel in his play *Impressions d'Afrique*, which was based on a system of homophones, slightly distorted (the key to which he was only to publish many years later). So, for example, the fantastic construction in *Impressions d'Afrique* of a 'life-size statue light enough to travel on rails made of calf's lights' (*mou à veau*) was inspired by the term *mou à raille*: 'mocked, spineless creature'. The 'philosophical comedy' of Roussel's play encouraged Duchamp's rejection of formal pictorial values in favour of 'scientific fantasy'. He was to continue his interest in puns later in connection with his female alter ego *Rrose Sélavy* [*arroser la vie/ eros c'est la vie*].

Secondly, the *Large Glass* and *The Green Box* notes contain ironic hints of another ambition, to make a 'total work of art' which brings together all the senses: sound, movement, colour and form. The notion of the *Gesamtkunstwerk* had haunted artists and musicians through the nineteenth century, and the most recent instance was Kandinsky's musical drama *The Yellow Tone* (1912). Since the 1890s there had been several attempts, moreover, to harness music and colour by mechanical means. The Illuminating Gas and the Malic Moulds as 'gas castings' may refer not only to the popular novelty spectacle of coloured gas lanterns but also to an experimental instrument invented by Georg Friedrich Kastner in 1875, the Pyrophone, which linked the sounds made by gas jets to colours. Coloured glass tubes contained 'gas jets (whose tone was correlated to the colour of the glass), which could be ignited from a controlling key board'. The Pyrophone, which aroused much interest in Paris, was a 'mechanized caricature' of a simplified synaesthesia, the linking of the senses, sight, hearing, smell. This popular idea, whose most famous expression was perhaps the

line in Baudelaire's sonnet 'Correspondances': *Les parfums, les couleurs et les sons se répondent* ('Perfumes, colours and sounds speak to one another') is woven closely into Symbolist art (and the pseudo-scientific beliefs of Theosophy).

There are other suggestions of sound or music in the *Large Glass*, for example, the 'litanies' of the Chariot or Glider. Among the unrealized projects for the *Large Glass* is the 'bottle of Benedictine', which both sang and functioned as a lead weight. *The Green Box* notes describe a '*Song*: of the revolution of the bottle of Bened.'. This recalls the synaesthetic 'mouth-organ' in Huysmans's novel *A Rebours* (1884), which consisted of a series of miniature liqueur barrels in a sandalwood casing, arranged according to tonalities: dry Curaçao corresponded to the clarinet, for instance; Benedictine to the minor key. The orchestration of sensations by the main character Des Esseintes, however, resulted in a state of enervation, or 'neurasthenia'. Duchamp also introduces the notion of debility in his description of the bottle of Benedictine, which he links to the charged sensations of gravity produced by falling and rising: 'After having *pulled* the chariot by its fall, the bottle of Benedictine lets itself be raised by the hook C; it falls asleep as it goes up; the dead point wakes it up suddenly and with its head down. It pirouettes and falls vertically according to the laws of gravity.' This particular fall is one of several references in the notes to ascents and descents, to movements obeying or defying the laws of gravity.

In spite of the fact that the generation of the *Large Glass* was in so many ways fuelled by Duchamp's anti-retinal convictions, one important aspect of it is profoundly retinal: that is, perspective. Perspective is one of several 'ordering systems' that Duchamp activates, and the way he does this is illuminating for the whole conceptual structure of the *Large Glass*. He makes use, not of a single system of perspective, but of alternative ones, and then suggests ways in which these overlap or intersect with totally different kinds of order or structure.

Duchamp uses perspective, a method of pictorial construction by then largely discarded by the avant-garde, in a way that disturbs rather than codifies patterns of seeing. The startling disunity between the upper and lower panels of the *Large Glass* first impresses itself visually through the use of perspective in the Bachelors' Domain, and its apparent absence in that of the Bride. The latter's world is abstract, organic and even formless, the other

rigidly constructed according to the laws of perspective. This difference is crucial: Duchamp described the *'principal forms'* of the bachelor machine' as 'imperfect: rectangle, circle, parallelepiped, symmetrical handle, demi-sphere = i.e. they are mensurable'. The implication is that if the Bachelors are imperfect and measurable, the Bride in her domain is immensurable, her form either perfect, or perhaps unknowable.

Duchamp's 'rehabilitation of perspective', whose presence in Cubism was ambiguous to say the least, and whose absence was often noted by Cubism's critics, had begun with the *Chocolate Grinder*, and Duchamp used strict one-point perspective in the *Large Glass* for both the major machine forms. Glass itself has a close relationship with traditional perspective, as in Albrecht Dürer's famous demonstrations during the sixteenth century and this may have been another inspiration for Duchamp's choice of medium. Among his notes omitted from *The Green Box* and published as *A l'Infinitif* (1964) is the following direction: *'Use transparent glass and mirror for perspective.'* Duchamp took the opportunity of working in the Bibliothèque Sainte Geneviève in Paris while he was preparing the notes for the *Large Glass* to study the collection of works on perspective housed there. A note from around 1914 says: 'Perspective. See Catalogue of Bibliothèque St Geneviève, the whole section on perspective.' The art historian Jean Clair has revealed the numerous references in Duchamp's work to such sources. The proportion and placing of the two panes of glass one above the other, for instance, are very similar to the format of the illustrations in such seventeenth-century treatises on perspective as Du Breuil's *La Perspective pratique* (1042).

82

If the *Large Glass* is exhibited so that there is sufficient space beyond it – floor or ground of some kind – the Bachelor Machines look as though they are in that space, standing on the ground

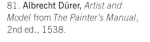

81. **Albrecht Dürer,** *Artist and Model* from *The Painter's Manual*, 2nd ed., 1538.

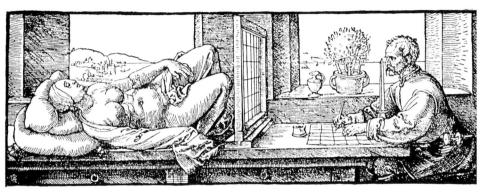

111

beyond the glass – their very precise shapes constructed through perspective giving them an appearance of three-dimensionality, an illusion impossible in painting where the fictive setting is bound within the frame. Only by making the support disappear altogether, become transparent, is the real fiction of perspective rendered. A comparable effect cannot be achieved with the upper half, because the Bride, though seeming to float in space, is left suspended and cannot be incorporated into any illusionistic schema.

Nonetheless, Duchamp's musings on perspective also and more surprisingly concern the Bride, but with a very different – even reverse – effect. The *Pendu femelle* is, one of *The Green Box* notes tells us, 'the form in *ordinary perspective* of a *Pendu femelle* for which one could perhaps try to discover the true form. This comes from the fact that any form is the perspective of another form according to a certain *vanishing point* and a certain *distance*'. In other words, the given representation of the Bride could, if we knew where to stand, produce her 'true form'. This purely speculative idea, a characteristic distortion of a scientific law, suggests the possibility of reconstructing an unknown (and indeed previously non-existent) being. Though perspective is used in each half, it prevents a consistent pictorial resolution to the whole.

The Bride was, Duchamp said, 'a new human being, half robot, half fourth dimensional', whose 'invention' would be the result not of dreams or fantasy but of applying the laws of perspective *ad absurdum*, and also combining this operation with another popular idea of the time, the 'fourth dimension'. 'Simply, I thought of the

idea of a projection, of an invisible fourth dimension,' Duchamp told Cabanne, 'something you couldn't see with your eyes. Since I found that one could make a cast shadow from a three-dimensional thing, any object whatsover – just as the projecting of the sun on the earth makes two dimensions – I thought that, by simple intellectual analogy, the fourth dimension could project an object of three dimensions, or, to put it another way, any three-dimensional object, which we see dispassionately, is a projection of something four-dimensional, something we're not familiar with. It was a bit of a sophism, but still it was possible. The Bride in the *Large Glass* was based on this, as if it were the projection of a four-dimensional object.'

Duchamp's ideas about the fourth dimension, as the art historian Linda Dalrymple-Henderson has demonstrated, seem to have been largely derived from Alain Jouffret's *Géométries à 4 dimensions* and from Poincaré, the philosopher of science and mathematician, who was known in the circle of Duchamp and his brothers. Poincaré argued that we are completely free to choose which geometry of physical space we prefer to determine measurement in the universe. His 'n-dimensional' geometry fascinated Duchamp and although still highly controversial, in terms of the theories it inspired, such as the existence of a fourth-dimension, it nonetheless belongs to those dramatic revisions at the turn of the century in our understanding of the physical universe that undermined traditional ideas of the homogeneity of space and the universality of time. In *A l'Infinitif*, pages are devoted to calculations about the fourth dimension to which Duchamp alludes in various ways, but notably by means of mirrors, the mirror being like a shadow projected in three dimensions. The plane of the mirror, he suggests, 'is a convenient way of giving the idea of 3-dim'l infinite space'; the 4-dim'l continuum 'is *essentially* the mirror of the 3-dim'l continuum'. Duchamp's interest in mirrors during the period of working on the *Large Glass* took many forms, for example the trick photograph of himself reflected five times; the silvering of the glass to create the Oculist Witnesses, the peeping toms who are partially reflected back on themselves and the reference to the *Large Glass* as a 'two-way mirror'. Duchamp may have known of the Michelson-Morley experiment of 1887, which attempted to detect the time difference that should exist in waves of light travelling through ether (the stationary substance that was believed to exist in what we now call space), in which a beam of light was directed on to a half-silvered glass plate. The failure of this experiment was to lead Einstein to develop his theory of relativity.

83

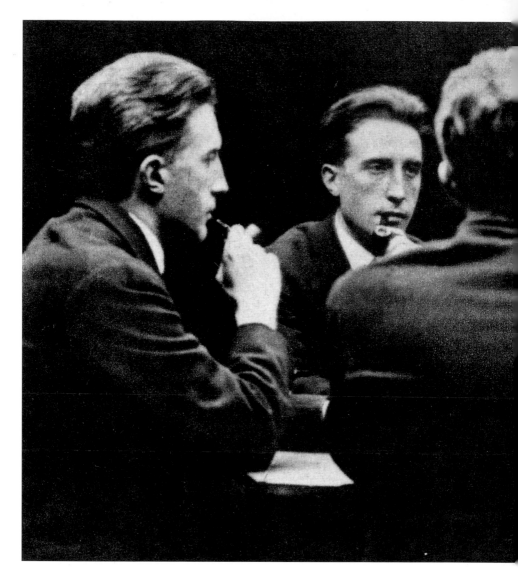

83. Photograph of Duchamp using a hinged mirror, 1917.
Duchamp's pleasure in popular novelty tricks and technological
devices naturally extended to photography, whose various
dimensions he explored in different ways all his life. Here, the
repeated 'man before the mirror' appears to be produced without
a photographer, a kind of automatic 'self-portrait', leaving the
question of authorship unresolved. Duchamp's friends Francis
Picabia and Henri-Pierre Roché had similar photographs taken,
probably on the same occasion: 10 October 1917, at the
Broadway Photo Shop in New York.

If we recall Duchamp's comment to Pierre Cabanne that painting used to have other functions: 'religious, philosophical, moral', to what extent might Duchamp have intended the *Large Glass* to have an overall conceptual scheme that could restore some such function to art? Or, to put it a different way, what function is played in the *Large Glass* by the diverse references to religion, mythology and literature? We have seen how science and perspective as ways of describing the 'real' played a part in the genesis of its imagery. What of belief systems or myths of a different kind?

The relationship between imagery and format in the *Large Glass* has prompted much speculation about literary, mythological and religious sources, from Alfred Jarry to the Greek myths. Jarry, whose short, hilarious and blasphemous commentary on 'The Passion Considered as an Uphill Bicycle Race' (1903) probably inspired Duchamp's 1914 drawing *To Have the Apprentice in the Sun*, published *Le Surmâle (The Supermale)* in 1902, a cynical-lyrical tale concerning human survival in a world of machines. The hero, who has a huge sex drive, makes love for two days to the American heroine; as he remains a sexual mechanism rather than a man with a soul, scientists devise a machine to inspire love, an apparatus that is strapped to his head. An indescribable phenomenon then occurs: 'Everyone knows that when two electro-dynamic machines are coupled together, the one with the higher output *charges* the other.' Jarry's supercharged erotic hero reverses the energy flow from machine to man; his power flows into the machine which falls in love with him, overheats and kills him. Traces of misogyny in Jarry's novel have parallels in Duchamp's Bride, while his Bachelor Apparatus, although neurasthenic and onanistic, take Jarry's supermale a stage further in demythologizing the idea of the unbeatable alliance between man and machine.

Analogies have been drawn with various mythological figures and the Bride. Octavio Paz, the Mexican poet and critic, one-time associate of the Surrealists, made a comparison between the Bride and Diana, the goddess of the moon and the hunt. Diana, an 'arbor-type' like the Bride, avenged herself on Actaeon, the youth who had spied her and her nymphs bathing naked in a pool, by setting her dogs on him. Paz also proposed a parallel with the Hindu Kali, the goddess who 'represents the world of phenomena, the incessant energy of this world, which is shown as destruction – sword and shears – as nourishment…and as contemplation'.

Both Diana and Kali offer mythical prototypes of the female element as active (who not only gives life but also brings destruction). Other analogies have been made with the female as passive recipient of male attention, such as the idealized lady of courtly romance, desired but untouchable, or with the nude symbolizing truth. 'Stripping bare' is moreover a stage in the alchemical process of refining base matter, and is sometimes symbolized by a naked woman in illustrations to alchemical texts.

However, by far the most extensive comparisons, taking into account the composition and format of the *Large Glass*, can be made with Christianity. Duchamp's ironic attitude to metaphysics

84. (opposite) *To Have the Apprentice in the Sun*, 1914

— avoir l'apprenti dans le soleil. —

Marcel Duchamp 1914.

works to make and unmake the icon. To begin with the arrangement of the *Large Glass*, in which one half is placed above the other; analogies with windows (stained glass, perhaps), photographic glass plates, diagrams from books on perspective are all convincing, but the most striking parallels are with representations of the Virgin set in heavenly splendour. The Bride, who is 'above', is described in *The Green Box* notes as the 'apotheosis of virginity'; the parallel with Titian's *Assumption of the Virgin* (1516–18) or Raphael's *Coronation of the Virgin* (1502–3) is, as John Golding has said, made visually manifest. She is raised among (above) the clouds, in the upper or 'heavenly' realm, with a massed crowd of (male) onlookers on the earth below.

The figures in the Bachelor Domain are divided into the protagonists and the Oculist Witnesses. These 'peeping toms', or male gazers, are usually, in the tradition of painting the nude, assumed to be the spectator and therefore not actually represented. In Christian imagery the witness of miraculous events, such as the Virgin's Assumption, may be an historical figure or may be elided with the act of devotion represented by the painting itself, like Francisco de Zurbarán (1598–1664) who painted St Luke, palette in hand, in the posture of adoration, gazing on the figure of Christ that he had just painted.

A posthumously published note headed 'Pictorial Translation', probably from 1912, reveals that the birth of the *Enfant-phare*, the 'headlight child' of the 'Jura-Paris road' who originated from the powerful headlamps on Picabia's enormous car, gives a special meaning to the Bride's 'blossoming'. 'This machine of five hearts will have to give birth to the headlight. This headlight will be the child-God, somewhat resembling the Jesus of the primitives. He will be the divine blossoming of this machine-mother.' Thus the Bride's blossoming is (among other things) the parthenogenetic birth of Christ, the child born without a father. The Bride's apparently capricious behaviour (she 'warmly rejects', but 'not chastely', the 'bachelors' brusque offer', and reaches autonomously 'this happy goal – the bride's desire') can be explained in terms of one of the greatest theological conundrums, the doctrine of the Virgin Birth. In *The Green Box* notes Duchamp plans, for his 'top inscription' (or title) which was to be reproduced photographically along the Milky Way (as though flashed on the clouds): 'blossoming'.

The 'child born without a father' fits into the contemporary ideas about man and machine; Picabia, who, following Duchamp's example, had produced works that played ironically with a

Fille née sans mère

Picabia

sexualized machine imagery, titled a drawing of 1915 the *Girl Born without a Mother*. Duchamp elaborated his Virgin/machine analogy: 'In graphic form I see him as pure machine compared to the more human machine mother. He will have to be **radiant with glory**. And the graphic means to obtain this machine-child, will find their expression in the use of the purest metals for a construction based (as a construction) on the concept of an endless screw.' This note also suggests the idea of putting Virgin/Mother and Machine/Child together, though this disturbs the apparently solid structural division of gender in the *Large Glass*. The 'stripping of the bride', too, has a double significance in terms of gender. Duchamp, in a BBC radio interview of 1959, remarked of the title *The Bride Stripped Bare...*: 'stripped bare: – I mean, it even had a naughty connotation with Christ. You know, the Christ was stripped bare, and it was a naughty form of introducing eroticism and religion.' The *Large Glass* is shot though with a blasphemous mélange of sex and religion.

André Breton saw its balance between the rational and the irrational in the form of a dialectic of desire, resolved in the notion of the 'delay in glass'. Duchamp himself speculated on the operations of desire as a kind of 'playful physics', with positive and negative rods, as in this note of 1915:

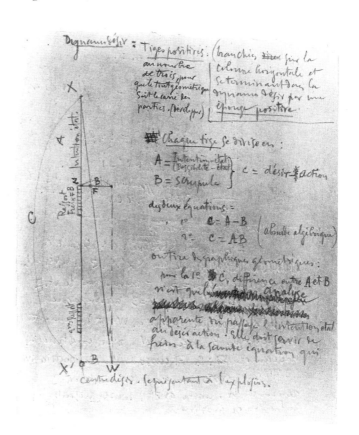

87. From the notes found after Duchamp's death, published in facsimile with translations by Paul Matisse, 1980 (no. 162 recto).

Each rod is divided into:
A = intention state/possibility state
B = scruple $\Big\}$ *C = desire-action.*

Elsewhere he offers a simplified form of this dialectic of desire:

> *1. Intention*
> *2. Fear =(equals) 3. desire*
> *[/desire centres 3 in number contain a material analogous to platinum sponge = slow to ignite.]*

From this formulation he derives an equation which he calls 'algebraic-absurd'. The very structure of the *Large Glass*, with an above and below divided by a bar, mimics this algebraic equation: 'a over b equals', or, 'a is to b as', leaving the other part of the equation or proposition open to numerous comparisons. He uses it in *The Box of 1914* in the form of a completed proposition, echoing the word play at the opening of Jarry's play *Ubu Roi* (1896), *Merdre* ('shitte'):

arrhe is to art as
shitte is to shit.

$$\frac{arrhe}{art} = \frac{shitte}{shit}$$

This format is used by Duchamp to bring into play various 'ordering' systems, which interact and conflict, like the principals themselves. None of the readings of the *Large Glass* alluded to above, nor their sources and associations, can be regarded as a definitive interpretation. There is no single key to this work. The ideas that are brought into play, such as alchemy, might seem to be an attempt to reinvest the visual with wider cultural meanings, with those 'religious, philosophical, moral' functions that, as Duchamp said, he felt painting had lost in its pursuit of retinal pleasure. Yet the structural analogies, with their tumultuous and cynical overlappings, are destabilizing and iconoclastic. It was the resistance of the *Large Glass* to artistic routine and what is falsely described as progress that attracted Breton. He ends 'Lighthouse of the Bride' by saying: 'It is wonderful to see how perfectly the *Large Glass* keeps intact its powers of anticipation. It is imperative that it should be kept luminously erect, its light there to guide the ships of the future through the reefs of a dying civilization.'

Duchamp sets up his pairs: nature/civilization (or industry), female/male, abstraction/figuration, heaven/earth, in terms of this algebraic equation, a set of relations in a constant state of deferred and absurd comparison. In a sense the whole *Large Glass* is allegorical – the machines, bodies and bits stand also for, even symbolize, other orders or types of thing or idea. The allegorical relationships, however, are not fixed but are fragmentary and contradictory. They point to the vanity and ephemerality of the histories and ideas that used to provide meaning, rather than proposing a return to them. An 'allegory of forgetting', Duchamp remarked ominously in the notes. Perhaps, after all, desire is all that is left.

Chapter 6: Anti-Art, Rrose Sélavy and Surrealism

After withdrawing from the pre-war Cubist circles around 1912, Duchamp never joined an artistic movement again. He participated in Dada and then in Surrealism, as and when he felt like it, detaching himself with perfect freedom. Neither movement influenced him, yet each in turn found in his activities justification for their own ideas and solicited his support. His preference for the 'conceptual' and 'anti-retinal' was to have important implications for both movements, and they admired, as André Breton said in 'Lighthouse of the Bride', his 'policy of absolute negation', from which flowed his profound originality.

Duchamp was, as has often been said, Dada *avant la lettre*, like his friend Picabia. He used to qualify this by saying that the Dada spirit was the 'non-conformist spirit of every century that has existed since man is man'; he argued that Rabelais and Jarry were also men of a Dada disposition. How far Duchamp's 'policy of absolute negation' reached into the Dada movement as a whole is not simple to determine. That he was a legendary figure to Paris Dada – its last and most extreme manifestation, in the early 1920s – is indisputable. His own most public 'anti-art' gesture, the *Fountain* scandal of 1917 in New York, however, was orchestrated by his own small group of friends and not under the Dada banner. Word of the new movement did not reach him until Picabia returned to Europe later that year.

Though he is often seen as detached, solitary and self-sufficient, avoiding those group activities that were the lifeblood of Dada and Surrealism, Duchamp in fact enjoyed collaborating with his close friends, particularly Picabia and Man Ray. It was often through their publications and activities that his ideas entered Dada. Although Duchamp was only directly concerned with Paris Dada and its late appearance in New York, Picabia's intervention in Zurich Dada was crucial for the direction the movement took. In 1918 Picabia made contact with Tristan Tzara (1896–1963), and the Zurich-based periodical *Dada 3* published a drawing from his book *Poèmes et dessins de la fille née sans mère* (1918). This issue also contained Dada's most aggressive

manifesto to date, Tristan Tzara's *Dada Manifesto 1918*, whose nihilism, in part indebted to Picabia, introduced a new note to Dada. Up to this point Dada, which had began in neutral Zurich in 1916, had been notable for its strongly anti-war stance, its embrace of the irrational and of chance, and its radical attitude to abstraction in language and in art. Like-minded groups of artists and writers in Europe, Russia and America adopted the name Dada, but what was produced in its name differed dramatically according to local social, political and artistic conditions. In Berlin, a city torn apart by defeat and revolution, Dada became more urban, streetwise and violent between 1918 and 1920, and under its cover photomontages and constructions using ready-made materials – such as the dummy with an iron cross and a light bulb for a head – carried powerful anti-military messages. Richard Huelsenbeck's *En avant Dada* of 1920 rejected the 'art for art's sake' attitude of Tzara and Zurich Dada who 'failed to advance along the abstract road, which ultimately leads from the painted surface to the reality of a post-office form'. Their use of real materials, however, was probably as much aligned to the post-revolutionary Russian Productivist artists like Tatlin as to Duchamp. Dada's use of new non-artistic materials, provocative exhibition installations and constructions, whatever their origins, had a profound, long-term effect on twentieth-century art.

Above all, though, Dada shared Duchamp's opposition to an official avant-garde. Duchamp's attitude is highlighted in an incident a couple of years after his move to New York in 1915. This was *The Blind Man* episode of 1917, better known as the *Fountain* scandal. As a 'public' manifestation on Duchamp's part it was ambiguous because he operated under a pseudonym. In New York he was famous as the artist who had painted *Nude Descending a Staircase, No. 2*, the most controversial exhibit at the Armory Show of 1913, which had introduced modern art – from post-Impressionism to Cubism and Matisse – to an American public. Duchamp was welcomed after his arrival in the United States as the sophisticated Frenchman whose iconoclasm was aimed especially at the old world and who had shown in interviews in the New York press a gratifying recognition of the dynamism of the new one.

It was therefore natural that he should be closely involved in the fledgling American Society of Independent Artists, which aimed to foster new art in New York. Not only was he on its board of directors, but he was also head of the hanging committee of its first exhibition planned for April 1917. In this post he took the

38

rather unusual decision to hang, not according to any visual criteria, but in alphabetical order. In April 1917, Duchamp, Henri-Pierre Roché and Beatrice Wood published a magazine called *The Blind Man*, to coincide with the opening of the exhibition.

The Blind Man encouraged its readers to support the Society of Independent Artists and its exhibition, which promised entry into the mainstream of modern art: 'Where art is concerned is New York satisfied to be like a provincial town?' A note by Henri-Pierre Roché in the first issue of *The Blind Man* stressed the need for the exhibition: 'Russia needed a political Revolution. America needs an artistic one. *291* and *The Soil* have come. Every American who wishes to be aware of America should read *The Soil.*' Both *291* and *The Soil* took a radical view of modern art that set the scene for *Fountain*. *291*, published by Alfred Stieglitz (1864–1946) for one year (1915–16), during which his magazine *Camera Work* was suspended, was a bold, sumptuous, large-format, but slim review remarkable for Picabia's machine drawings, including both his Bride-like *Girl Born without a Mother* and more precise mechanical drawings symbolizing human figures, like the sparking plug entitled *Portrait of a Young American Girl in the State of Nudity* reproduced in the magazine in July/August 1915. These ironic drawings brought to the public for the first time the kind of deadpan machine style pioneered by Duchamp. Picabia borrowed

88. (below left) Cover of *The Blind Man, No. 1*, April 1917

89. (below right) Cover of *The Blind Man, No. 2*, May 1917

90. **Francis Picabia**, *Portrait of a Young American Girl in the State of Nudity*, one of Picabia's 'symbolic portraits' reproduced in Stieglitz's review *291*, nos. 5/6, July/August 1915.

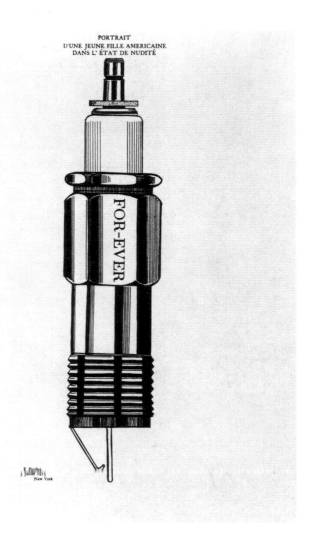

PORTRAIT
D'UNE JEUNE FILLE AMERICAINE
DANS L' ÉTAT DE NUDITÉ

FOR-EVER

New York

directly from sources like *The Scientific American*, but in a spirit very unlike the Futurist aesthetic. A different tone was struck by Paul Haviland, who drew a positive picture of photography as a 'fine fruit' of the union of man and machine. The following year, April 1916, Duchamp's drawing of the *Chocolate Grinder, Celibate Utensil* and two of the readymades (one of which may have been *Traveller's Folding Item*) were included in the exhibition at the Bourgeois Galleries in New York, where Schamberg's machine pictures were first shown. Thus in the period leading up to the Independents' exhibition, refugee avant-garde Europeans were giving an ambiguous message about the place of a machine 'aesthetic' in art.

91. An illustration from the
'Moving Sculpture Series'
reproduced in Robert Coady's
review, *The Soil*, no. 2,
January 1917.

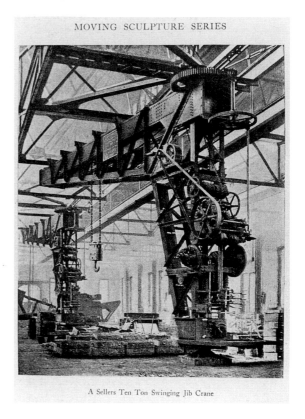

MOVING SCULPTURE SERIES

A Sellers Ten Ton Swinging Jib Crane

Robert Coady's *The Soil*, the other publication named in *The Blind Man*, was a home-grown review whose attitude to modern art was slightly different but still provocative. Coady had recently run sequences of photographs in *The Soil* that challenged contemporary sculpture to rival modern machines in their power and beauty; locomotives and steam hammers were reproduced beside decorative beaux-arts monuments with captions that asked: 'Which is the monument?' Although Coady's appreciation of the grandeur of the machines may have drawn on a Futurist aesthetic, it goes a stage further in challenging the capacity of art itself to produce comparable effects. In spite of the Futurist echoes, the photographs of large industrial objects seem more akin to the readymades than to Futurist illusions of power and speed.

During the installation of the exhibits for the Independents, a white porcelain urinal appeared on a black pedestal in the storeroom, submitted by a Richard Mutt. An emergency meeting of available directors was held and Mr Mutt's defenders were outvoted by a small margin. The object was not exhibited and

temporarily disappeared. Duchamp immediately resigned from the hanging committee in protest, followed by the President of the Society of Independent Artists, Walter C. Arensberg. The personal column on the back of Picabia's *391*, no. *5* (June 1917) announced:

MARCEL DUCHAMP
French language teacher at Washington Square University has resigned from the committee of the Independents.

The identity of Mutt was not at this stage revealed to the general public – and it is not clear exactly when it was. There is nothing in the second issue of *The Blind Man*, which appeared in May 1917 amid the flurry of publicity, that actually states Duchamp was R. Mutt. The lively press coverage of the affair centred on the conflict between the stated aims of the Independents – that any artist paying the entry fee (a mere six dollars) was free to exhibit – and the complaints of the members of the committee that the object in dispute was indecent, or, in the opinion of at least one of them, Duchamp's friend Katherine Dreier, 'unoriginal'.

The second issue of *The Blind Man* defended the urinal; it carried a photograph of the (now recovered) work, with the caption 'Fountain by R. Mutt; the exhibit refused by the Independents', a short, unsigned editorial entitled 'The Richard Mutt Case' and a longer text by Louise Norton called 'Buddha of the Bathroom'.

The editorial is Duchamp's only contemporary statement about a readymade:

> *They say any artist paying six dollars may exhibit.*
> *Mr Richard Mutt sent in a fountain. Without discussion this article disappeared and never was exhibited.*
> *What were the grounds for refusing Mr Mutt's fountain:–*
> *1. Some contended that it was immoral, vulgar.*
> *2. Others, it was plagiarism, a plain piece of plumbing.*
> *Now Mr Mutt's fountain is not immoral, that is absurd, no more than a bath tub is immoral. It is a fixture that you see every day in plumbers' show windows.*
> *Whether Mr Mutt with his own hands made the fountain or not has no importance. He CHOSE it. He took an ordinary article of life, placed it so that its useful significance disappeared under the new title and point of view – created a new thought for that object.*
> *As for plumbing, that is absurd. The only works of art America has given are her plumbing and her bridges.*

89

The Blind Man thus offers both an aesthetic and an ethical defence of the *Fountain*, although it probably did not help to further the cause of modern art as it was understood by most of the supporters of the Independents.

With the submission of *Fountain* Duchamp succeeded in demonstrating the qualified nature of artistic 'independence'. The promise of free entry to the Independents exhibition on payment of a fee was illusory; a work that did not conform to the organizers' ideas, even if no rules were laid down, was subject to censorship, just as *Nude Descending a Staircase* had been unacceptable to the hanging committee of the Cubists involved in the 'Salon de la Section d'Or' exhibition in 1912. 'It was a sad surprise', Louise Norton wrote in 'Buddha of the Bathroom', 'to learn of a Board of Censors sitting upon the ambiguous question, What is ART?'

Newspaper coverage of the period and letters exchanged between members of the committee offer enough circumstantial evidence to prove that the short editorial, 'The Richard Mutt Case', was carefully written to answer specific objections raised by different parties in the debate. Some felt *Fountain* broke both social and artistic taboos. Beatrice Wood, a close friend of Duchamp and co-editor of *The Blind Man*, recalled in her memoirs a conversation between Arensberg and another artist member, George Bellows, in front of the controversial work, in which Bellows angrily claimed that if this was allowed, anything would be: a heap of manure fixed to a canvas, for instance. The editorial points out that *Fountain* belongs to a given type or series of objects: an everyday article, seen in plumbers' show windows. The implication is that it is the artistic context, the exhibition, that makes the urinal offensive. The second objection – that *Fountain* was not a genuine work of art because it was not *made* by the artist – elicits one of the key statements about the readymade and its conceptual basis. Mr Mutt did three things: he chose the object, gave it a new title (by calling it *Fountain* it becomes a type of decorative, monumental object, and, moreover, the direction of flow is theoretically reversed in that a fountain projects, while a urinal receives, liquid) and a new point of view (one might say, perspective) by tilting it on to its back. The complete alteration of its circumstances – removal of its utilitarian function – gives it, as the editorial says, 'a new thought', a new identity, whereby the objections that it is neither creative nor original are also answered. Dreier's comment on its lack of originality is an attempt to avoid criticism based on non-artistic criteria, moral, physical or social repugnance, and judge it purely according to her own aesthetic

beliefs. Significantly, the editorial mentions a new 'point of view', but does not specifically name art as this new context. It does not claim that the functional object is being elevated into an art object. Rather, it questions the process that makes it art. Because it is exhibited must it be art? The problem – that the object cannot belong to both utilitarian and non-utilitarian, art and non-art – is triumphantly though speciously solved by the assertion that the two are in fact identical: plumbing and bridges are American works of art. *Fountain* is thus also a disguised critique of an incipient nationalism in American cultural life.

When *Fountain* re-appeared in 1917, Duchamp took it to Stieglitz's studio to be photographed for *The Blind Man*, against the background of Marsden Hartley's painting *The Warriors* (1913). The visual eloquence of Stieglitz's carefully posed photograph in which the smooth curves cast an undeniably anthropomorphic shadow, was elaborated by Louise Norton in her essay 'Buddha of the Bathroom'. She centres her defence on a sly appeal to the visual purity of a machine aesthetic: 'To an "innocent" eye how pleasant is its chaste simplicity of line and color! Someone said, "Like a lovely Buddha"; someone said "Like the legs of the ladies by Cézanne".' This notion of the 'innocent eye', blind to the

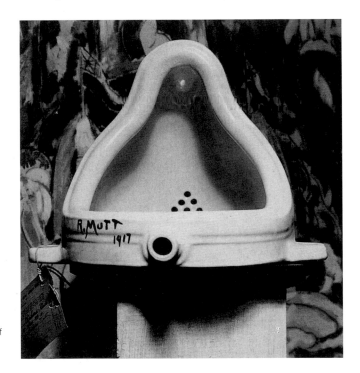

92. **Alfred Stieglitz**, photograph of Duchamp's *Fountain* from *The Blind Man, No. 2*, May 1917.

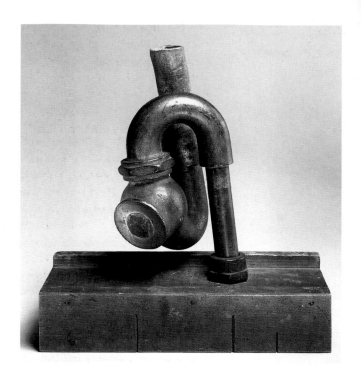

scatological implications of the object, refers to the idea shared by
Futurism and Dada that they were 'primitives of a new sensibility'.
The smooth white curves of *Fountain*, like a simplified nude but
with visual references to both the Buddha and the Virgin Mary,
dramatized by Stieglitz's photograph, even points to abstract art.
Norton asks: '"Is he serious or is he joking?" Perhaps he is both.'

The Mutt case can be seen as a deliberate attempt to short-
circuit the creation, or at least the institutionalization, of an avant-
garde in America. The consequences are hard to analyse. It is
notable that accounts of the origins of modern art in the United
States tend to begin with Duchamp, rather than with indigenous
artists like Charles R. Sheeler or Charles Demuth. Their machin-
ist and abstract paintings have some affinities with Duchamp and
Picabia, but it was especially John Covert and Morton Schamberg
who responded to the more ambivalent mood of Duchamp's work.
Schamberg (1881–1918), who, like Apollinaire, died in the 'flu epi-
demic of 1918, is best known for a Dada artefact very different
from his elegant machine paintings: a plumbing trap inverted in a
box and named *God* (*c.* 1917). The art historian Francis Naumann
argues that this work was jointly produced with the eccentric

94. (below left) *L.H.O.O.Q.*, 1919

95. (below right) **Francis Picabia**,
*Tableau Dada par Marcel
Duchamp* in *391*, March 1920

poet Baroness Elsa von Freytag-Loringhoven who passionately admired Duchamp, and photographed by Schamberg. Such interventions certainly interrupted the smooth development of a modern aesthetic in New York. *Fountain* thus brought into the open a debate about modern art in the industrial age in America and the effect of its anti-aesthetic on the New York avant-garde was long-lasting. The link with Stieglitz and the strength of photography in the context of modern art in America is especially pertinent.

The split that Duchamp opened up between himself and an accredited avant-garde, exemplified by the *Fountain* episode, was to make him, together with Picabia, a key figure for the Paris Dadaists. He returned to Paris in July 1919 and crossed the Atlantic four times again before settling in Paris in 1923. He sporadically attended the café meetings of the *Littérature* group, founded by André Breton, Louis Aragon and Philippe Soupault, at the Certà, in the Passage de l'Opéra – immortalized by Aragon in his book *Paris Peasant* (1926) whose equivocal atmosphere provided relief from the picturesque artistic haunts of Montmartre and Montparnasse.

Shortly before he left for New York again at the end of 1919, Duchamp showed Picabia and possibly Breton his latest rectified

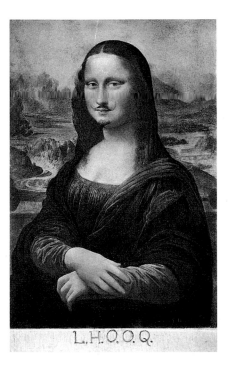

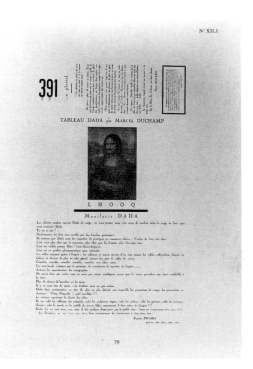

or assisted readymade (existing objects changed or added to). This was a cheap chromolithograph reproduction of the *Mona Lisa*, to which Duchamp had added a beard, moustache and the inscription *L.H.O.O.Q.* (pronounced in French as *Elle a chaud au cul*, 'she has a hot ass'). Picabia wanted to reproduce it in *391*, but Duchamp omitted to leave it, so he made his own version, forgetting the beard and adding the title *Tableau Dada par Marcel Duchamp*. Duchamp described this as 'a combination readymade and iconoclastic Dadaism'. On the following page of *391* Picabia matched Duchamp's secular sacrilege with a blasphemous stain of his own: a splattered ink blot called *Sainte Vierge* ('Holy Virgin'). There seems to be a shared secret language merging iconoclasm and blasphemy dating back to Duchamp's *Passage from Virgin to Bride*.

In April 1920 Picabia reproduced Duchamp's 'reverse readymade', the *Tzanck Cheque* labelled 'Dada drawing', and the July issue of *391* included a work on glass for the first time: Duchamp's *To be Looked At (From the Other Side of the Glass) with One Eye, Close To, for Almost an Hour* (1918). Significantly he does not label this 'Dada', suggesting that only the readymades connect with Dada.

Two incidents in 1921 illustrate Duchamp's ironic attitude to Dada. In April he produced with Man Ray the single issue of *New York Dada*. Inside was an 'authorization' by Tristan Tzara to call their review Dada, surely reproduced in a spirit of mockery, given Tzara's own protestations that 'Dada belongs to everybody'. Tzara was now firmly established as the impresario of Paris Dada and Duchamp's attitude to the movement's activities was highlighted by his rude telegram to Tzara on 21 June 1921 on being invited to contribute to the Salon Dada exhibition at the Galerie Montaigne in Paris: 'PODE BAL' (*Peau de Bal*, 'Ballskin'). The organizers saved face by blowing up the catalogue numbers of Duchamp's contributions and hanging them instead.

The crisis triggered by Dada among the *Littérature* group split the movement; an atmosphere of extreme disillusionment with the anarchy and nihilism of Dada pushed Breton and the group to seek alternatives. Breton now categorized Dada as 'the vulgarized image of a state of mind it in no way contributed to'. Dada had performed the function of freeing him from any lingering belief in 'Art for art's sake', but Dada's only solution – of giving up poetry altogether – seemed tantamount to committing suicide; if 'Art for art's sake' was unacceptable, Dada's renunciation of art was increasingly like a renunciation of life. In 1921 Breton had boldly proclaimed that he would never write again, but he

soon found this position untenable. The solution was promised in an enlarged understanding of poetry, which he believed, as he wrote in 'Clairement' in 1922, was within, rather than an adjunct to, life:

I think that poetry…emanates more from the lives of human beings, whether writers or not, than from what they have written…or could write…. Life, as I see it, is not the sum total of actions that can ultimately be ascribed to an individual, but rather the way in which he seems to have accepted the unacceptable human condition…. It is still in the domains bordering literature and art that life, thus conceived, tends to reach its veritable fulfilment.

For Breton, Duchamp was one of the very few who seemed to occupy this borderland, reaching 'the *critical point* of ideas faster than anyone else'. It was not because Duchamp had renounced art, Breton wrote in his 1922 *Littérature* essay on Duchamp, but because his 'readymade expression', according to Breton, delivered us from the 'blackmail' of sentimental lyricism. He had introduced a new mode of activity, the 'personality of choice'. For Duchamp, 'the question of art and life…does not even arise'.

In Breton's important lecture, given in 1922, 'The Characteristics of Modern Evolution and Those who Participate in It', Duchamp and Picabia are the central figures. Duchamp was a pioneer, his name an 'oasis for those who are still seeking', because of his 'disdain for the thesis', his refusal of aesthetic systems. It was irrelevant that Duchamp was an artist rather than a poet: his activity in any case led him beyond such conventional distinctions.

Breton's admiration for Duchamp in 1922 was fuelled by the belief that he offered a way out of the Dada trap. Picabia put the position thus in *Le Pilhaou-Thibaou*: 'All our enemies talk about Art, literature or anti-literature, you are anxious to know whether your works are art or anti-art? The only really ugly things are Art and anti-art!' In an interview in 1959 Duchamp said that art and anti-art were just two sides of the same coin. He preferred the term 'a-art', or 'an-art', that is, no art at all.

Dada had aimed to cause maximum confusion and encouraged the experimental subversion of identity, the adoption of masks, the encouragement of instability. One of the qualities Breton admired was Duchamp's 'marvellous instability'.

It was through words as well as the visual image, and as a woman, that Duchamp appeared in *Littérature* in 1922. A mysterious photograph by Man Ray was annotated: 'This is the domain of Rrose Sélavy/How arid it is – how fertile it is – how joyous it is –

how sad it is/View taken from an aeroplane by Man Ray – 1921 [sic].' Unrecognizable to any who did not know the *Large Glass*, it was of the Bachelor Domain under a thick coating of dust, looking like a desert with markings resembling the Nazca lines.

Duchamp's female alter ego emerged in 1920. Wanting to change identity, he first thought of taking a Jewish name. 'I was Catholic,' he told Cabanne, 'and it was a change to go from one religion to another!' Then the idea came, as he put it, to 'change sex': 'It was much simpler.' The name, already a pun – Rose Sélavy reads in French as *Rose c'est la vie* – acquired an extra 'R' when she signed Picabia's painting, *L'Oeil cacodylate* (1921): *en 6 qu'habilla Rrose Sélavy* (which roughly puns as '[Fr]ancis whom Rrose Sélavy dresses' or '[Fr]ancis Picabia water life'). Rrose Sélavy was credited with the puns published in *Littérature* in October 1922. During 1922 the *Littérature* group conducted experiments with hypnotic trances as part of their investigation into the creative sources of the unconscious. One of those most adept at dropping into a hypnotic trance was the poet Robert Desnos, who, 'asleep', produced a stream of verbal puns that he claimed were transmitted to him by Rrose Sélavy. Nine pages of puns were published in the December 1922 issue of *Littérature*, together with a text by Breton arguing their importance in terms of the liberation of language.

Taken in conjunction with *L.H.O.O.Q.*, Rrose Sélavy, it has been suggested, completes Duchamp's interest in the creative androgyne. Duchamp's friend, the writer Robert Lebel, commented that Man Ray's photographs of Duchamp as a woman 'might suggest…the artist's inherent androgyny in the manner of Leonardo da Vinci to whom Duchamp had paid homage in his own way by providing the *Mona Lisa* with masculine attributes'. Arturo Schwarz argues that Duchamp's apparent bisexuality is the symbol of a union of creative opposites; he recalls Jung's contention in *The Archetypes and the Collective Unconscious* (1951) that in the human psyche the unconscious has the masculine sign, 'while the unconscious is by nature feminine'. However, there were also widespread socio-anthropological as well as psychological debates in Europe and the United States at the time, influenced by, among others, Freud and Jung, that challenged male and female stereotypes. These ideas were adopted by many of the artists associated with Dada. Rather than expressing the union of fixed opposites of androgyny, Duchamp's female alter ego tests the unstable nature of gender difference and stereotypes. An extremely influential socio-anthropological study was Havelock Ellis's *Man and Woman: A Study of Human Secondary Sexual Characters,*

96. (opposite) *To Be Looked At (From the Other Side of the Glass) with One Eye, Close To, for Almost an Hour*, 1918

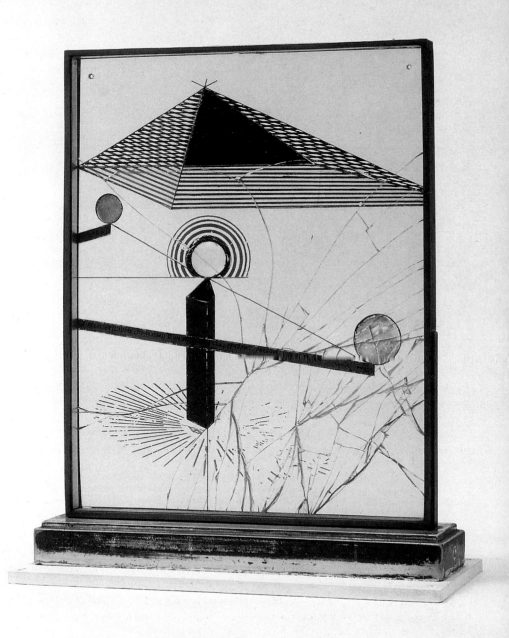

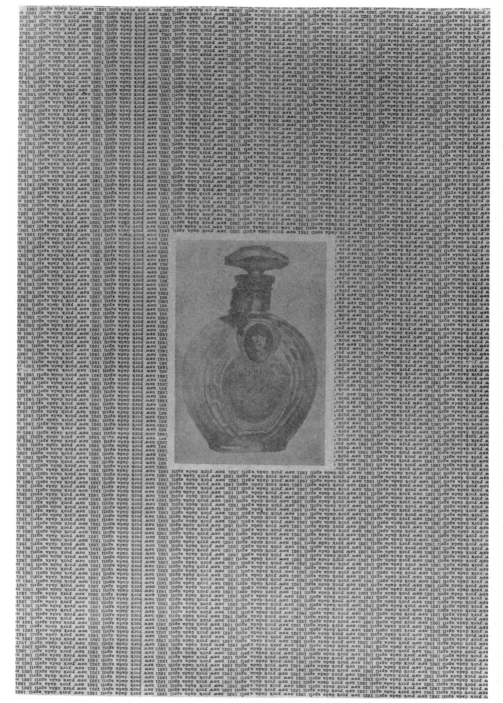

first published in 1894, and rarely out of print since then. In it he places the equation of nature/female within an historical process and concludes that it is impossible to determine any 'radical and essential characters of men and women uninfluenced by external modifying conditions'. The shattering of sexual stereotypes and assumptions about male superiority, and the rise of the new emancipated woman, must have intrigued someone as absorbed in the erotic as Duchamp.

Yet Rrose Sélavy as photographed by Man Ray, with her exaggerated femininity, seems to be an experiment in difference. The first photographs he took of Duchamp dressed as a woman were part of the brief Dada campaign in New York in 1921. In *Belle Haleine, eau de voilette (Beautiful Breath, Veil Water)* an oval photograph was added to an altered perfume label and pasted on to a glass bottle. The collage was photographed for the cover of New York Dada, whose title was printed repeatedly upside down, a 'world upside down' trope continued in Tzara's 'Authorization', whose addressee is consistently female.

Rrose Sélavy is photographed as a distinctly fashionable woman, especially in the second set of photographs by Man Ray probably taken in 1924. These take the 'fashion' metaphor that Dada had often used to parody changes in artistic taste even further and exaggerate the features of conventional femininity.

97. (opposite) Cover of *New York Dada*, 1921

98. (below left) **Man Ray**, *Rrose Sélavy*, 1924(?). The hat and hands in this series of photographs of Duchamp dressed as Rose Sélavy belonged to Picabia's wife Germaine Everling. The photographs, taken in Paris, are variously inscribed 1921 and 1924.

99. (below right) **Man Ray**, *Rrose Sélavy*, 1921, from a series of photographs taken in New York of Duchamp dressed as Rrose Sélavy, used for the label of the assisted readymade perfume bottle *Belle Haleine, eau de voilette (Beautiful Breath: Veil Water)*, which then figured on the cover of *New York Dada*.

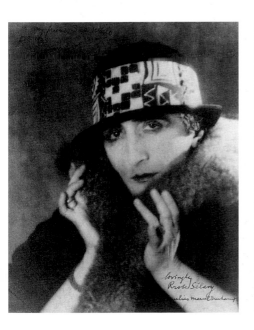

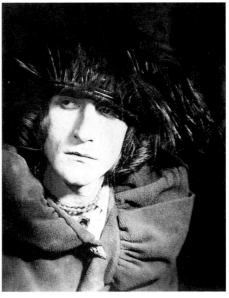

A companion set of photographs by Man Ray shows Duchamp with shaving soap sculpting his hair into satyric horns – one of these was used on the *Monte Carlo Bond* of 1924. Another linguistic pun seems to have generated this image: if, as Duchamp once said, Rrose Sélavy was a *femme-savante* ('intellectual woman'), the soap portraits show Duchamp as her male alter ego, an *homme savant/savon* ('soap man'). The shaving soap also introduces the idea of mirrors, reflections and their role in the construction of identity. Perhaps, in the case of Rrose Sélavy and the soap man, there is an allusion to classical myths concerned with reflections: Narcissus and Medusa, whose snaky locks are here transformed by shaving soap, with typical Duchampian derision. The *Monte Carlo Bond* is, significantly, signed by both Duchamp and Rrose Sélavy. Another possible source for this 'horned' head is the sculpture of the prophet Moses (*c.* 1515) by Michelangelo, which was the subject of a psychoanalytical case study by Freud.

101. (right) **Michelangelo**, *Moses*, c. 1515

Rrose Sélavy positioned before the mirror/camera lens is evidently there 'to be looked at'. Arrayed and posing for the viewer, she becomes the work of art. Perhaps, then, she was one of the consequences of Duchamp's withdrawal from making art – first with the readymades, then with the long 'delay' and final abandonment of the *Large Glass*. The substitute for the erased male artist was Rrose him/herself in the guise of the object of the lens/viewer.

Rrose Sélavy signed a few other works, like *Fresh Widow* 12 (1920) and appeared – this time in a more androgynous guise – in the *rue Surréaliste* at the 'Exposition Internationale du Surréalisme' held in Paris in 1938 as a female mannequin dressed in Duchamp's clothes, but without the trousers. Asked in the 1960s whether Rrose Sélavy had made her last appearance with the *Jeux de Mots* published by G.L.M. in 1939, he replied, 'She's still alive; manifests herself little or not at all.' In this, she was not unlike Duchamp himself.

Like a handful of former Dadaists, Duchamp effectively ceased, for a time, to be an artist. From 1923 he turned seriously to chess; always a favourite diversion (a chess game had settled the friendly rivalry between *The Blind Man* and *391*, in 1917, in favour of the latter), it had become by the end of the 1920s his major activity. For abandoning the other game he had been playing, Breton severely criticized him in the *Second Surrealist Manifesto* of 1929.

Duchamp never gave up 'tinkering', and was perfectly happy to accept the reputation that he had given up art for chess. An extract from Duchamp's book on endgames in chess appeared in *Le Surréalisme au service de la Révolution* in 1931. It is an elegant apology on Breton's behalf. The reconciliation cannot be said to have come from any change of heart on Duchamp's part, but from certain shifts within Surrealism, such as the reduced influence of automatism and the rise of the Surrealist object. It was in the context of Surrealism, in the journal *Minotaure*, that Breton's account of *The Bride Stripped Bare by Her Bachelors, Even* (the *Large Glass*), 'Lighthouse of the Bride', was published.

For someone who remained so detached from artistic movements, refusing to sign manifestos or to change his ideas, Duchamp played a surprisingly prominent public role in Surrealism. He served on the editorial boards of *Minotaure* and the war-time New York Surrealist review *VVV*. He also worked as a 'designer-engineer' for various Surrealist projects, designing the glass door for Breton's gallery Gradiva and arranging two window installations for him in New York in 1945, for the publication of *Arcane 17* and *Surrealism and Painting*. The following year he

102. Mannequin for the Surrealist
street at the 'Exposition
Internationale du Surréalisme'
held in Paris in 1938. Rrose
Sélavy has a red electric lamp
in her breast pocket.

103. Cover for André Breton's volume of poetry, *Young Cherry Trees Secured Against Hares*, 1946.

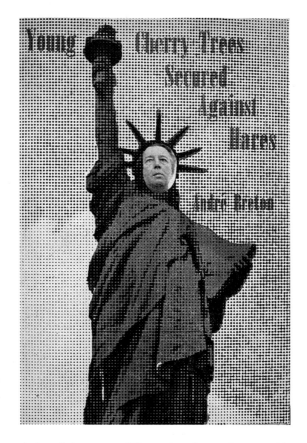

designed the cover of Breton's volume of poetry, *Young Cherry Trees Secured Against Hares*, substituting Breton's face for that of the Statue of Liberty. In all his work, including the installations he devised for exhibitions, familiar themes and preoccupations occur in new forms: the glass of shop windows, assisted readymades, transformations of identity through the photographs.

For Breton, the readymades, especially the 'assisted readymades', provided an infinite series of latent possibilities, capable of metamorphosing the object; they led, for Breton, to the Surrealist object, constructed of readymade materials according to the unconscious desires of the maker, ideally able to provoke the erotic imagination of the spectator as well as to cast doubt on the reality of the ordinary utilitarian objects of the world. Readymades were inevitably seen by this stage through the lens of Surrealism, and, indeed, Duchamp willingly responded to this adoption of his ideas in turn by inventing exhibition environments in line with Surrealist thought.

Duchamp was the *générateur-arbitre* (producer-adjudicator), as he was inventively named for the 'Exposition Internationale du Surréalisme' at the Galerie Beaux-Arts, Paris, in 1938 for most of the major Surrealist exhibitions. For the 1938 exhibition, he arranged for the installation of over one thousand empty coal sacks to hang above a darkened chamber that contained a brazier, foliage-fringed pool, double beds and a dinner table on which a live nude was 'laid' for the opening. In 1942, for the 'First Papers of Surrealism' exhibition arranged by the Surrealists who had taken refuge in New York, string was wound round the screens on which the paintings were hung. Duchamp encouraged children to romp around the gallery during the opening, making viewing of the pictures even more difficult. According to his usual custom, he attended neither of these openings himself. The catalogue for this exhibition, on Duchamp's suggestion, substituted a series of 'compensation portraits' for the normal ones of contributing artists; Duchamp chose to appear as an emaciated woman from a Ben Shahn photograph.

105

106

107

On the Surrealists' return to Paris after the war, he was 'co-presenter' with André Breton of the exhibition 'Le Surréalisme en 1947'. Duchamp planned the installation of the *Salle de Pluie* (the Rain Room) and the Maze. He and Enrico Donati hand-coloured 999 foam-rubber 'falsies', false breasts, for the de luxe edition of the catalogue. The ordinary edition had a photograph of the alarmingly realistic-looking (single) breast on a black velvet ground, an image that has a close relationship with *The*

104. *Prière de toucher (Please Touch)*, 1947

105. Installation for the 'Exposition Internationale du Surréalisme' held at the Galerie des Beaux-Arts, Paris, in 1938. The empty coal sacks were brightly lit, but the room was dark, and torches were distributed at the opening to illuminate the individual paintings and objects.

106. Installation for the exhibition 'First Papers of Surrealism' for the Coordinating Council of French Relief Societies, New York, 1942, 'organized by André Breton and "his twine" Marcel Duchamp'. The pun on *ficelle*, meaning both 'string' and 'pal', rendered as 'twine', perhaps prompted Duchamp's economical design. String was cheap, and he bought sixteen miles of it, but used only one.

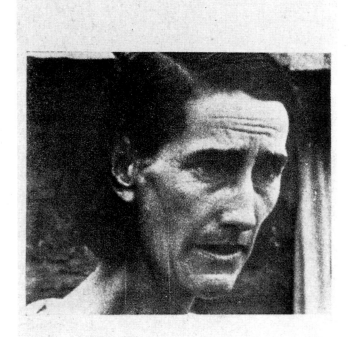

Marcel Duchamp

Illuminating Gas and the Waterfall, the study for *Etant donnés* of 1948–49, the final construction on which Duchamp had already begun to work in secret. Breton and Duchamp again collaborated for the 'Exposition Internationale du Surréalisme' of 1959–60, at the Galerie Daniel Cordier in Paris, on the theme of eroticism. Entry to one room was through a padded slit shaped like vertical lips or a vagina.

152

Perhaps it is here, in their mutual devotion to the erotic, that Duchamp and the Surrealists come closest together. 'I believe', he said to Cabanne, 'in eroticism a lot, because it's truly a rather widespread thing throughout the world, a thing that everyone understands. It replaces, if you wish, what other literary schools called Symbolism, Romanticism. It could be another "ism", so to speak.'

The only Surrealist exhibition at which Duchamp was not represented was the one held in 1965: he had refused to sign a protest drawn up in his own defence, against an exhibition in Paris entitled 'The Murder of Marcel Duchamp'.

Chapter 7: The Readymades and 'Life on Credit'

With characteristic simplicity, Duchamp once described a 'ready-made' as a 'work of art without an artist to make it'. In principle, the readymades are mass-produced objects that have been signed and sometimes inscribed by the artist. Although over the last thirty years the readymades have been discussed as though they were a coherent project, Duchamp himself usually insisted in interviews on the vague and almost accidental way in which each one came into existence. In 1961 he gave a talk at the Museum of Modern Art in New York, describing the casual genesis of some of the first readymades:

In 1913 I had the happy idea to fasten a bicycle wheel to a kitchen stool and watch it turn. A few months later I bought a cheap reproduction of a winter evening landscape, which I called Pharmacy *after adding two small dots, one red and one yellow, in the horizon. In New York in 1915 I bought at a hardware store a snow shovel on which I wrote 'In Advance of the Broken Arm'. It was around that time that the word 'readymade' came to mind to designate this form of manifestation.*

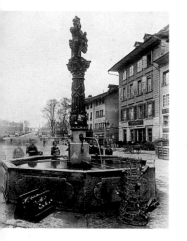

108. **Eugène Atget**, *Fountain at Berne, Switzerland*, with rack for drying bottles, *c.* 1900.

The still unnamed 'readymade' was initially a private act, in the studio; Duchamp linked it to the idea of chance, of 'letting things go by themselves', but also 'having a sort of created atmosphere in a studio'. He described to Schwarz the pleasure of watching *Bicycle Wheel* (1913) turning, like 'looking at the flames dancing in a fireplace'. The originals of *Bicycle Wheel* and *Bottle Dryer (Bottlerack)* of 1914, left behind in Paris when he went to New York in 1915, have disappeared. He reassembled the former in his New York studio, possibly round about the same time (January 1916), that he wrote an important letter to his sister Suzanne in Paris asking her to retrieve them from his studio there. He introduced her to his adopted term 'readymade', and explained that he had purchased the bottlerack as a 'sculpture already made', which he now proposed to turn into a ' "readymade" from a distance' by having her paint on the base and inside the bottom ring an inscription and sign it '[after] Marcel Duchamp'.

The idea of exhibiting the readymades only came later. Two were shown to little response in 1916; only with the highly provocative public gesture of *Fountain*, in 1917, were the implications of the readymade publicly recognized. *Fountain* was the only one to be accompanied by a published statement about its aim.

Bicycle Wheel clearly relates to a number of Duchamp's works during this period, including *Coffee Mill, Chocolate Grinder, No. 1* and *Chocolate Grinder, No. 2*, the Water Mill Wheel in the *Large Glass* and the drawing *To Have the Apprentice in the Sun*. It brings the preoccupation with gyrating machines full circle in the guise of an eccentric and apparently meaningless construction or very uncomfortable unicycle. As has been widely acknowledged, *Bicycle Wheel* can be seen as a direct or half-satirical response to the demands of the Futurist manifestos, and in particular of Umberto Boccioni's 'Technical Manifesto of Futurist Sculpture' of 1912. Although this text was not translated into French at once, Duchamp may well have learnt of its contents from Apollinaire who favourably reviewed Boccioni's exhibition at the Galerie de la Boëtie in Paris, which ran from 20 June to 16 July 1913. Duchamp's interest in Futurism and Cubism was evident in his *Nude Descending a Staircase, No. 2*, which was exhibited in 1913 at the Armory Show in New York, where it had become one of the most

109. (above left) *Bicycle Wheel*, 1913, original lost; 1964 version.

110. (above right) *Bottle Dryer (Bottlerack)*, 1914, original lost; 1964 version.

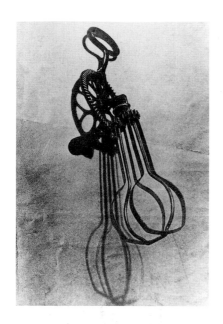

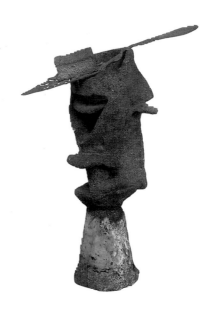

notorious exhibits. Boccioni's manifesto demanded that a combination of new materials, such as 'glass, wood, cardboard, iron, cement, hair, leather, cloth, mirrors, electric lights' be used in the realization of Futurist sculpture. Another passage in this manifesto celebrates the so-called machine aesthetic: 'We cannot forget that the...opening and closing of two cogwheels...the fury of a flywheel or the turbine of a propeller are all plastic and pictorial elements of which a Futurist work in sculpture must take account. The opening and closing of a valve creates a rhythm just as beautiful but infinitely newer than the blinking of an animal eyelid.' However, unlike Duchamp's *Bicycle Wheel*, Futurist sculpture did not take up the manifesto's challenge. Boccioni tried to represent movement or dynamism by illusionistic representational means, using traditional sculptural materials. Even in the now lost sculpture of a figure seated on a balcony, the planes of glass and metalwork were incorporated in a plaster construction. Duchamp's wheel has the brazen arrogance of minimal effort, a lack of obvious representational content, a sculpture including real – not represented – movement, made wholly of found materials. Man Ray's readymade *Man* (1918), perhaps a self-portrait or merely a domestic object gendered as male, continues Duchamp's preoccupation with mock-Futurist gyrating machines.

111. (above left) **Man Ray**, *Man*, 1918

112. (above right) **Pablo Picasso**, *Glass of Absinth*, 1914

The first 'pure' readymades, the snow shovel *In Advance of the Broken Arm* (1915) and *Bottle Dryer* show Cubist concerns with

the tension between the real and the represented. Cubist collages contained 'real' materials like newspaper to represent itself and Picasso, who had been experimenting since 1912 with constructions made from tin and wire, incorporated a real spoon into his *Glass of Absinth* (1914) and later made sculpture out of tin cans. The intrinsic value of traditional materials (oil paint, marble, plaster, etc.) used to make art were thus already being called into question by the avant-garde.

Pharmacy (1914) shows a slightly different application of the readymade procedure. Duchamp produced a readymade picture by buying a cheap representation of a winter landscape. The specific if obscure title and coloured objects – inspired by the coloured bottles displayed in chemists' windows – hint at bodily concerns.

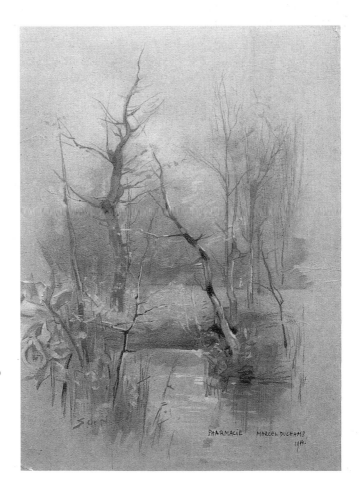

113. *Pharmacy*, 1914. Duchamp added two dots, red and yellow (green in a later replica), to the horizon. They suggest figures, but were inspired by different coloured lights seen at night, prompting an association with glass bottles displayed in chemists' shop windows.

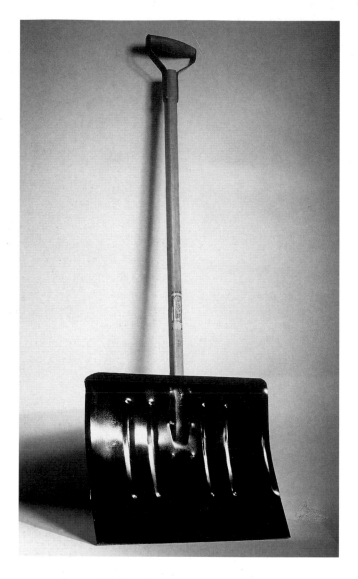

In Advance of the Broken Arm (1915), with the snow shovel bought during the winter of 1915 in New York, is yet again slightly different in the way it has been executed and in its mood. The object itself has not been modified at all, but Duchamp has added for the first time an inscription, to provide what he called 'verbal colour'. To the inscription 'In Advance of the Broken Arm' Duchamp added the phrase '[from] Marcel Duchamp' (recalling his instruction to his sister for *Bottle Dryer*), a subtle adjustment to the normal artist's signature to indicate that though the object

115. Duchamp's studio, 33 West 67th Street, New York, c. 1917, showing *In Advance of the Broken Arm, Fountain* and *Hat Rack* suspended from the ceiling.

came from him it was not made by him. He also set this and other readymades in an unusual context by suspending them from the ceiling, as a photograph of his New York studio shows. In this way he not only gave the object a 'new thought', as he had proposed with *Fountain,* but also escaped 'from conformity', as he told Arturo Schwarz, that demanded 'works of art be hung on the wall or presented on easels'.

The vital question is whether the readymades are works of art and the answer obviously depends on how art itself is defined. Duchamp responded in a BBC radio interview from 1959, when he was asked whether there was any way in which we can think of a readymade as a work of art:

That is the very difficult point, because art first has to be defined. Alright, can we try to define art? We have tried, everybody has tried and in every century there is a new definition of art. Meaning that there is no essential, no one essential, that is good for all centuries. So if we accept the idea of trying not to define art, which is a very legitimate conception, then the readymade can be seen as a sort of irony, because it says here it is, a thing that I call art, I didn't even make it myself. As we know art etymologically speaking means to 'make', 'hand make', and there instead of making, I take it readymade. So it was a form of denying the possibility of defining art.

151

Duchamp leaves us firmly with the problem, not with a solution, and he posed the question for himself, 'Can one make works which are not works of "art"?' His determination to keep the paradox comes over clearly in the interviews of the 1950s and 1960s, when the arrival of Pop Art and Neo-Dada revived interest in the readymades. Duchamp may also intend a mild rebuke to Breton, who was the first to designate the readymades as 'works of art', in 1935 in 'Lighthouse of the Bride': 'The wide range of hypotheses resulting from the thought he has given to the *readymades* (manufactured objects promoted to the dignity of objects of art through the choice of the artist) by means of which he has proudly expressed himself.' Since then it has often been assumed that Duchamp intended to elevate these objects into works of art; the historian Jerrold Seigel, for example, writes of 'Duchamp's famous 1913 project of turning bicycle wheels (later hat racks and urinals) into works of art'. In fact, Duchamp's idea of 'an-art' was precisely to maintain the gap, the *terrain vague* inhabited by the readymades.

What prompted Duchamp to develop this initially idly conceived concept into a major part of his output, one he came to regard as 'the most important single idea to come out of my work'? The very difficulty in finding a single term to describe what is done to the readymade is instructive: choosing, designating, signing, inscribing, encountering, exhibiting are all possible but incomplete to account for the action whereby the object is 'elevated' or a 'new thought' given to it. Philosophers of language, like J. L. Austin, have tried to define statements that accomplish an action – such as 'I declare you man and wife' – as 'performative'. Duchamp's actions could also be 'performative', making an analogy between legalistic announcements and the moment when an artist presents an object as 'a work of art'.

There are perhaps three ideas behind the readymades in their various guises. Firstly, a concern to challenge by example contemporary assumptions about the nature of artistic creation, especially the roles of conception, manual skill and accident or chance in the making of art. Secondly, a desire to expose the role of institutions and social groups in defining what counts as art. Thirdly, a fascination with industrially manufactured, and therefore usually anonymously produced, 'objects of desire'.

The readymade was controversial because it questioned the value attached to both mass-produced commercial objects and the unique works by individual artists. It raised serious philosophical,

aesthetic and social questions. The readymades have played a significant role this century in reassessing the processes used by art institutions to classify and validate works of art. Duchamp's interest in the kind of work needed to be done by society to produce a work of art was, of course, a response to a particular and long history. Tension between skill in mimesis and the power of the imagination goes back to antiquity; the history of art from the Renaissance on, though, marks a shift in emphasis from craft and manual skills towards the value of conception and inspiration. More importantly, the late eighteenth-century Romantic movement had valued creative genius more than skill. In the course of the nineteenth century in France the lack of a standard by which works of art could be created and judged, or at least an increasing interest in challenging the criteria established by the major teaching and exhibiting institutions, had resulted in a wave of exuberant extremism and the search for new standards. Duchamp was sceptical of both 'essential' definitions of art and claims to originality by artists who continued to reproduce the same type of art in order to satisfy a market.

Duchamp summed up his own attitude in an interview with the art critic Francis Roberts: 'It is paradoxical. It is almost schizophrenic. On one side I worked from a very intellectual form of activity, and on the other de-deifying everything by more materialistic thoughts.' Avant-garde creativity without skill had recently been mocked on the basis that 'a child could do it'. Duchamp was aware of at least one example: the work of the 'Excessivist' painter 'Joachim-Raphael Boronali', a donkey belonging to a famous café owner Père Frédé, whose work (produced by strapping a brush to her tail) was entered in the Salon des Indépendants of 1910 (by

116. **Anon.**, photograph of the 'painter Boronali' at work.

simply paying a fee) and fooled many of the visiting public. This version of an 'automatically' produced work satirizes new forms of abstraction and claims to an absolute authenticity of individual expression through gesture. Duchamp, by contrast, produced 'no work at all'.

Duchamp's work seems to require no manual skill, no real making. What were the criteria by which he chose a readymade? Readymades have, first of all, been considered as demonstrations of the importance of choice by an artist. The written statement defending *Fountain* (signed with the pseudonym R. Mutt) that was published in *The Blind Man* in 1917 claimed: 'Whether Mr Mutt with his own hands made the fountain or not has no importance. He CHOSE it.' André Breton, one of the first after Apollinaire to comment on the readymades, emphasized the 'personality of choice' as a new procedure in the context of Dada. It is Duchamp's decision to choose whichever object he wants. It is essentially this kind of decision that any painter or sculptor has always had to make in producing an art object. The reasons for these choices are hidden in the privacy of the studio; above all, the artist must decide that the work is finished and must choose whether or not to show it to the public. These decisions are not connected to the manual work or skill of the artist (the physical aspect of his or her work), but are influenced by the internal workings of the artist's mind (the mental aspect).

What were the criteria on which these choices were made? Were there aesthetic considerations after all, a new conception of 'beauty' rooted in an industrial aesthetic? In interviews given in the 1950s and 1960s, Duchamp firmly rejected the role of 'beauty' in his selection of readymades. 'A point which I want very much to establish is that the choice of these "readymades" was never dictated by aesthetic delectation.'

When asked by Pierre Cabanne how he chose the readymades, Duchamp commented: 'That depended on the object. In general, I had to beware of its "look". It's very difficult to choose an object, because, at the end of fifteen days, you begin to like it or to hate it. You have to approach something with indifference, as if you had no aesthetic emotion. The choice of readymades is always based on visual indifference and, at the same time, on the total absence of good or bad taste.' The theme of indifference to the aesthetic appearance of the readymades clearly relates to Duchamp's anti-retinal view, as well as to his scepticism about essential definitions of 'Art'.

By distancing himself from the 'operations of taste' in this way Duchamp implies that aesthetic choices are no different from

those that determine the day-to-day choice of household goods. If taste is fluctuating and unstable, and yet the basis on which aesthetic decisions are made, is the reaction of indifference to the readymade then the paradoxical guarantee of lasting value?

The idea of the readymade produced an entirely new set of problems for artistic production. Duchamp wondered whether he should 'limit the production of "readymades" to a small number yearly'. Each readymade in effect remained distinctive and had its own method of production. A note from *The Green Box* describes his task, 'to separate the mass-produced readymade from the readyfound – the separation is an operation'. The distinction between the mass-produced and the found readymade could take on meaning in the context of a manufactured as opposed to a natural object. The idea of a 'work' of nature with the power to rival a work of art has a long history beyond western Romanticism. Chinese scholars, for instance, traditionally select a rock to place in their studies as a contrast to the elegant artifice of furniture. Yet Duchamp's readymades are not natural but industrial objects, an ironic modern equivalent of the 'found natural object' beloved of the Surrealists, their production being no less anonymous and apparently autonomous than rocks or fallen leaves. Duchamp's 'separation' of what is made from what is found is thus not so much an act of distinguishing artifice from nature, but of shifting between the stance of producer and consumer, and of ironic recognition of the industrial object as the perfect union of natural and artificial aspects so long desired by artists.

The idea of separation here is also related to the notion of the 'infra-thin' (see Chapter 8); infra-thin separation is an operation and the idea of the action to be performed by the artist led Duchamp to regard the creation of the readymades as a kind of event, something intimately connected with a moment in time and probably his personal presence. As he wrote in *The Green Box* in the 'Specifications for "Readymades"':

> by planning for a moment to come (on such a day, such a date such a minute), "to inscribe a readymade"– The readymade can later be looked for.– (with all kinds of delays)

The important thing then is just *this matter of timing, this snapshot effect, like a speech delivered on no matter what occasion but* at such and such an hour. *It is a kind of rendezvous.*

> –Naturally inscribe that date, hour, minute, on the readymade as information.
> also the serial characteristic of the readymade.

117. *Comb*, 1916

This note may be a clue to the unknown inscription on the lost 'original' version of *Bottle Dryer*. The clearest fulfilment of the plan is probably *Comb* (1916), inscribed with its date: '3 OU 4 GOUTTES DE HAUTEUR N'ONT RIEN A FAIRE AVEC LA SAUVAGERIE M.D. FEB 17 1916 11 AM.' ('Three or four drops from [of] height have nothing to do with savagery. Feb. 17 1916 11 AM'). This peculiar text written in the style of Raymond Roussel, possibly with cabalistic connections, seems entirely unrelated to the object with which Duchamp has made his appointment. It does, nevertheless, lend the steel dog comb a sadistic trait. (This sadistic side of the readymades was important to Surrealism. It is obvious in the spikes of the *Bottle Dryer* and in the 'broken arm' of the snow shovel from *In Advance of the Broken Arm*.) The inscription of a precise date and time for the encounter is also given in the pseudo-readymade (but in fact carefully crafted) postcard text *Rendez-vous du dimanche 6 février 1916 à 1 h. ¾ après-midi*.

Alternative conditions for the 'encounter' hint at an ironic standardization of the chance operations: 'Look for a readymade/which weighs a weight/chosen in advance/first decide on a/weight for each year/and force all readymades/of the same year/ to be the same weight.' There is no way of knowing whether any of the readymades were produced like this: probably the intersection between planning (the 'given') and chance remained speculative, like the operation proposed in the notes for what Duchamp dubbed 'a reciprocal readymade'. The most famous of this particular category of readymades was the instruction in *The Green Box* notes to use 'a Rembrandt as an ironing-board'. Part of the idea of reciprocity is to reverse the readymade's 'transformation' of the ordinary manufactured object into a 'work of art' by transforming a work of art into a utilitarian object. The iconoclastic idea of using 'a Rembrandt as an ironing-board' probably led to Man Ray's Dada object, *Gift*, a flat iron with tin tacks nailed to its base, which also shares the aggressive, sadistic character noted above.

To return to the 'encounter' — this theme appears in various guises, almost as a mock general principle. The date inscribed on *Comb* was the third anniversary of the opening of the Armory Show. Duchamp was aware of the connection between his new practice and relics or souvenirs, records of particular places or events. A hitherto unknown object, *Bilboquet* (1910) has recently emerged, which precedes the *Bicycle Wheel* by three years. Duchamp gave this wooden toy to his friend, the artist Max

-toir. On manquera,à la fois,de moins qu'avant cinq élections et aussi quelque accointance avec q--uatre petites bêtes; il faut oc--cuper ce délice afin d'en décli--ner toute responsabilité. Après douze photos,notre hésitation de--vant vingt fibres était compréh--ensible, même le pire accrochage demande coins porte-bonheur sans compter interdiction aux lins: C--omment ne pas épouser son moind--re opticien plutôt que supporter leurs mèches? Non,décidément,der--rière ta canne se cachent marbr--ures puis tire-bouchon. "Cepend--ant,avouèrent-ils,pourquoi viss--er,indisposer? Les autres ont p--ris démangeaisons pour construi--re,par douzaines,ses lacements. Dieu sait si nous avons besoin,q--uoique nombreux mangeurs,dans un défalquage." Défense donc au tri--ple, quand j'ourlerai ,dis je,pr-

-onent,après avoir fini votre ga--ne. N'empêche que le fait d'éte--indre six boutons l'un ses autr--es paraît (sauf si,lui,tourne a--utour) faire culbuter les bouto--nnières. Reste à choisir: de lo--ngues,fortes,extensibles défect--ions trouées par trois filets u--sés,ou bien,la seule enveloppe pour éte-ndre. Avez vous accepté des manches? Pouvais tu prendre sa file? Peut-être devons nous a--ttendre mon pilotis,en même tem--ps ma difficulté; avec ces chos--es là,impossible ajouter une hu--itième laisse. Sur trente misé--rables postes deux actuels veul--ent errer,remboursés civiquement, refusent toute compensation hors leur sphère. Pendant combien,pou--rquoi comment,limitera-t-on min--ce étiage? autrement dit: clous refroidissent lorsque beaucoup p--lissent enfin derrière,contenant

-este pour les profits,devant le--squels et,par précaution à prop--os,elle défonce desserta,même c--eux qu'il est défendu de nouer. Ensuite,sept ou huit poteaux boi--vent quelques conséquences main--tenant appointés; ne pas oubli--er,entre parenthèses,que sans 1' --économat,puis avec mainte sembl--able occasion,reviennent quatre fois leurs énormes limes; quoi! alors,si la férocité débouche de--rrière son propre tapis. Dès dem--ain j'aurai enfin mis exactemen--t des piles là où plusieurs fen--dent,acceptent quoique mandant le pourtour. D'abord,piquait on ligues sur bouteilles,malgré le--ur importance dans cent séréni--tés?' Une liquide algarade,après semaines dénonciatrices,va en y détester ta valise par un bord suffit. Nous sommes actuellement assez essuyés,voyez quel désarro-

porte,dès maintenant par grande quantité,pourront faire valoir l--e clan oblong qui,sans ôter auc--un traversin ni contourner moin--s de grelots,va remettre. Deux fois seulement,tout élève voudra--it traire,quand il facilite la bascule disséminée; mais,comme q--uelqu'un démonte puis avale des déchirements mains nombreux,soi compris,on est obligé d'entamer plusieurs grandes horloges pour obtenir un tiroir à bas âge. Co--nclusion: après maints efforts en vue du peigne, quel dommage! tous les fourreurs sont partis e--t signifient riz. Aucune deman--de ne nettoie l'ignorant ou sc--ié teneur; toutefois,étant don--nées quelques cages,c'eut une profonde émotion qu'éxécutent t--outes colles alitées. Tenues,v--ous auriez manqué si s'était t--rouvée là quelque prononciation

118. Rendez-vous du dimanche 6 février 1916 à 1 h. ¾ après-midi, 1916

119. *Paris Air (50 cc of Paris Air)*, 1919

120. *Pliant de voyage (Traveller's Folding Item)*, 1916, original lost; 1964 version, which Duchamp inscribed '*Pliant...de voyage 1917*'. Lebel suggests this was one of the two readymades in the 'Exhibition of Modern Art' held at the Bourgeois Galleries, New York, in 1916, but Duchamp said these readymades were 'exhibited in the umbrella stand'.

Bergmann, on 18 April 1910, inscribed: *Bilboquet Souvenir de Paris A mon ami M. Bergmann Duchamp printemps 1910*. This anticipates another souvenir, Duchamp's *Paris Air (50 cc of Paris Air)* of December 1919, a chemist's ampoule emptied of its fluid and labelled *Sérum physiologique*, which Duchamp had brought back from Paris for Walter Arensberg, 'who had everything money could buy. So I brought him an ampoule of Paris air'.

Two other works develop the theme of the souvenir as the traveller's portable memento. In 1916 Duchamp produced the *Pliant de voyage (Traveller's Folding Item)*, an Underwood typewriter cover, thereby introducing the notion of flexibility into sculpture. This idea was continued with the *Sculpture de voyage (Sculpture for Travelling)* of 1918, a work made out of a suspended web of rubber strips inventively sliced from multi-coloured bathing caps, which Duchamp was able to re-create out of his suitcase at every stop on his trip from New York to Buenos Aires in 1918.

121. *Sculpture de voyage (Sculpture for Travelling)*, 1918

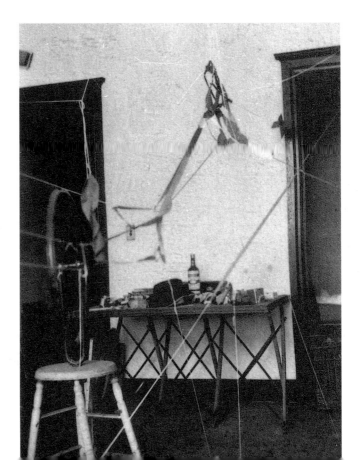

The themes of indifference and the chance meeting with the mass-produced commodity object lead on to another very significant aspect of the readymades: 'window shopping', where the feigned indifference of the consumer to the commodity contributes to the pleasure, as well as being necessary for financial success and survival (i.e. avoid being a spendthrift or being 'ripped off'). The indifference Duchamp said he felt in selecting (buying) a ready-made may in part mimic the attitude of the consumer protecting him or herself from the seller's desire to exploit the prospective purchaser, or from desires that may be unrealizable. Through the encounter with the commodity object expressed in both the ready-mades and the notes, Duchamp also highlights the traditional hypocrisy of pretending that there is a contradiction between 'Art' and 'Commodity' and that aesthetic and commodity values are totally opposed to one another.

Duchamp was keenly interested in the place of the machine in modern life and in the ever-increasing and simultaneous development of advertising and of commodity production. After the arrival of rail and electricity, the 'machine age' was evident to the average city dweller in the expanded ranges of both seductively marketed luxury goods and of household items with brand names. Duchamp found inspiration for the readymades and for the *Large Glass* in the language of advertising and commerce. *Chocolate Grinder*, for example, was to be a 'first-class article'. Duchamp even considered creating a kind of advertising slogan for the grinder's operation. A note in *The Green Box* reads:

The bachelor grinds his chocolate himself–
commercial formula, trade mark, commercial slogan inscribed like an
advertisement on a bit of glossy and colored paper (have it made by a
printer)– this paper stuck on the article 'Chocolate Grinder'.

That the very medium of the *Large Glass*, or at least of the glass division between the Bride and the Bachelors, is influenced by the idea of an erotic encounter through a window is borne out by another rather gloomy note, from *A l'Infinitif* (also known as *The White Box*):

The question of shop windows
To undergo the interrogation of shop windows
The exigency of the shop window
The shop window proof of the existence of the outside world
When one undergoes the examination of the shop window, one also
pronounces one's own sentence. In fact, one's choice is 'round trip'.
From the demands of the shop windows, from the inevitable response to
shop windows, my choice is determined. No obstinacy, ad absurdum, of
hiding the coition through a glass pane with one or many objects of the
shop window. The penalty consists in cutting the pane and in feeling
regret as soon as possession is consummated. Q.E.D.

<div align="right">

Neuilly, 1913

</div>

The analogies between sexuality and window shopping explored in the *Large Glass* and *The Green Box* in terms of desire and deferment should also be considered in relation to the auto-erotic and 'perverse' aspect of the readymades, commodity objects with which Duchamp has had a chance and productive encounter. Many of the readymades suggest a body, or particular parts of the body, or invite and anticipate bodily actions. The *Bicycle Wheel*, for example, clearly waits to be spun, while the *Comb* is ready to run through hair. These repeatable and perhaps pleasurable actions both symbolize and undermine the unhealthy appetites and false needs Karl Marx stated that capitalist commodity production and the 'consumer society' would generate, whereby the consumer is seduced into a purchase by promises of (erotic) satisfaction. Marx argued that the economic conditions of capitalism created the phenomenon of 'commodity fetishism', the tendency to ascribe to ordinary objects quasi-human powers and desires. Money itself, the symbol of all commodities, with its apparently unaccountable fluctuations in the market, continues to dictate human fortunes. However, just as money and commodity create misery, they also promise untold sensuous reward; such promises are made in advertisements or shop windows. Thus Duchamp's use of the erotic metaphor for the shop window encounter and for the appeal of the commodity object seems apposite – money is, after all, the 'universal pimp' for Marx.

Furthermore, Duchamp's tendency to endow objects in the *Large Glass* and in the readymades with human desires and emotions, such as the *Unhappy Readymade* (1919), and to select or construct readymades with human uses or even form, is intimately

122. *Trébuchet (Trap)*, 1917, original lost; 1964 version. A coat rack nailed to the floor for people to trip over (*trébucher*).

related to the description that Marx gives of the effects of 'commodity fetishism'. Yet at the same time the little pleasures that the readymades suggest are not entirely passive, as they might be if their consummation were simply a kind of ruthless exploitation of, for instance, the 'Bachelor' – the lonely masturbatory consumer – who might indulge in them. This Bachelor remains slightly outside the all-powerful system, by converting the ordinary commodity into his own pleasure-machine, by using it privately and even inappropriately, not according to the manufacturer's instructions. In becoming metaphorically but almost literally eroticized, the readymades lead to the Surrealist object and its subversion of the supposed utility function of the daily commodity.

This repossession of the commodity object was developed in a more slapstick mode in readymades like *Trébuchet (Trap)*, a coat rack converted into a *trébuchet* (also a move in chess) by nailing it to the studio floor in 1917. The *Hat Rack* (1917) is rendered useless by hanging it on a piece of string. These two readymades are also odd stand-ins for the human body, in that they wait to receive its cast-off clothes.

There were various categories of readymade, including the 'assisted readymade', which combined manufactured and found objects in constructions that prefigure the Surrealist object. The assisted readymade *With Hidden Noise* (1916) took up the theme of the chance encounter. It consists of a ball of string pressed between two brass plates, joined by four long screws and an inscription. Duchamp ensured a rendez-vous of sorts by asking his friend and patron Walter Arensberg to insert a secret object within the ball of string and to seal the plates while he was absent. The object could thus be heard but not seen.

123. *Hat Rack*, 1917, original lost; 1964 version.

124, 125. *With Hidden Noise*, 1916. The words inscribed on the upper and lower plates were, as Duchamp explained to Schwarz, 'an exercise in comparative orthography'; the gaps were to be replaced by letters from the other two lines. French and English are mixed, making no sense.

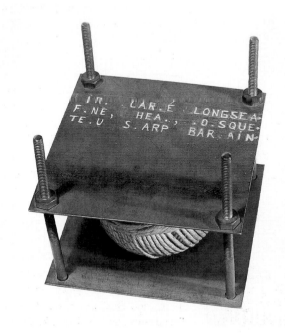

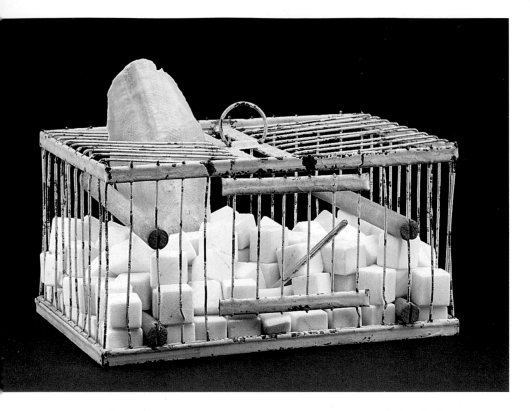

126. *Why Not Sneeze Rose Sélavy?*, 1921

127. (opposite) *Fresh Widow*, 1920, the first work signed by Duchamp's female alter ego Rose Sélavy. A second 'r' was later added to form 'Rrose'.

The 'genre' of the readymade expanded as Duchamp began to commission objects or parts of objects to be made to 'readymade' specifications by craftsmen. A highly constructed 'semi-readymade', as Duchamp called it, of 1921 asks the question *Why Not Sneeze Rose Sélavy?* The question of the title seems comic, as a sneeze is, of course, involuntary. The sugar lumps that fill the cage (together with cuttlebone and a thermometer) turn out, when the cage is lifted, to be made of marble, meticulously sawn into cubes, producing another involuntary shudder with the unexpected weight. *Fresh Widow* (1920), a small model of a window, was made to Duchamp's specifications by a carpenter in New York. The first work to be signed by 'Rose Sélavy', it has been described as a French window 'with a head cold'. Related to Duchamp's works on glass, it had panes of glass covered with leather, which, Duchamp instructed, should be polished like glass. The black leather, though, is a grim replacement for the transparency of glass and recalls the black veil of the Bride's message-bearing Draught Pistons in the *Large Glass*, giving a less innocent meaning to the verbal pun.

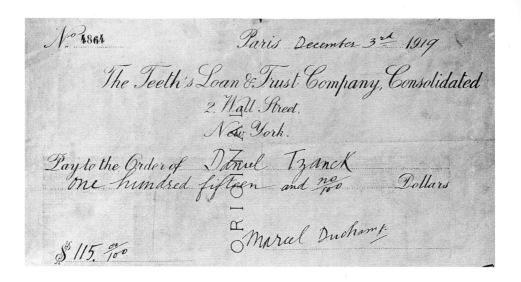

Duchamp's activity with the readymades reached its height during the early years of his arrival in the United States, where they were first exhibited in 1916. It is fitting that these works, at least partly musings on consumer capitalism, should have been shown first in the United States, the heart of consumer capitalism. This period also coincides with the work on the *Large Glass*, and it was towards the end of this long-delayed project that Duchamp began to show an interest in two other key figures in capitalism beside the window-shopping consumer: the inventor and the entrepreneur. The *Tzanck Cheque* (1919) is a mock-readymade and a natural extension of Duchamp's interest in the relationship between money and the body – this time a painful rather than a pleasurable one. Duchamp was unable to pay his dentist Daniel Tzanck for some work he had done. Fortunately, Tzanck was also a collector of modern art. Duchamp set about producing a phoney cheque – stamped 'original', which of course it was – issued from The Teeth's Loan & Trust Company, Consolidated, of 2 Wall Street, New York. The implicit pun is on drawing works of art, cheques and teeth. Two years later, Duchamp's female alter ego Rrose Sélavy turned entrepreneur and produced *Belle Haleine, eau de voilette ('Beautiful Breath, Veil Water')*, an 'assisted readymade', prototype for an unmarketable perfume.

In testing out the roles of inventor and entrepreneur Duchamp was probing those separations between industrial products and the fine arts, invention, production and creation, patron

and punter, mass production and uniqueness, speculating and collecting, genius and anonymity – divisions whose contradictions, ambiguities and arbitrary values are often highlighted by his activities. Some of Duchamp's works, such as his 'portable museum', the *Boîte*, play on the historical transformations, the ruptures and continuities associated with the shift in manufacture of product from handcraft to mechanized industrial serial production.

136

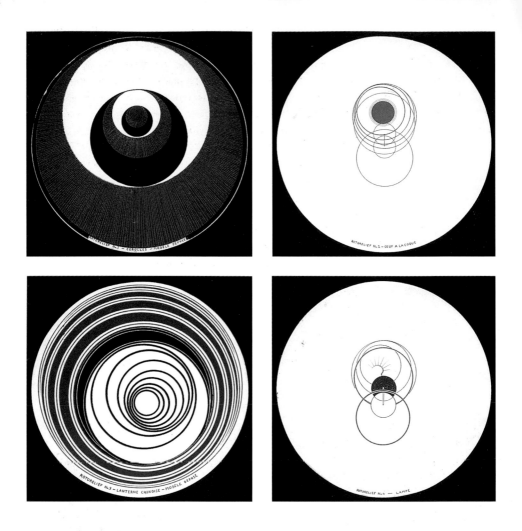

130. *Rotoreliefs (Optical Disks)*,
from the set of six disks, 1935

Two ventures – of very limited success – were linked
respectively to his interest in optics and in chance. The climax of
his optical projects came in 1935 with his *Rotoreliefs (Optical Disks)*
after a long gestation. In 1920 his first optical machine was con-
structed, *Rotary Glass Plates (Precision Optics)*. This one-off device,
five rectangular glass plates mounted several inches apart along a
metal axle, created, when spinning, the effect of continuous black-
and-white concentric circles. It was filmed in action by Duchamp's
friend Man Ray. A second machine, *Rotary Demisphere (Precision
Optics)* of 1925, was commissioned by Duchamp's patron Jacques
Doucet. Duchamp corresponded with Doucet throughout the
construction and the letters show the scrupulous care he took

with the technicalities of the work and document his collaboration with an engineer and with those who provided the different parts of the machine, a painted wooden demisphere mounted on a copper disk that was covered in dense black velvet. When spun, the black circles of this machine appeared to contract and expand, producing an illusion of depth. An engraver inscribed a Rrose Sélavy pun on the edge of the copper disk (RROSE Sélavy ET MOI ESQUIVONS LES ECCHYMOSES DES ESQUIMAUX AUX MOTS EXQUIS). In a short film by Man Ray and Duchamp of the same period, with the almost palindromic title *Anémic Cinéma* (1925), a sequence of nine disks inscribed with similar puns alternated with ten 'optical disks', or disks bearing black-and-white eccentric circles. The word-bearing disks were filmed spinning gently in one direction, while the optical disks turned faster in the other to create optical illusions.

Marketing the optical projects was not a success. The *Rotoreliefs (Optical Disks)* of 1935 were a set of six cardboard disks, printed on both sides in colour offset lithography, which could be 'played' on a gramophone; at 33⅓ revolutions per minute, they created various optical effects. Duchamp prepared an edition of 500 and in the autumn of 1935 he rented a stand to sell them at an inventors' fair, the Concours Lépine in Paris. He explained:

131. (below left) *Rotary Glass Plates (Precision Optics)*, 1920

132. (below right) *Rotary Demisphere (Precision Optics)*, 1925

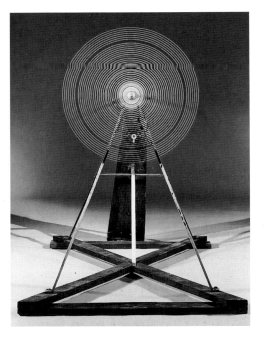
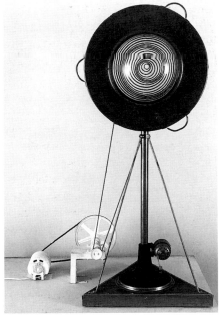

In 1934, from abstract drawings which were spirals alone, I went further by reconstituting the object like, for example, the fish in a bowl turning. I called them Rotoreliefs. It's a relief obtained by rotation. That's the origin of the word. I did twelve drawings at that time and published them and I even had the nerve to show them in Paris in a big international fair for gadgets. I had a whole stand with the electric motors making those things turn, hoping people would buy them. Cheap, too, and in the course of the month I sold one. I had a secretary doing this you know. I couldn't stay there all day so it was a pure flop, the whole thing.

Duchamp remarked when his friend Henri-Pierre Roché dropped by: 'Error, one hundred per cent.'

Perhaps the most surprising of Duchamp's speculative ventures was the *Monte Carlo Bond* (1924). Duchamp pursued further his interest in chance and the language of the stock market with these bonds priced at 500 francs each. He planned to issue thirty, but only a few were finally produced. The investors' money was used to play the roulette tables at Monte Carlo and invest in mining, with a view to returning 20 per cent interest to all stock-holders. This pseudo 'assisted readymade' is a wonderfully crafted imitation of a share or stock. Each was assembled individually, but intended to mimic a mass-printed bond. It is an intricate photo-collage, using a printed reproduction of a roulette table and board, the edges filled with the continuously repeated pun *moustiquesdomestiquesdemistock* ('half-stock domestic mosquitoes') in letter-press, with a photograph of Duchamp by Man Ray imposed on the wheel. The counter-signatures of Marcel Duchamp and Rrose Sélavy appear at the bottom. A note about the *Monte Carlo Bond* appeared in *The Little Review* in the winter of 1924 to 1925: 'If anyone is in the business of buying art curiosities as an investment, here is a chance to invest in a perfect masterpiece. Marcel's signature alone is worth much more than the 500 francs asked for the share.' Yet his pseudo-readymade is not all a joke, since Duchamp did indeed spend a season in Monte Carlo playing his own 'Martingale' or gambling system. He wrote to Picabia: 'For five days with very little capital I have tried out my system.… It's delicious monotony without the least emotion.… You see I haven't quit being a painter, now I'm sketching on chance.' That the bond was still consonant with Duchamp's long-standing interest in chance and consequence, as well as a genuine money venture, is also clear from a letter to Jacques Doucet, one of his shareholders: 'This time I think I have eliminated the word chance. I would like to force the roulette to become a game of chess.

A claim and its consequences: but I would like so much to pay my dividends.'

Duchamp's career as cranky speculator and inventor thus comprised various ventures – and often shows his interest in devices for things intimate (such as teeth, eyes, breath). The tone of the aborted 'moneyspinners' that Duchamp produced after giving up art in 1923 is not consistently Jarryesque and it is impossible to say whether he genuinely believed that one of the projects of this period might bring real financial reward.

One of the mysteries of Duchamp's career is how he actually survived financially whilst apparently avoiding dealers and selling little of his own work until quite late in life. French language lessons, sporadic support from wealthy patrons and collectors, a little dealing in the work of artist-friends like Brancusi and Picabia and a short-lived arranged marriage in 1927 to the daughter of a wealthy industrialist were some of the ways. Recent biographies by Calvin Tomkins and by Jennifer Gough-Cooper and Jacques Caumont describe these and other activities, which were usually temporary or expedient, intended, perhaps, to 'Gain Time', as he says in one note.

Perhaps he did, as another note says, live 'Life on Credit'. Duchamp summed up his revisionist and almost politicized position on money, work and intellectual freedom, which forms the background to the inventions and the speculative projects in 1966, talking in an interview to Pierre Cabanne: 'I've never worked for a living. I consider working for a living slightly imbecilic from an economic point of view. I hope that some day we'll be able to live without being obliged to work.'

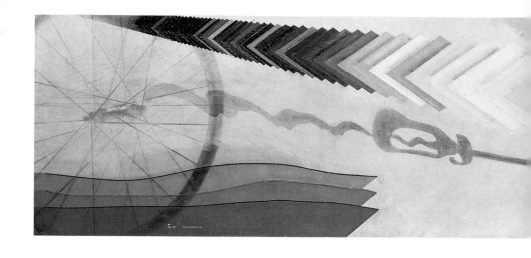

Chapter 8: Replicas, Casts and the Infra-thin

As Duchamp replaced the notion of representation by traditional methods with other means of production and reproduction, he became increasingly interested in the question of the replica. His thinking led broadly in two directions: on the one hand, towards an extended exploration of the possibilities of moulds and casts and, on the other, towards the reproduction in facsimile of his own works. The examination of casts culminated in his last work, *Étant donnés*, which will be discussed in the next chapter. Linked to this exploration was the intriguing notion of the *Infra-mince* (the 'infra-thin'), on which Duchamp speculated in a series of notes that began around 1937, but were not published until after his death.

Facsimiles and replicas go far beyond the idea of a simple copy for Duchamp: he had an abhorrence of repetition. Duchamp's idea of making an 'inventory' of, in fact an index to, his own work first manifested itself in his very last – and largest – oil painting on canvas, *Tu m'* (1918).

This painting, over ten feet (three metres) long, was commissioned by Katherine Dreier for a space above specially constructed bookshelves in her New York apartment. It is both valedictory and anticipatory and, perhaps in response to the fact that it was commissioned, is reminiscent of one of the classic forms of decorative art favoured by aristocratic eighteenth-century patrons – the 'attributes' (of music, military arts, etc.). Here, it is

133. *Tu m'*, 1918

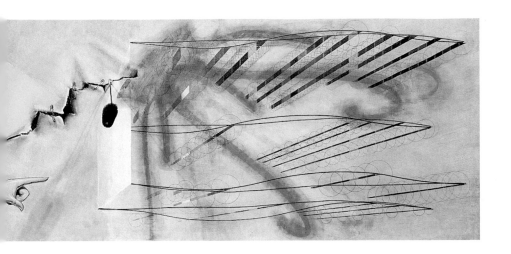

the 'attributes of painting', now gone, as far as Duchamp was concerned, for good.

Tu m' casts a last and ironic look at modes of representation and pictorial illusion. Its title, 'you...me', can be completed in many ways, *tu m'aimes* for instance, but the verbs that suggest themselves by and large express disgust – *agacer, ennuyer, emmerder* (irritate, annoy, bore stiff). Thus the addressee could be the very art of painting itself. Pronounced with an English accent, *Tu m'* produces 'tomb', and this invocation of mortal remains is echoed in the narrow horizontal format of the painting, which recalls Holbein's *Dead Christ* (1521).

Despite the apparent incongruity of the painting's elements and a decorativeness that Duchamp always disliked, it is an impressive work. It is an 'anthology' in an odd sense, however: three readymades – *Bicycle Wheel, Hat Rack* and a corkscrew that 109, 123 was not 'realized' as a readymade – are represented in the painting only by their shadows, cast on the canvas using a projector and traced by hand. On the lower left and the right are the curving lines of the *3 Standard Stoppages*, now bearing a curious resem- 60 blance to William Hogarth's 'serpentine line', the ideal composi-tional form proposed by the painter in his *Analysis of Beauty* (1753), rather than to their origin as an irrational measurement. They thus point to a dialogue in this work between abstract composi-tional procedures and the representation of objects. These two areas marked out by the *3 Standard Stoppages* are balanced by a third element – a stack of 'colour cards', a kind of house painter's

chart functioning as a snide reminder of the mechanism of paint-
ing in oil, rushing in from the top left like the Swift Nudes in the
painting *The King and Queen Surrounded by Swift Nudes* (1912).
They provide the colour 'hues', while the *3 Standard Stoppages* on
the left produce tone, or shades from dark to light, and those to the
right the graphic elements. Delicately drawn circles around rods
extending back from the curved lines suggest, but not consistent-
ly, perspective. There is thus a complete 'inventory' of a traditional
painter's stock in trade. Over the painting hang the huge shadows
of the readymades, which are cast from outside, from the space
occupied by the artist with his 'brush' and the spectator, while the
'colour cards' advance from the illusionistic 'depth' to meet them
on the canvas surface. Three additions in the centre function like a
'signing off' of Duchamp the painter: a hand that he had painted by
a professional sign painter and signed by him in pencil, 'A. Klang';
an illusionistic tear painted in the canvas and fastened by real
safety pins; and another real object, a bottle brush protruding out
from the canvas into the spectator's space (like the artist's brush in
reverse). This object makes it impossible to represent the work
adequately in a photograph and introduces the problem of how to
reproduce a work that exists simultaneously as a flat object and 'in
profile'.

♕ ♕ ♕

Duchamp's *Boîte-en-valise* was a still more comprehensive
anthology of his own works and also considerably more than a
compilation of reproductions. It relates to his thinking about the
facsimile and about the nature of the 'work of art in the age of
mechanical reproduction', to use the title of Walter Benjamin's
famous essay of 1936. The *Boîte* presented Duchamp with techni-
cal problems to solve, to which he applied his usual 'meticulosity'.

In retrospect, it is surprising that Duchamp's reputation as an
artist who had ceased to practice, or in some obscure way 'gone
underground', survived his actual activities during the 1930s and
after, including his various interventions in Surrealist exhibitions
or reviews and the sporadic appearance of objects from the late
1940s whose links to the last major work, *Etant donnés*, could not
have been known. The *Boîte-en-valise* (the 'Box in a Suitcase' or
'Travelling Box') was simply not recognized as a 'work of art' at
all, and, indeed, was even regarded as proof that he had ceased to
be an artist.

In this respect it was not unlike Edgar Allan Poe's 'The
Purloined Letter', the case of the stolen letter hidden from trained

134. (below left) Duchamp demonstrating the open *Boîte-en-valise* in New York, 1942. Duchamp made twenty numbered, and four *hors série*, examples of the *Boîte-en-valise*, the de luxe version, each containing an original work.

135. (below right) *Paysage fautif (Wayward Landscape)*, 1946. An original work from the *Boîte-en-valise*, no. XII, dedicated to Maria Martins, Brazilian sculptor and the model for *Étant donnés*, who was very close to Duchamp at the time.

detectives by being placed in the open in a letter rack, rather than concealed. The *Boîte-en-valise* was assumed to be just a commercial set of reproductions of existing works. Little account was taken of the fact that it was also a unique 'construction' produced serially as a limited edition. Each of the de luxe versions, moreover, contained an 'original work of art', some of a highly personal character intended for the owner of that box.

The *Boîte-en-valise*, or 'portable museum', as Ecke Bonk describes it in his detailed study, could be said to belong to the series of facsimile editions dating back to *The Box of 1914*. In 1935, a few months after publishing *The Green Box* notes, Duchamp wrote to Katherine Dreier that he was considering making an 'album of approximately all the things I produced'. He immediately began gathering photographs of the works he intended to include in what was initially conceived as a book, though it soon assumed its unique format. However, Duchamp took a leisurely attitude towards the project, which was clearly not geared to maximize profit. The entire edition had not been completed when he died in 1968. A comparison can be made with the idea of 'delay', which he had chosen as the subtitle of the *Large Glass*, and which he had there symbolized in the accumulation of dust.

The *Boîte* combined the practice of publishing facsimiles of notes and drawings loose in boxes with three-dimensional constructions related to ideas of storage and display. The works

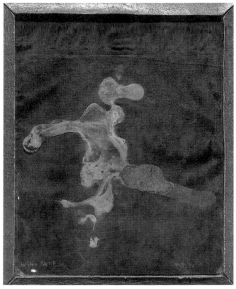

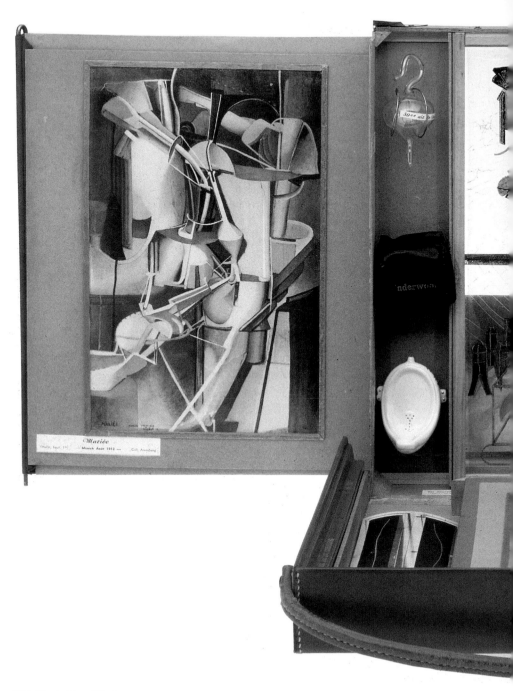

136. *Of or by Marcel Duchamp
or Rrose Sélavy (*the *Boîte-en-
valise)*, 1935–41; 1941 version.

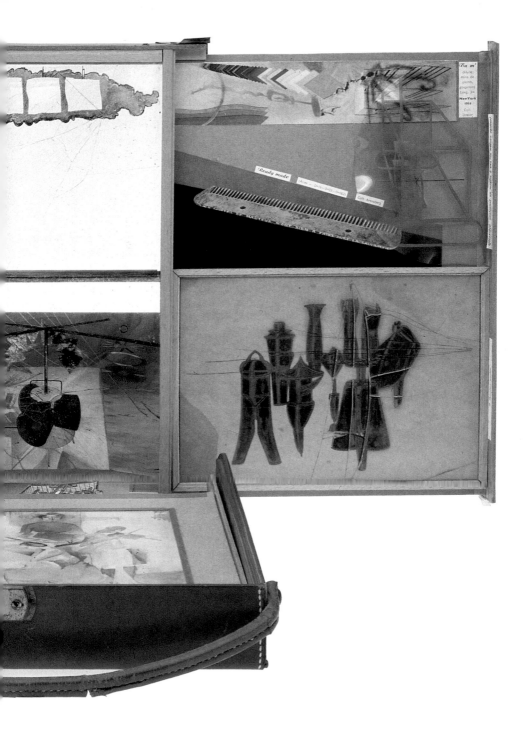

could be packed away in a portable form and then, like a travelling salesman's wares, unpacked, revealing the ingenious, partly mobile display frames fitted inside. It thus becomes a self-contained travelling exhibition, independent of museum or gallery. From 1935 and over the next five years, Duchamp assembled reproductions of 69 items – an erotically significant number – that were positioned in the box in a variety of intricate ways, some fixed, some movable, some in black folders. Twenty-four de luxe copies were placed in a portable leather case with a handle (the *Boîte-en-valise* proper), while the ordinary edition of three hundred were just put in boxes. The first few de luxe copies contained, in addition to an original work of art, a *coloriage original* (a 'colour guide'), a stage in the *pochoir* ('stencil') technique, a hand-made, perfectionist method for producing coloured multiples of pictures. First of all, Duchamp collected black-and-white photographs of the works to be included, which he then hand-coloured, or whose colours he recorded in detailed notes. It was partly to look again at his paintings that he made an extended visit to the United States in 1936, where the majority of them were in private collections, notably those of Walter Arensberg and Katherine Dreier. From these coloured or annotated photographs, monochrome collo-types were made, the first proofs of which he hand-coloured him-self: the *coloriages originaux*. The sequence of colours was then established through a series of watercolours made by the *pochoir* specialists and hand-cut stencils were prepared for each colour, which was applied individually with a special brush. This highly skilled, time-consuming process was unsuited, as Bonk notes, 'for projects of a commercial nature'.

Duchamp had made use of stencils over a long period, beginning with the humorous drawings of 1910. He used *pochoir* for *Chocolate Grinder, No. 2* in 1914 as part of his rejection of the tyranny of the hand. Just as the tyranny of the eye, the purely retinal, had prompted him towards the conceptual framework of the *Large Glass*, so the tyranny of the hand had led to the idea of the readymade. It is ironic that he chose with the *Boîte* to use a highly skilled method to reproduce the work of art – *pochoir* prints being both multiple and hand-finished, with the appearance of a 'real' painting. Stencils are also a kind of two-dimensional mould and Duchamp's interest, as Bonk says, in 'the interplay of mould and cast, and in its two-dimensional counterpart, the figure-ground problem, made stencils of all kinds into an ideal instru-ment'. It was at this time, when Duchamp was experimenting with the two- and three-dimensional reproductions of his works for the

Boîte, that he also began to make notes on the concept of the 'infra-thin'.

The problem of including three-dimensional facsimiles in the Travelling Box of readymades and assisted readymades, perhaps determined Duchamp to prepare a container rather than a book, though he continued to call it an album until 1940. In letters of the following year, he refers to it as his 'box'.

Duchamp decided to install in the *Boîte*, arranged in a vertical column beside the celluloid reproduction in *pochoir* of the *Large Glass*, three miniature readymades: the urinal, *Fountain*, next to the lower section, the Bachelors' Domain; the *Traveller's Folding Item*, the typewriter cover, next to the central line; and *Paris Air (50 cc of Paris Air)* next to the upper section, the Bride's Domain. The careful way in which the readymades were placed in relation to the *Large Glass* suggests correspondences between them. He said to Walter Hopps in 1963: 'They are kind of readymade talk of what goes on in the *Glass*.' The effect is to introduce or confirm

136

137. Photograph of *Sonata* (1911), with colour notes for *pochoir* colouring, 1936

the gender of individual readymades. In this way the urinal belongs to the male domain; the typewriter cover, normally installed by Duchamp on a music stand to lift it to the height of a skirt, mimics the ('stripped') Bride's clothes, which lay on the border between the two domains. *Paris Air* has a connection with the upper section not so much in its female as in its ethereal 'Virgin' quality: it is also suspended on a hook, like the *Pendu femelle*.

The miniature replicas of the readymades in the *Boîte* produced the ironic situation that the mould of an already mass-produced object had to be hand-crafted in order to mass-produce it again. Their reproduction gave him the first opportunity to explore in practice what he had so often speculated about in the notes: the interplay between 'original', mould and cast. The 'original' of *Fountain*, itself a cast, could only have been used as a model; as it had been lost, Duchamp made from memory a tiny papier-mâché version, based on the 1917 photograph by Stieglitz and other shots taken that year of the urinal suspended from the ceiling of his studio in New York. This model, a 'little masterpiece of humorous sculpture' as Henri-Pierre Roché called it in his diary, was the basis for an inter-positive copy made to scale, which Duchamp commissioned from a potter, and from which a mould was taken to produce the cast multiples. The first batch was made using an elaborate white porcelain glaze, later changed to a cheaper matt glaze.

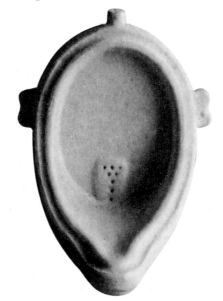

138, 139, 140. (above) *Fountain*, papier-mâché model for the miniature in the *Boîte-en-valise*, 1938

141. (right) *Fountain*, 1938, miniature ceramic model produced for the *Boîte-en-valise*.

The solution to the problem of reproducing the semi-readymade *Why Not Sneeze Rose Sélavy* introduced a new form, 'somewhere between the second and the third dimension', as Bonk put it. Duchamp varnished a photograph by Man Ray of the birdcage poised over a mirror to reveal the title-inscription below, then stamped out the image and pasted it on to a three-dimensional plaster 'mould', based on the perspectival view of the readymade in the photograph. This fourth miniature replica, a 'three-dimensional photograph', was placed at the centre base of the *Large Glass* in the *Boîte*.

It took Duchamp from 1935 until the end of 1940 to assemble all the 'documents' for the proposed 320 boxes: the first appeared on 1 January 1941, entitled *de ou par MARCEL DUCHAMP ou RROSE SELAVY (Of or by Marcel Duchamp or Rrose Sélavy)*. He completed some de luxe copies of the *Boîte-en-valise* and a few of the *Boîte* under difficult conditions, while the Germans took Paris. During the summer of 1941 he managed to transport some of the materials for the *Boîte* from Paris to the unoccupied zone in the South of France (armed with papers lent him by his friend Gustave Candel, where his occupation was given as 'cheese merchant'). When he finally reached the United States in 1942, he had the material for making fifty boxes. With the help of Joseph Cornell, he resumed their assemblage, but it took over three decades to complete the full edition, which consists of seven series of slightly different versions.

142. *Why Not Sneeze Rose Sélavy*, 1921. A photograph taken in 1940 for the miniature in the *Boîte-en-valise*, where it was pasted on to a little plaster mount. (See ill. 126.)

Making his multiples portable could refer not only to his own journeys across the Atlantic, but also to the very idea of departures that had begun to haunt Europe with the renewed threat of war, the attendant nightmare of displaced populations and refugees. Duchamp's pre-war and early war-time mechanical images countered the glorification of the machine by the Futurists, so closely linked in their aesthetic to the glorification of war. So now perhaps the sense of impermanence and change, of travelling light in an aesthetic as well as a literal sense, of salvaging fragments, of mementos of a past about to be buried, clings to the *Boîte*.

The *Boîte* also corresponds in certain respects to some of the ambiguities in Walter Benjamin's writings about the 'aura' of a work of art and its loss in an age of mechanical reproduction. Photography and film, Benjamin argued, represent a crisis for painting, which, as an object for 'contemplative immersion' cannot tolerate mass viewing conditions. Human perception and response necessarily change when technology represents reality in different ways. Benjamin analysed Dada montage as a foretaste of film, which has a violent impact upon the spectator, driving away associative thought and contemplation. There is an ambivalence, though, in Benjamin's writing about 'aura', whose meaning is not entirely clear; on the one hand, its loss is celebrated as the end of the exclusive, private, ritual status of an art object in favour of the demotic and popular, and, on the other, mourned as the disappearance of aesthetic experience of a unique, unrepeatable kind. Duchamp consistently challenged the old modes of art: he rejected painting, worked with film and photography, experimented with stereoscopy, chose his readymades and inaugurated multiples, but his escape from conformity was in some respects as much to protect as to disband his artistic identity. Duchamp recognized that the art object will have a different presence in a world where its function is no longer 'religious, philosophical, moral', and that, in the age of facile mechanical reproduction, it will take its value from something other than mimesis in the traditional sense.

Just what this might be, and how Duchamp formulated new responses, above all in *Etant donnés*, will be discussed in the light of his notion of the 'infra-thin' and the method of reproduction offered by moulds and casts.

In about 1937, while Duchamp was thinking about the replicas for the *Boîte*, he began to elaborate a new idea in his notes: the *infra-mince*, or 'infra-thin'. The ideas or 'states' to which infra-thin refers are elusive, and he applies the term in numerous contexts. By and large infra-thin indicates liminal changes in a body or object, barely perceptible differences, or forms of separation. The very term has a delicate precision: *mince* translates as 'thin', but instead of using 'super' or 'supra'-thin, which would express the 'extra-thin', Duchamp chooses the opposite 'infra-', meaning below rather than above, a word analogous to 'infrasonic' (frequencies below the range that can be heard by the human ear), or 'infrared'.

The notes only offer instances of infra-thin. It is, he says, always an adjective, never a noun, so that it can never exist as a thing in its own right. What it aims to isolate is a kind of displacement that bears a trace without necessarily being 'indexical' (as a footprint in the sand would be), a kind of interface or state of being 'inbetween':

When the tobacco smoke smells also of the mouth which exhales it, the 2 odors marry by infra thin (olfactory infra thin).

Infra-thin could also relate to a potential state, in which there is an element of chance: 'The possible is an infra-thin – The possibility of several tubes of colour becoming a Seurat is the concrete "explanation" of the possible as infra-thin.'

An example of 'visible infra-thin' is iridescent cloth, or shot silk, which has a different character or colour according to the light. He compares these moiré effects with corduroy 'which when brushing against itself gives an auditory inf thin [sic]'.

Infra-thin then points to a condition of liminality, that is, something on the threshold (between inside and outside, for example); the interface between two types of thing (smoke and mouth); a gap or shift that is virtually imperceptible but absolute; a separation or passage from one state or condition or dimension to another. An example, looking back at Duchamp's earlier activities, might be the change recorded in the photographs of the *Draught Pistons* (1914) in a two-dimensional piece of gauze as the wind blows it into three-dimensional shapes and also Duchamp's speculations on the shift from the third to the fourth dimensions.

Infra-thin encompasses time and space as well as indefinable relations such as exchange and response, for example, that govern the reception of works of art, a matter in which Duchamp took an increasing interest. 'The exchange between what one puts on view…and the glacial regard of the public (which sees and forgets

immediately). Very often this exchange has the value of an infra-thin separation (meaning that the more a thing is admired and looked at the less there is an inf.t.sep.'

Duchamp also wrote: 'Allegory (in general) is an application of the infra thin.' Allegory is derived from the Greek term *allegoria*, which means leading or guiding by means of another thing. Here he points to the separation, or gap between what is presented and what is signified, between the given concrete particular and a more general or abstract dimension.

Another 'infra-thin' concerns 'the difference between 2 mass-produced objects from the same mould…when the maximum precision is obtained'. The interval between 'identicals' is an infra-thin, and this, he says, is a better way of describing it than by making some general descriptive analogy, such as '2 twins look like 2 drops of water', which is simply another example, circular, without isolating the question of the difference between identicals, which have a separate physical existence.

Many of the infra-thin notes concern the sense of body, absent or present, the qualitative rather than purely descriptive sense of the term *mince* in its bodily connotations. There is no single physical sense to which infra-thin relates, however, as infrasonic does to the ear. Duchamp uses the word infra-thin explicitly to refer to touch and smell as well as hearing and sight. Although the

145. *Feuille de vigne femelle*
(Female Fig Leaf), 1950

body is often present there are also more intangible effects of the infra-thin to be experienced. One infra-thin note considers the doubled moulding interaction of body and clothes, with implications of gender power (who wears the trousers): 'Crease molds/in the elbow's case (right elbow)/Mold type ex. – worn trousers and very creased./(giving a sculptural expression of the individual who wore them)/the act of wearing the trousers, the trouser/wearing is comparable to the hand/making of an original sculpture

'With in addition, a technical inversion:/while wearing the trousers/the leg works like the hand of the/sculptor and produces a mold (instead/of a molding) and a mold in cloth/which/expresses itself in creases.' Clothes would be to the body as a sculpture is to the hand: in terms of readymades, the body is to clothes as the production line is to the mass-produced object. Clothes are both moulded by and confer identity on the body. In 1938 Duchamp had dressed his mannequin for the *rue Surréaliste* in his own clothes, thus producing a tension between body (female) and clothes (male), raising the question which will mould which? The *Couple of Laundress's Aprons* (1959) become clothes by virtue of their title; they are novelty oven-gloves, bought in New York, a readymade in two parts (male and female).

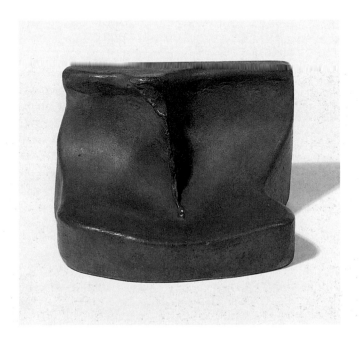

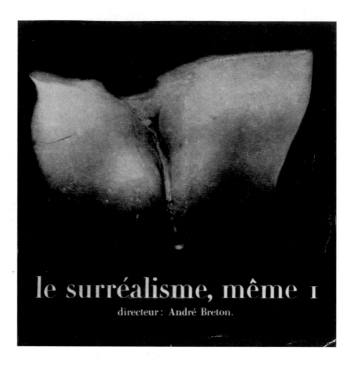

The notion of the infra-thin relates the body closely to ideas about moulds and casts. Duchamp's thoughts in this area had long ranged over materials with suitable properties, like chocolate (which melts and sets), or unsuitable ones, like gas. It had amused him to think of the Malic Moulds of the *Large Glass*, as 'gas castings'. As well as resembling lanterns, they also recalled dummies, and some of their forms, as we have seen, originate in drawings of tailors' dummies, which are like the body's 'intercopy' for clothes. An 'intercopy' is a model made for a mould to provide, for instance, a set of replicas, different in scale from an original – like the miniature *Fountain* in the *Boîte*. The Malic Moulds are described in *The Green Box* notes as 'eros' matrix'. This term, matrix (*matrice*), is a perfect linguistic hinge for the erotic 'moulds' that Duchamp produced after the Second World War. Sharing the same stem as 'maternal', matrix has come, from its original sense of womb, to mean point of origin, the material in which a mineral is embedded, and a type-set letter or the plaster mould in which metal stereotypes are cast.

The negative/positive processes of moulding and casting, with their reversing internal and external surfaces, convexities and concavities, have clear applications to the sexual themes that

had long preoccupied Duchamp, to ideas of the intimate fitting and folding together of bodies. Most of the objects sporadically produced in the post-war period involve casts (or 'body-moulds', that is, clothes), where the process of production can be made to mimic the erotic in terms of the infra-thin. The three small objects – *Feuille de vigne femelle (Female Fig Leaf)*, *Objet-Dard (Dart-Object)* and *Coin de chasteté (Wedge of Chastity)* – explore either literally or metaphorically cast-mould interactions in relation to the body.

Feuille de vigne femelle (1950) is a suggestive 'creased' cast of part of the female body, its angle in relation to the actual body left ambiguous. A photograph of this object in negative was used for the cover of *Le Surréalisme, même* in 1956, which reads as a positive, convex mould of female buttocks: an illusion in terms of the actual scale of the sculpture. The second of these objects, *Objet-Dard* (1951) was a by-product, like *Feuille de vigne femelle*, of the making of *Etant donnés*, part of the armature supporting the breast, looking something like a rib. Its title is a pun in French on *objet d'art*, but *dard* means 'sting', the 'forked tongue of a snake', or 'javelin' ('dart' conveys the sense well enough). The eroticism of these objects is actually a complex affair, implicating the spectator unexpectedly in ambiguous specular as well as physical engagement.

Coin de chasteté (1954), resembling a tooth rather than any of the more erotically defined parts of the body in the other two objects, has the quality of the 'Surrealist object functioning symbolically', an object that implies movement and is capable of arousing an erotic *frisson*. Made of plaster and pink dental plastic, it was Duchamp's present for Teeny Matisse on their wedding in 1954. The idea of the matrix, in the sense of the plaster mould for a metal stamp, hovers behind the visible analogy with the tooth, and its 'infra-thin' relation to the gum. Mouth and teeth have long been associated with sexual anxiety rather than pleasure, from the idea of the *vagina dentata*, the fearsome toothed hole created by male sexual fears, to the idea that loss of teeth could symbolize (in dreams, for instance) castration or impotence. Notoriously sceptical of psychoanalysis, Duchamp is most unlikely deliberately to have conferred such symbolic intentions on this object in the way that Dalí did with his Freudian fangs and jugs. Indeed, the gesture of removal and insertion implied in this two-part piece remains loosely suggestive, like Breton's favourite unconsciously Surrealist object 'functioning symbolically', the gold-leaf electro-scope that springs apart when a rubbed rod is brought near to it.

145

147

148

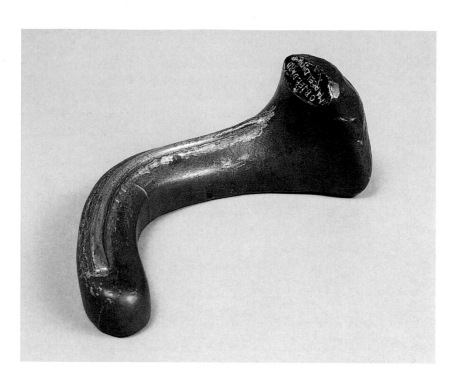

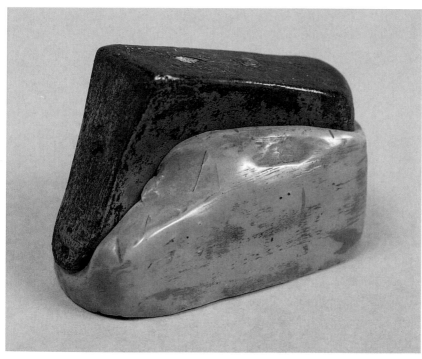

Casts of fragments of the body have their lugubrious side, and one of the other objects of this period is the 'death-mask' self-portrait *With My Tongue in My Cheek* (1959), which is, or purports to be, a cast of part of Duchamp's face. The plaster cast is mounted on a wooden wedge, and 'completed' by the careful drawing of the profile with an open eye – something that could not actually be cast, as the subject was alive. The fragment thus paradoxically asserts the living – if dumb – status of the original. It is not in fact a death mask, despite its deathly appearance and fossilized look. Like all plaster casts of the body, the aura of death hangs over it, in part because of the absence of colour – exact as the copy must be, it lacks this evidence of life.

with my tongue in my cheek marcel Duchamp 59

189

Chapter 9: Etant donnés

After Duchamp's death in October 1968 the existence of his last major work, *Etant donnés: 1. La chute d'eau 2. Le gaz d'éclairage (Given: 1. The Waterfall 2. The Illuminating Gas)* was revealed. He had worked on it in total secrecy, with only Teeny and later William Copley as accomplices. As with the *Large Glass*, this work has a 'kind of subtitle': 'Collapsible mock-up made between 1946 and 1966 in New York with scope for ad-libbing during assembly and disassembly' (*Approximation démontable, exécutée entre 1946 et 1966 à N.Y. Par approximation j'entends une marge d'ad libitum dans le démontage et remontage*).

Duchamp had assembled it slowly over twenty years, first in his Fourteenth Street studio in New York and then in a small rented room on Eleventh Street. According to Duchamp's wishes, and with the help of his instruction manual, *Etant donnés* was installed in 1969 in the Philadelphia Museum of Art, where it joined the *Large Glass*, *Bride* and other important works. Complementary and opposite to the *Large Glass*, the two works have shared sources in the notes.

Etant donnés suddenly gave a focus to the casts and other objects that had been produced sporadically during its construction, some of which now took on greater meaning, like the small leather nude mounted on velvet, *Le Gaz d'éclairage et la chute d'eau (The Illuminating Gas and the Waterfall)* of 1948–49. This leather nude is a study for *Etant donnés*. A drawing now in the collection of the Moderna Museet, Stockholm, entitled *Etant donnés: Maria, la chute d'eau et le gaz d'éclairage (Given: Maria, the Waterfall and the Illuminating Gas)* of 1947, confirms the identity of the model as the Brazilian sculptor Maria Martins.

While the *Large Glass* is free-standing ('sculptural') but two-dimensional – it can be seen through and walked around, although the lower section uses a one-point perspective system that implies a 'place to stand', *Etant donnés* is three-dimensional but can never be seen (or photographed) as a whole. In a bare room, a dead end in the Philadelphia Museum of Art, beyond the *Large Glass*, is a large wooden door set in a brick arch. There is no visible means of opening the door, but two small holes at eye level invite closer inspection.

150. (opposite) The wooden door in *Etant donnés: 1. La chute d'eau 2. Le gaz d'éclairage (Given: 1. The Waterfall 2. The Illuminating Gas)*, 1946–66.

What is seen through the holes is startling and unexpected. Beyond a dark space and a jagged hole in a brick wall is a brilliantly lit landscape with, in the foreground, the 'real' figure of a woman, prone, naked, legs splayed to the spectator. In her raised left arm she holds a small gas lamp, faintly glowing, which resembles one of the drawings for the *Pendu femelle (Female Hanged Body)*. Rather than the two-dimensional images on the *Large Glass*, this is three-dimensional: palpable things in real spaces, solid, tangible. Except that it can never be touched, not because of any constraints imposed by the museum, but because it is separated from the spectator by the impenetrable barrier of the door, and moreover, can only ever be seen from one viewpoint. Although it is (mostly) three-dimensional, which in theory invites viewing from more than one position, this is in practice ruled out. A comparable but opposite set of promises and illusions conditions the physical presence and spectators' responses to the two works.

To retreat again to the first thing one sees, the door. This old wooden door, found in Spain and shipped back to New York, is heavily studded with nails, but lacks a handle. It might once have had a small peephole covered with a metal grill, typical of such doors, up in the right corner, but this has been boarded over. There is no means of telling whether we are looking at the inside or outside of the door, whether, in other words, we are excluded or enclosed. The two small holes, allowing natural bifocal looking rather than the single viewpoint that would be allowed by a keyhole, give visual access on to further openings. The rough hole in a brick wall is separated from the door by a short, dark passage (lined in black velvet), through which the nude is seen lying on a bed of twigs. Her head is hidden by the edge of the brick wall, and the spectator's first instinct is to shift position to try, in vain, to see the whole figure. The spatial depth and the materiality of the scene are difficult to determine with any precision. The body lies on real twigs, but the landscape background must be two-dimensional, although the point at which they meet is masked. The landscape consists of a manipulated photograph taken while Duchamp was on holiday in 1946 at Chexbres, on Lake Léman in Switzerland, near a mill where a waterfall flowed on the right. The waterfall appears to run down a mossy grotto in a cypress-dotted hill, like an Italian garden, visibly catching the light and glinting as it 'moves'. A light mist seems to rise from the water, and the gas lamp held aloft in the nude's hand appears to be the source of light.

150

♛ ♛ ♛

152. (opposite) *Le Gaz d'éclairage et la chute d'eau (The Illuminating Gas and the Waterfall)*, 1948–49

153. (below left) *Etant donnés: Maria, la chute d'eau et le gaz d'éclairage (Given: Maria, the Waterfall and the Illuminating Gas)*, 1947

154. (below right) Note from *The Green Box*.

Since the installation of *Etant donnés*, the technical manual 155–57 Duchamp prepared as a guide has been published. It contains photographs of the installation and materials at various stages of construction. While it consists largely of precise instructions, it is more than a mere handbook for installation, not least in its views 'behind the scenes' and of those elements integral to its conception but not visible in its finished state.

Behind the scenes there is a tangle of roughly connected wires; the waterfall is created using a lamp and an aluminium disk with holes that rotates inside a biscuit tin; the clouds are made out of cotton wool. Hidden entirely is a chequered black-and-white floor, reminiscent of Dutch interiors and of chessboards. The nude was to be placed exactly on the table support 'at the 3 points of impact' – a detail that recalls the significance of number in the *Large Glass*, especially 3 and its multiple 9. The nude herself consists of plaster sections supported on wooden batons, covered, like the earlier study for *Etant donnés – The Illuminating Gas and the Waterfall –* with leather. The velvety, pink texture brings it to life in a way that a plaster cast alone could never achieve.

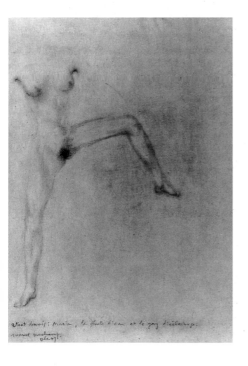

155, 156, 157.
(this and next four pages)
Pages from Duchamp's installation manual for *Etant donnés* (1946–66). The ring binder containing Duchamp's instructions for reassembling his 'room' was published in 1987: the terms of the agreement whereby the Philadelphia Museum of Art acquired the work had forbidden the publication of any photographs of the interior of the construction or of the manual for fifteen years. The instructions for the *Approximation démontable*, or collapsible mock-up, as Duchamp subtitled *Etant donnés*, include notes, diagrams, annotated photographs of the work at different stages of its construction and a cardboard model to scale. The manual is basically a practical guide, offering no explanations, but it not only reveals in raw detail the rather ramshackle arrangements but also supplements in unexpected ways its mysterious subject. The chequered floor, for example, is invisible in the finished work, and harks back to the theme of chess in Duchamp's early paintings, which saw the emergence of the 'Queen' and 'King' and then the Bride and the Bachelors as erotic principals. Enigmatic photographs of Teeny and Marcel bending over the nude are probably intended to demonstrate how she is to be lifted: in the instruction for the eleventh of the fifteen 'operations' for the reassemblage Duchamp writes that it is best 'to *be two* in order delicately to lift the nude and place it *exactly* at the 3 points of impact'. There are echoes of the 'operations' in the earlier notes relating to the *Large Glass*, their aura of technological ritual now rendered human.

Vue générale
plus complète

At one stage in its construction Duchamp laboriously removed the pigskin that had been glued to the plaster maquette to paint the exact skin tone he required on the inside surface. The black cloth-lined passage is reminiscent of the old plate-cameras that required the photographer to cover his head and the back of the camera with a black hood to exclude the light.

The position of the spectator looking through a fixed viewing-hole into a room also recalls illustrations in seventeenth-century treatises on perspective, though in making two holes through his door Duchamp creates a 'stereoscopic' view.

Pages 46 and 47.

les droites verdicales sont paralleles fonte la peinture

Blanc bois sapé, frottement à terre du mur

Blanc Loose

65 ↓ sol.

White Shade (plastic) up. (frosted up

White Shade (plastic) down

Everything points to the presence here of the Bride of the *Large Glass*, now manifest as a traditional nude (although the French philosopher Jean-François Lyotard has argued that the nude bulges suspiciously in the groin and suggests an androgynous, male-female identity). The 'Italianate' setting (although based on a scene in the Swiss lakes) invites comparison with the great tradition of the female nude of Giorgione and Titian; the painted icon is replaced with the very symbol of beauty, palpable but unreachable. The natural setting distinguishes her from the more urban, social settings of the modern nudes, Manet's *Olympia* (1863) or Picasso's *Les Demoiselles d'Avignon* (1907).

Yet the nude in *Etant donnés* transgresses the polite convention of the reclining nude, body aligned parallel to the picture plane. Her body is swivelled so that the legs extend towards the spectator and the genital area is exposed, although her face is hidden. It is as though Duchamp was taking literally the viewpoint of Dürer's artist making a perspective drawing of a female figure through a squared glass screen. The figure is shown from the side, with her body parallel to the picture plane, which is how she is being depicted by the artist, although Dürer shows him positioned as though looking at her end on. In *Etant donnés*, it is the artist's view that is logically shown by Duchamp.

Taken in isolation, the posture of Duchamp's nude recalls Courbet's notorious painting *Origine du monde* (1866). Maxime Ducamp's memorable reaction, in *Les Convulsions de Paris* (1878), to seeing this painting, normally kept hidden behind a green veil, registers a double shock:

I stood astonished at seeing a woman naked, from the front, extraordinarily moved and convulsed, remarkably painted, reproduced con amore, as the Italians say, the last word in realism. But by an inconceivable oversight, the artisan, who had copied his model from nature, had neglected to represent the feet, the legs, the thighs...the chest, the hands, the arms, the shoulders, the neck and the head. There is a word that describes people capable of this kind of filth, worthy of illustrating the works of the Marquis de Sade, but I can't use this word before the reader, because it is only used in butchers' shops.

There is also a striking similarity to Hans Bellmer's *Doll* (1938); photographs showing different versions of his female doll, 'Variations sur le montage d'une mineure articulée', fragmented and sometimes headless, were included in the same issue of the Surrealist journal *Minotaure* that printed Breton's essay on the *Large Glass*, 'Lighthouse of the Bride'. One photograph not

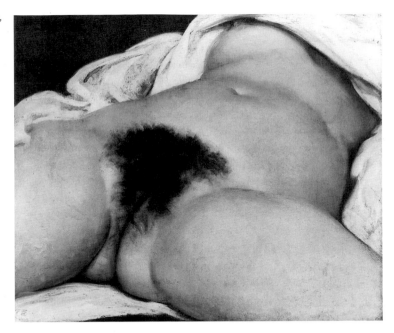

158. **Gustave Courbet,**
Origine du monde,
1866

159. **Hans Bellmer,**
La Poupée (Doll), 1938

included in *Minotaure* shows the doll prone on a bed of twigs. Such comparisons suggest that the splayed and truncated nude in *Etant donnés* had been subjected to some kind of violence. An alternative interpretation proposes a detached attitude on Duchamp's part, a kind of exploratory medical gaze that invites associations with anatomical models of the naked body that have removable parts to reveal the organs.

However, a close examination of the work discounts such a reading. Although her face is invisible, it appears not so much missing, the nude headless, as hidden partly by her blonde hair and partly by the wall. Furthermore, she is not wholly passive, holding up the phallic gas light in a posture that suggests the 'blossoming' Bride who 'has reached the goal of her desire'.

The combination of this light and the heavy wooden door makes a completely different link, one that forms a parallel to the religious connotations of the *Large Glass* and the blasphemous (as Duchamp admitted) association between the 'stripping bare' of the Bride and Christ. It recalls an image by Holman Hunt in *Light of the World* (1851–53), in which Christ stands holding a lamp before a closed door, symbolizing presumably an unawakened soul. Another possibility is the biblical parable of the wise virgin, who kept her lamp trimmed in readiness. These are fleeting echoes, but point to the potential for an allegorical reading and remind us of the perennial ambiguity of the nude, its capacity to bear other meanings besides sex: the alchemical prime matter, truth, ideal beauty, wisdom. Her very setting – out in the bright light, while the spectator is hidden in the shadow – her remoteness and distance endow her with an aura that has connections with both Benjamin's notion of the lost aura once possessed by the work of art and the idea of a unique guiding love, like Dante's Beatrice.

If she is the Bride nude (whether remote, satisfied, violated or even dead) we, as the spectators, take up the position of the Oculist Witnesses from the lower section of the *Large Glass*, a peeping tom peering through a (stereoscopic) keyhole. However, only one spectator can ever see this work at a time, an almost brutal enforcement or possibly parody of the private nature of looking at art. The experience of viewing *Etant donnés* is unique; no technical device can substitute for the physical encounter of the eyes with the holes in the door. It is literally impossible to photo-graph all of *Etant donnés* – the outside and the inside – at one time. It exists as a whole, but the viewing of it is a sequence, an action. Through two holes, we look through another on to yet another.

In his lecture 'The Creative Act' given in Houston in 1957, Duchamp made his most complete a-aesthetic statement about art: 'Art may be bad, good or indifferent, but, whatever adjective is used, we must call it art, and bad art is still art in the same way as a bad emotion is still an emotion.' There are two poles to the creative act – the artist and the spectator. The artist 'goes from intention to realization through a chain of totally subjective reactions. His struggle toward the realization is a series of efforts, pains, satisfactions, refusals, decisions, which also cannot and must not be fully self-conscious, at least on the esthetic plane.' Duchamp strikes at the heart of the modernist idea about the self-sufficiency of the work of art, its immutable and independent quality, in his ideas about the spectator, who, for him, is the other pole of the creation of art. There is a gap in the chain of reactions accompanying the creative act, a difference he calls the 'personal art coefficient', 'an arithmetical relation between the unexpressed but intended and the unintentionally expressed'. This 'art coefficient' cannot be determined in advance, but 'must be "refined" as pure sugar from molasses, by the spectator'. Duchamp thus dismisses the Expressionist fallacy, and then uses a double alchemical/Catholic metaphor to describe the process: 'The spectator experiences the phenomenon of transmutation; through the change from inert matter into a work of art, an actual transubstantiation has taken place.' The key point Duchamp is making is that the work of art cannot exist without the spectator: 'All in all, the creative act is not performed by the artist alone; the spectator brings the work in contact with the external world by deciphering and interpreting its inner qualifications and thus adds his contribution to the creative act.' From the readymades to *Etant donnés*, this idea, abnegation even, has been a constant feature of his work. In *Etant donnés* it reaches its most complete, physical manifestation. Rather than indifference to his own works, Duchamp's detachment, or self-effacement as an artist, is built upon this faith, for 'posterity...sometimes rehabilitates forgotten artists'.

Postscript: Duchamp after Duchamp

Delay and ephemerality have governed both the production and the reputation of Duchamp's work. From *The Bride Stripped Bare by Her Bachelors, Even* (the *Large Glass*), which he described as a 'delay in glass', to the 'collapsible mock-up' *Etant donnés*, whose unveiling was delayed until 7 July 1969, nine months after his death, Duchamp eschewed immediate recognition in theory and in practice.

Ephemerality was built into the readymades, and their fragile presence between work of art and utilitarian object led to the unwitting consignment of *Bottle Dryer* and *Bicycle Wheel* to the garbage, like any other obsolete household utensil. Many other works came into existence by chance or to satisfy momentary sensations, like *Paysage fautif (Wayward Landscape)* of 1946, made of human semen on black cloth. The sense of a fugitive idea or effect is compelling in many of the works that have survived, their very modesty, physically, at odds with their fame. The significance of an artist's work, too, Duchamp held to be ephemeral: a work of art, he said, had a life of about forty years, after which it became art history.

That he was as ill at ease with this aspect of art, as he was with purely retinal pleasure, repetitive production for a market, or simple reliance on personal expression might be indicated by his own arrangements for posterity. Here his legendary indifference finds its natural and paradoxical opposite: no artist can know his posthumous reputation or be guaranteed its longevity. To leave his last major work undisclosed during his lifetime suggests that Duchamp was at least raising the possibility of contradicting his own maxim or extending its life for a period beyond his own.

The ramifications of this final work – and of the *Boîte* – are all the more poignant in the light of Duchamp's growing influence and reputation during the 1950s and 1960s. His legendary silence

and apparent inactivity, as well as his actual works, had an impact on a new generation of artists, art historians and critics. His ideas and the works themselves were becoming physically more accessible. For example, the *Large Glass* was bequeathed to the Philadelphia Museum of Art in 1953, Robert Lebel's album *Sur Marcel Duchamp* appeared in 1959 and the 'typographic version' of *The Green Box* by the British artist Richard Hamilton in English in 1960. Hamilton also organized a major retrospective at the Tate Gallery in London in 1966 with the unconsciously prophetic title 'The Almost Complete Works of Marcel Duchamp'; for this exhibition he constructed a replica of the *Large Glass*, which Duchamp signed, as was his habit for replicas made by others of his work: *pour copie conforme Marcel Duchamp*. An earlier replica was made by Ulf Linde for the 'Art in Motion' exhibition held at the Moderna Museet in Stockholm in 1961 and two others exist: Tokyo (1980) and Stockholm (1991–92). Walter Hopps's 1963 retrospective at Pasadena, California, 'By or of Marcel Duchamp or Rrose Sélavy' emphasized his 'recent activity' and showed the original galvanized plaster as well as the bronze casts of the erotic objects (the latter lent by Jasper Johns).

A special issue of the Surrealist-orientated journal *View* in New York in 1945, with illustrations of his work, including the *Large Glass*, had underlined his relevance both to an abstracted human morphology and to the kind of science fiction space popularized by Roberto Matta (b. 1912), whose *Grands Transparents*, beings in space of which we cannot be aware, had illustrated Breton's 'Prolegomena to a Third Surrealist Manifesto or Not' (1942). Although painters like Matta and Arshile Gorky (1904–48), on the fringe of Abstract Expressionism and Surrealism, refer specifically to Duchamp's earlier paintings, his conceptual and anti-retinal attitudes had a longer-lasting impact. Duchamp's *Paysage fautif* could be seen as satirizing the emphasis on 'retinal', painterly values and the vaunted virility of the Abstract Expressionist painters.

During this period Duchamp lived an 'underground' existence in New York, but his example was of particular significance for artists like Robert Rauschenberg (b. 1925) and Jasper Johns (b. 1930) who flouted the Modernist aesthetic being developed in this period by Clement Greenberg (1909–94), one of the main advocates of Abstract Expressionism. While Greenberg argued that the different arts (painting and sculpture) should limit themselves to their 'separate areas of competence' – which meant, in American painting, the refinement of the purely optical abstract

language of Jackson Pollock (1912–56) and Barnett Newman (1905–70) – Rauschenberg blithely confused artistic idioms in his 'combine paintings' like *Bed* (1955), and parodied the Abstract Expressionists' brushwork in slapdash fashion. A proto-happening collaboration involving the composer John Cage (1912–92), a friend of Duchamp's since 1942, and Rauschenberg at Black Mountain College in North Carolina in 1952 featured the latter's all-white paintings, described by Cage as 'airports for the lights, shadows and particles', which hung from the ceiling. Like Cage's *4'33"*, also of 1952, which consisted of three 'silent' movements in which noises off constituted the music, these paintings suppressed the expressive role of the artist, as well as involving eastern philosophies like Taoism and Zen.

Jasper Johns was similarly disenchanted with Abstract Expressionism and even more intrigued by the conceptual and formal intricacies of Duchamp's work. The subtleties of ready-mades, casts and moulds in particular prompted Johns's *Painted Bronze* (1960) and *Target with Plaster Casts* (1955), which cryptically alludes to the Oculist Witnesses and the shots of the Bachelors – a visual pun on the targeting of the spectator's vision as he or she contemplates the work. What Duchamp had helped open up, as Rauschenberg put it, was the fertile gap 'between art and life'.

These were also the grounds on which Greenberg's critical ally Michael Fried made a famous attack on the 'theatrical' tendency in modern art. Fried argued that art based on the relationship between spectator and work of art was flawed because it denied the self-sufficiency of the art-object and appropriate forms of aesthetic response. After Duchamp, the floodgates were opened for a wave of so-called 'theatricality' in post-war art in America and elsewhere; its forms including Fluxus, Arte Povera, Minimalism, Conceptualism, Performance and Land Art. Points of contact with Duchamp may be traced between works as diverse as the *Metered Bulb* (1963) by the Minimalist artist Robert Morris (b. 1931), which deals with the life-span of a work of art, or Piero Manzoni's *Artist's Shit* (1961). Duchamp's output generated a plethora of responses from male artists: a progeny of 'Bachelors'. However, as women gained increasing representation in the art world from the 1960s onwards, they too entered into dialogue with him. Eva Hesse (1936–70) in America was one of the first. Her 'rope pieces' of 1969–70 turned Jackson Pollock's painterly webs into three-dimensional terms, following up the implications of Duchamp's *Sculpture for Travelling*. More recently, the American

160. (above) **Robert Rauschenberg**, *Bed*, 1955

161. (right) **Jasper Johns**,
Target with Plaster Casts, 1955

162. (below) **Eva Hesse**,
Right After, 1969

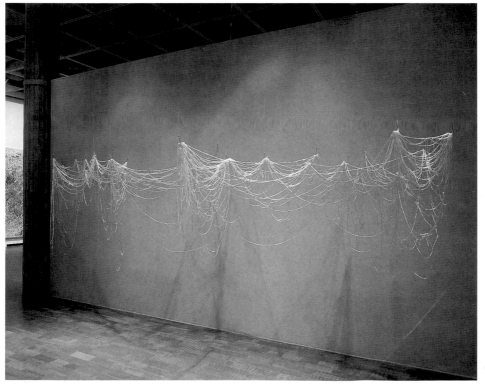

artist Sherrie Levine (b. 1947) produced a shiny bronze version of *Fountain*, turning it from a 'male' into a 'female' object, whilst the British artist Helen Chadwick (1953–96) responded both to *Fountain* and to Duchamp's idea of 'infra-thin' with her pristine *Piss Flowers* (1991–92). Alluding to the Duchampian tradition of body casting, these consisted of positive casts obtained from the indentations produced when she and her male partner urinated in the snow. She produced the phallic stamens, he the surrounding petals.

Duchamp's refusal to follow the conventional professional artistic career with regular selling exhibitions and a dealer was understood from early on as part of a radical critique of artistic institutions, and he was linked not only with Dada but also with the revolutionary nihilism of Kasimir Malevich (1878–1935), and the Russian Constructivists of the early 1920s. These various artistic practices have been contrasted with the post-war American avant-garde movements – Pop Art, Neo-Dada etc. – which have been seen by radical critics like Peter Bürger as vapid and counterfeit, cashing in on, rather than attacking, the commercial and institutional consumption of modern art.

In November 1964, the German sculptor Joseph Beuys (1921– 86) expressed irritation at Duchamp's silence, in his televized 'Action': *The Silence of Marcel Duchamp is Overrated*. Yet Beuys's annoyance at Duchamp's failure to act on the social and political consequences of his works, especially the readymades,

misfired in the sense that Duchamp's 'silence' was rendered even more potent by the statement. Duchamp was largely content to sit back and let others realize the consequence of his output.

Duchamp's significance within these various tendencies was acknowledged (and resisted), and by the end of the 1960s artists were increasingly concentrating on his ideas. In 1969 the conceptual artist Joseph Kosuth (b. 1945) declared, in his text *Art After Philosophy and After*, that 'all art (after Duchamp) is conceptual (in nature) because art only exists conceptually'. Sol LeWitt (b. 1928) asserted in his famous essay in *Artforum* in 1967 that 'the idea becomes a machine that makes the work of art'.

In the early 1960s Andy Warhol (1928–87) decided to function as a 'machine' and mass-produce his readymade media imagery via silkscreen reproduction in his 'Factory'. Although it is difficult to envisage his 1962 *Dollar Bill* silkscreens without the precedent of the *Tzanck Cheque*, the link is not so much an aesthetic of mass-production, but the acceptance of art's inextricable links with capital.

However, not all artists working within the 'expanded' aesthetic arena for which he was partly responsible accepted what they conceived as Duchamp's position. Two left-wing American artists levelled a powerful critique at him in the late 1960s. Carl Andre (b. 1935), whose Minimalist works used readymade, standardized units to produce 'materialist' non-hierarchical structures, employed a Marxist-derived vocabulary to accuse Duchamp of 'nothing but the substitution of exchange value for production value in art'. The Land Artist Robert Smithson (1928–73) argued in *Artforum* in October 1973 that 'Duchamp offers a sanctification for alienated objects.... It is a complete denial of the work process and it is very mechanical too'. In the light of subsequent work, such well-intentioned arguments seem to have missed the point. Andre's bricks become icons of exchange value just as surely as any of the contemporaneous 'Pop' works he disdained. As ever, Duchamp seems to have been one step ahead, his readymades still relevant in an art world where the alienation of the conscience-stricken modernist gave way to the resigned acceptance that artistic insights and ideals soon become 'readymade' (and vice versa).

Duchamp's visible and invisible influence on art's direction is a tale of presence and absence. If the first half of the twentieth century was dominated by Picasso and Matisse, the second half has been haunted by Duchamp. Indeed, the full consequences of his work and his attitudes may still be undergoing a 'delay'.

WANTED

$2,000 REWARD

For information leading to the arrest of George W. Welch, alias Bull, alias Pickens. etcetry, etcetry. Operated Bucket Shop in New York under name HOOKE, LYON and CINQUER. Height about 5 feet 9 inches. Weight about 180 pounds. Complexion medium, eyes same. Known also under name RROSE SÉLAVY

164. *Wanted: $2000 Reward*, 1923

Chronology

1887
Born at Blainville-Crevon, Normandy, France (28 July)

1902
Begins to paint

1904
Graduates from the Ecole Bossuet, Rouen. Moves to Paris to join older brothers; studies art sporadically at the Académie Julian

1905
Fails exam at the Ecole des Beaux-Arts. Starts one year of military service (October)

1906
Returns to Paris

1907
Exhibits five caricatures at the Salon des Artistes Humoristes, Paris

1908
Shows three works at the Salon d'Automne, Paris. Cartoon reproduced in *Le Courrier français* (November)

1909
Exhibits two works at the Salon des Indépendants, Paris. Frequents his brothers' house in Puteaux, where the new scientific, philosophical and artistic ideas are discussed. Three works in the Salon d'Automne

1910
Apollinaire describes Duchamp's nudes at the Salon des Indépendants as 'very ugly'. Relationship with artist's model Jeanne Serre. Five works in the Salon d'Automne

1911
Three paintings in the Salon des Indépendants, the exhibition that launched Cubism as a movement. Birth of daughter, Yvonne Serre (February). Exhibits two works with the Salon d'Automne Cubists

1912
Withdraws *Nude Descending a Staircase, No. 2* from the Cubist room of the Salon des Indépendants after a disagreement about its title with the leader of the Cubists, Albert Gleizes (March). Attends performance of Raymond Roussel's play *Impressions d'Afrique*. Spends summer in Munich, where he conceives the idea for *The Bride Stripped Bare by the Bachelors*. Paints *Bride* and other bizarre abstract works. Returns to Paris via Prague, Vienna, Dresden and Berlin. In October takes a memorable trip to the Jura Mountains with Picabia, Gabrielle Buffet-Picabia and Apollinaire. Disgusted with the Paris art scene, he abandons a career as a professional avant-garde painter

1913
Takes a job as a librarian at the Bibliothèque Sainte-Geneviève. *Nude Descending a Staircase, No. 2* is exhibited at the Armory Show in New York and becomes the centre of debate about modern art. Creates what he later dubs a 'readymade' – *Bicycle Wheel* – in his Neuilly studio

1914
Publishes the first 'edition' of his notes, *The Box of 1914*

1915
Sails for New York. Starts work on the *Large Glass*

1917
Fountain scandal in New York

1918
Moves to Buenos Aires when the United States enters the First World War. Death of his brother Raymond Duchamp-Villon

1919
Returns to Paris via London (end of July). Meets Jeanne Serre and is told that he is the father of Yvonne. Makes contact with Paris Dada group

1920
Returns to New York (January). Invents his female alter ego Rose (later Rrose) Sélavy. With Katherine Dreier and May Ray founds 'Société Anonyme: Museum of Modern Art' to promote and collect modern art. (The collection now belongs to Yale University.) First experiments with optical constructions

1921
With Man Ray, edits and publishes a single issue of *New York Dada* (April). Refuses to exhibit at the Salon Dada, Paris (June). Returns to Paris and introduces Man Ray to Paris Dada; continues his film experiments with moving optical devices

1922
Sails for New York (28 January).

In Paris, Robert Desnos publishes puns 'received' from Rrose Sélavy in *Littérature* and Breton publishes the first major essay on Duchamp

1923
Leaves the *Large Glass* 'definitively unfinished'. Returns to Paris. Becomes a close friend of Brancusi, for whom he subsequently acts as an agent. Relationship with Mary Reynolds. Starts serious career as chess player

1924
Comes tenth in the Second French Chess Championships at Strasbourg. Works on roulette system at Monte Carlo

1926
Accompanies Katherine Dreier to Italy (May). Sails for New York (13 October), acting as a courier for Brancusi sculptures. The *Large Glass* shown for the first time at the International Exhibition of Modern Art, Brooklyn Museum, organized by the Société Anonyme (19 November–9 January 1927)

1927
Both panes of the *Large Glass* shattered in return transit, but crate not opened until several years later. Returns to France (February). Marries wealthy Lydie Sarrazin-Levassor (8 June). Increasingly occupied with chess

1928
Divorces Lydie Sarrazin-Levassor (1 January)

1930
Member of French team at Third Chess Olympiad, Hamburg (July)

1932
With Vitaly Halberstadt, publishes book on endgames in chess, *L'Opposition et les cases conjuguées sont reconciliées* (June). Wins Paris chess tournament (August)

1933
Last important chess tournament at Folkestone (June). Resolves to emigrate after Nazis close Bauhaus. Sails for New York to organize a Brancusi exhibition at the Brummer Gallery (October)

1934
Leaves New York for Paris (20 January). Publication of *The Green Box* notes (edition of 300)

1935
Begins to plan an album of 'approximately' all his work, which becomes the *Boîte-en-valise*

1936
Returns to New York to prepare material for the *Boîte-en-valise* and to restore the *Large Glass*

1937
First one-man show at the Arts Club of Chicago. Designs glass door for Breton's Galerie Gradiva, Paris

1938
Co-organizes 'Exposition Internationale du Surréalisme' at the Galerie Beaux-Arts, Paris. Leaves on day of opening for London to prepare the summer exhibition of contemporary sculpture for Peggy Guggenheim's gallery (Guggenheim Jeune)

1941
Travels between German-occupied Paris and the 'free zone' in the South of France, moving the contents of the *Boîte* to Marseilles

1942
Sails for New York from Marseilles (May). Co-organizes the 'First Papers of Surrealism' exhibition. Joseph Cornell starts to help with the assemblage of the *Boîtes-en-valise*

1943
The *Large Glass* on view at the Museum of Modern Art, New York, until 1946. Editorial advisor for Surrealist journal *VVV*.

1945
Duchamp brothers' exhibition at Yale University Art Gallery. Installs show windows at Brentano's (5th Avenue) for Breton's *Arcane 17* and *Surrealism and Painting*. Special edition of *View* (March) devoted to Duchamp

1946
Begins affair with Maria Martins, sculptor and wife of the Brazilian ambassador to the United States. Starts work in secret on *Etant donnés* in his 14th Street studio. Visits Paris to help design catalogue and installation for the exhibition 'Le Surréalisme en 1947'

1947
Sails for New York before the opening (13 January)

1950
Death of Mary Reynolds

1951
Robert Motherwell publishes important anthology *Dada Painters and Poets*, with advice and contributions from Duchamp

1954
Marries Alexina (Teeny) Sattler, formerly married to Pierre Matisse (16 January). Acquires three step-children: Paul, Jacqueline and Peter. Arensberg Collection goes on permanent display in the Philadelphia Museum of Art; it contains forty-three works by Duchamp, including the *Large Glass* and *Bride*. Sails for Paris (5 November)

1955
Returns to New York (January). Becomes US citizen

1957
Major joint exhibition of Duchamp brothers at Guggenheim Museum, New York

1958
Starts to spend summer holidays at Cadaques, where Dalí has a house

1959
Robert Lebel publishes major study, *Sur Marcel Duchamp*. Publication of Michel Sanouillet's anthology of Duchamp's writings, *Marchand du Sel, Ecrits de Marcel Duchamp*. Moves to apartment at 28 West 10th Street, New York, where he and Teeny live until his death

1960
Publication of typographic translation of *The Green Box* by George Heard Hamilton and Richard Hamilton

1963
Deaths of brother Jacques Villon and sister Suzanne Crotti. First major retrospective, organized by Walter Hopps at the Pasadena Art Museum (October–November)

1964
After holidaying in Europe, he returns to New York. Forced to vacate 14th Street studio, he moves the nearly completed *Etant donnés* to a room at 80 East 11th Street

1966
Attends major exhibition in London, 'The Almost Complete Works of

Marcel Duchamp', organized by the artist Richard Hamilton. Establishes friendship with daughter in Paris, now an artist working under the name Yo Sermayer. Completes and signs *Etant donnés*

1967
Publication of a new set of notes, *A l'Infinitif*. Publication of Pierre Cabanne's *Entretiens avec Marcel Duchamp* (translated into English as *Dialogues with Marcel Duchamp* in 1971). Returns to New York (October)

1968
Works on handmade anaglyph of the fireplace and chimney he had constructed at the Duchamps' summer apartment at Cadaques. Orders Spanish bricks for the *Etant donnés* installation. Dies suddenly at his Neuilly apartment (1 October), after a dinner with his friends Robert Lebel and Man and Juliet Ray, at which he talks of his delight at the new edition of Alphonse Allais: 'ante-humous works only, though, not posthumous'. After his death, the existence of *Etant donnés* is made public. His gravestone in Rouen reads: 'D'ailleurs, c'est toujours les autres qui meurent'

Bibliography and Sources

Major sources consulted throughout and referred to in abbreviated form in the narrative bibliographies for individual chapters:

Catalogues and catalogues raisonnés

Bonk, Ecke, *Marcel Duchamp: The Portable Museum*, translated by David Britt, 1989 [Bonk]

Clair, Jean (ed.), *Marcel Duchamp*, 4 vols., exh. cat., Musée National d'Art Moderne, Centre National d'Art et Culture Georges Pompidou, Paris, 1977 [*Duchamp*, 1977]

Hamilton, Richard, *The Almost Complete Works of Marcel Duchamp*, exh. cat., Tate Gallery, 1966

d'Harnoncourt, Anne, and Kynaston McShine (eds.), *Marcel Duchamp*, exh. cat., Philadelphia Museum of Art, 1973 [*Duchamp*, 1973]

Marcel Duchamp, exh. cat., Palazzo Grassi, Venice, 1993 (contains a full listing of Duchamp's writings, interviews, letters and books or articles devoted to him up to 1968)

Schwarz, Arturo, *The Complete Works of Marcel Duchamp*, 1997 [Schwarz, 1997]

Collections of Duchamp's notes

Duchamp, Marcel, *A l'Infinitif (The White Box)*, translated by Cleve Gray, 1967

Hamilton, Richard, *The Bride Stripped Bare by Her Bachelors, Even*, a typographic version of Marcel Duchamp's *Green Box*, translated by George Heard Hamilton, 1960 [*Green Box*]

Matisse, Paul (ed.), *Marcel Duchamp: Notes* (facsimile edition), 1980 [*Notes*, 1980]

Sanouillet, Michel, and Elmer Peterson (eds.), *The Essential Writings of Marcel Duchamp*, translated by Elmer Peterson, 1975 (first published as *Salt Seller: The Writings of Marcel Duchamp*, 1973) [*Writings*, 1975]

Schwarz, Arturo (ed.), *Notes and Projects for the Large Glass*, 1969

Interviews and lectures

Cabanne, Pierre, *Entretiens Avec Marcel Duchamp*, 1967; translated by Ron Padgett as *Dialogues with Marcel Duchamp*, 1971 [Cabanne]

Duchamp, Marcel, 'Apropos of Readymades', talk given at the Museum of Modern Art, New York, on 19 October 1961; published in *Art and Artists*, vol. 1, no. 4, July 1966 (special issue on Duchamp with many other important texts) and in *Writings*, 1975

Duchamp, Marcel, 'Apropos of Myself', lecture delivered at the City Art Museum of St Louis, Missouri, on 24 November 1964; quoted in *Duchamp*, 1973

Hill, Anthony (ed.), *Duchamp: Passim, a Marcel Duchamp Anthology*, 1994; contains several interviews and lectures, including the 1959 BBC interview with George Heard Hamilton

Roberts, Francis, 'I Propose to Strain the Laws of Physics', 1963, interview with Marcel Duchamp, *Art News*, vol. 67, no. 8, December 1968

Biographical and critical studies

Breton, André, 'Lighthouse of the Bride', *Minotaure*, no 6, winter 1935, translated by Simon Watson Taylor in André Breton, *Surrealism and Painting*, 1972, and in the special issue of *View* dedicated to Duchamp, March 1945

Joseph Cornell/Marcel Duchamp... in Resonance, exh. cat., Menil Collection, Houston, Philadelphia Museum of Art, 1998

Duve, Thierry de (ed.), *The Definitively Unfinished Marcel Duchamp*, 1991

Golding, John, *Marcel Duchamp: The Bride Stripped Bare by Her Bachelors, Even*, 1973 [Golding, 1973]

Gough-Cooper, Jennifer, and Jacques Caumont, 'Ephemerides on and about Marcel Duchamp and Rrose Sélavy 1887–1968' in *Marcel Duchamp: Works and Life*, 1993 ['Ephemerides']

Kuenzli, Rudolf, and Francis Naumann (eds.), *Marcel Duchamp: Artist of this Century*, 1989

Lebel, Robert, *Marcel Duchamp*, 1985

Paz, Octavio, *Marcel Duchamp, or the Castle of Purity*, translated by Donald Gardner, 1970

Tomkins, Calvin, *Marcel Duchamp: A Biography*, 1996

Chapter 1

On turn of the century Paris, the dandy and Bohemian life see Jerrold Seigel, *Bohemian Paris*, 1986, and Roger Shattuck, *The Banquet Years*, 1968. The biographical material is drawn from Alice Goldfarb Marquis, *Eros c'est la vie*, 1981, 'Ephemerides', and Tomkins, op. cit. Duchamp's comments on his first paintings are from 'Apropos of Myself', op. cit. Michel Sanouillet describes the intellectual and cultural climate in 'Marcel Duchamp and the French Intellectual Tradition', *Duchamp*, 1973. Baudelaire's 'On the Essence of Laughter...' is translated by John Mayne in *Charles Baudelaire: The Painter of Modern Life and Other Essays*, 1964. For Baudelaire on the dandy see Mayne, op. cit. For Bergson's argument see *Laughter: An Essay on the Meaning of the Comic*, translated by Cloudesley Brereton and Fred Rothwell, 1911. Leszek Kolakowski's *Bergson*, 1985, is a useful introduction to Bergson's thought. The most detailed study of Duchamp's caricatures is in French: Michel Durand-Dessert with Liliane Durand-Dessert, 'Duchamp M'Harcèle: Contribution à une archéologie de Marcel Duchamp', 1975; some of their ideas are summarized in Schwarz, 1997. For Laforgue see Ron Johnson, 'Poetic Pathways to Dada: Marcel Duchamp and Jules Laforgue', *Arts Magazine*, vol. 50, no. 9, May 1976.

Chapter 2

For a fuller account of Catholicism in Duchamp's work see David Hopkins, *Marcel Duchamp and Max Ernst: The Bride Shared*, 1998. Duchamp's early paintings are analysed in Golding, 1973; see also Schwarz's controversial discussion of *Young Man and Girl in Spring* in Schwarz, 1997. For Theosophy in general see Sixten Ringbom and Robert Welsh's essays in *The Spiritual in Art: Abstract Painting 1890–1985*, 1987. Biographical information on Duchamp's family is from Goldfarb Marquis, op. cit., and Tomkins, op. cit. Kupka's influence is discussed in Margit Rowell, 'Kupka, Duchamp and Marey', *Studio International*, no. 189, January–February 1975. The Symbolist background is explored in Golding, 1973, and Hopkins, op. cit.; the Peladanian/Rosicrucian parallels are largely drawn from the latter.

Chapter 3

The interview with George H. Hamilton and Richard Hamilton comes from 'Marcel Duchamp Speaks', *Art, Anti-Art*, 1959. For the paintings of 1912 see Lawrence D. Steefel, Jr, *The Position of Duchamp's 'Glass' in the Development of his Art*, 1977, and 'The Art of Marcel Duchamp', *The Art Journal*, vol. 22, no. 2, winter 1962–63. Signac's treatise is translated as *From Eugène Delacroix to Neo-Impressionism*, 1995. The Marey and Muybridge connections are discussed in Rowell, op. cit., and related to Futurism by Aaron Scharf in *Art and Photography*, 1968. For Futurism and Cubism see John Golding, *Cubism: A History and Analysis 1907–1914*, 3rd revised edition, 1987, and for Futurism in general see Caroline Tisdall and Angelo Bozzola, *Futurism*, 1977. Albert Gleizes and Jean Metzinger's *Du cubisme* is translated in R. L. Herbert, *Modern Artists on Art*, 1964. Puteaux Cubism in general is discussed in Christopher Green, *Léger and the Avant-Garde*, 1976. The human/machine sources of Duchamp's mechanomorphs, such as Villier de L'Isle Adam's *L'Eve future*, 1886, are discussed in Michel Carrouges, *Les Machines célibataires*, 1954, and Jean Clair and Harald Szeeman, *The Bachelor Machines*, 1975. For Roussel's influence see *The Bachelor Machines* and also *Bizarre*, special number on Roussel, nos. 34–35, 1964. For interesting accounts of Duchamp's transitional phase in Munich see Thierry de Duve, 'Resonances of Duchamp's Visit to Munich' in Rudolf Kuenzli and Francis Naumann (eds.), op. cit., and his theoretically demanding *Pictorial Nominalism: On Marcel Duchamp's Passage from Painting to the Readymade*, 1991. Guillaume Apollinaire's important *Les Peintres cubistes*, 1913, is translated as *The Cubist Painters* (1949 and partially in H. B. Chipp, *Theories of Modern Art*, 1968; a new translation by Peter Read is due 1999). Kandinsky's *On the Spiritual in Art*, 1912, is translated in *Collected Works*, 1982. Duchamp's attitudes to gender in the Bride are drawn from Hopkins, op. cit., as are links to Descartes; for the latter see also Jean Clair, 'Duchamp and the Classical Perspectivists', *Artforum*, vol. 16, no. 7, March 1978. Descartes' *Description of the Human Body* in *Philosophical Writings*, vol. 1, translated by Cottingham, Stoothoss and Murdoch, 1985. The interview with William Seitz, 'What's Happened to Art?', was published in *Vogue*, no. 41, 15 February 1963.

Chapter 4

On the Cubist exhibitions see Golding, 1973. Apollinaire on Duchamp is quoted in Chipp, op. cit. For other art criticism by Apollinaire besides *The Cubist Painters*, including the *Le Temps* article 'Art and Curiosity: The Beginnings of Cubism', see L. C. Breunig (ed.), *Apollinaire on Art: Essays and Reviews*, 1972. Léger's account of the 1912 visit to the Salon de la Locomotion Aérienne is from his interview with Dora Vallier, 'La vie fait l'oeuvre de Fernand Léger', *Cahiers d'Art*, no. 3, 1954. For more on Apollinaire's role in Cubism see Katia Samaltanos, *Apollinaire: Catalyst for Primitivism, Picabia and Duchamp*, 1984. The 1956 television interview with James Johnson Sweeney is in *Writings*, 1975. Duchamp's comment about retinal painting appears in Cabanne. The 1961 text Duchamp wrote for the Philadelphia College of Art panel discussion is translated by Helen Meakins as 'Where Do We Go from Here?', *Studio International*, vol. 189, no. 973, January–February 1975 (reprinted Hill, op. cit.). Duchamp's comment about Matisse came from the interview with James Johnson Sweeney, 'The Great Trouble with Art this Century', *Bulletin of Museum of Modern Art*, vol. 13, nos. 4–5, 1946. The quotation from the lecture 'Apropos of Myself' at the City Art Museum of St Louis on 24 November 1964 is in *Duchamp*, 1973. On technical drawing see Molly Nesbit, 'Readymade Originals: The Duchamp Model', *October*, no. 37, summer 1986, and 'The Language of Industry' in Thierry de Duve (ed.), op. cit. The 1953 interview with Dorothy Norman was published in *Art in America*, no. 57, July–August 1969. Many of Alfred Jarry's works are available in translation: see Roger Shattuck and Simon Watson-Taylor (eds.), *Selected Works of Alfred Jarry*, 1965. John Golding made some important connections with Jarry (1973, op. cit.). The 1963 interview with Francis Roberts came from 'I Propose to Strain

the Laws of Physics', *Art News*, vol. 67, no. 8, December 1968. On chance see Harriet Watts, *Chance: A Perspective on Dada*, 1975.

Chapter 5

The notes in *The Box of 1914* are translated in *Writings*, 1975, which also includes *The Green Box* notes, as translated by George Heard Hamilton, but with a different ordering of the notes, also 'authorized' by Duchamp, from that in Richard Hamilton's typographic version of 1960, *Green Box*; *Writings* also includes *A l'Infinitif (The White Box)*, translated by Cleve Gray, 1966, and Arturo Schwarz's translation of the notes 'Cast Shadows' and 'Possible', from his facsimile edition *Notes and Projects for the Large Glass*, 1969. *Marcel Duchamp: Notes*, a facsimile edition of unpublished notes found after Duchamp's death, includes 'Infra-thin' and notes on the 'Large Glass', 'Projects' and 'Word Plays'. For Duchamp in New York, see below, Chapter 6. Ideas about the *Gesamtkunstwerk*, the Pyrophone and Mallarmé's 'book' are indebted to Joseph Rykwert. Jean Clair gives an excellent summary of Duchamp's uses of perspective in the *Large Glass* and elsewhere in 'Marcel Duchamp et la tradition des perspecteurs' in *Abécédaire, Marcel Duchamp*, vol. 3, 1977. The best general accounts of the *Large Glass* remain Golding, 1973, and Octavio Paz, *Marcel Duchamp, or The Castle of Purity*, translated by Donald Gardner, 1970. The scientific and mechanical sources are analysed in Linda Dalrymple-Henderson, *Duchamp in Context: Science and Technology in the 'Large Glass' and Related Works*, 1969; see also Juan Antonio Ramirez, *Duchamp: Love and Death, Even*, translated by Alexander R. Tulloch, 1998; Ivor Davies, op. cit., discusses Marey's physiological experiments. There is a fascinating account of debates about neurasthenia in psychological and scientific circles during the period in Anson Rabinbach, *The Human Motor: Energy, Fatigue and the Origins of Modernity*, 1990. For parallels with alchemy see above, Chapter 3, and for links with western and eastern mythology see Paz, op. cit., and his '* water writes always in * plural' (*Duchamp*, 1973); for an attempt to interpret the workings of the *Large Glass* see Jean Suquet, 'La Mère machine' in Jacqueline Chénieux-Gendron and Marie-Claire Dumas (eds.), *L'Objet au défi*, 1987. The catalogue *Le Macchine Celibi/The*

Bachelor Machines, 1975, is an imaginative and wide-ranging survey of the mechanical-erotic. Alfred Jarry's *The Supermale: A Modern Novel* is translated by Ralph Gladstone and Barbara Wright, 1968. Duchamp's 1959 BBC radio interview is published in Hill, op. cit.

Chapter 6

For Duchamp in New York, see Rudolf Kuenzli and Francis Naumann (eds.), op. cit.; *Making Mischief: Dada Invades New York*, 1996–97, and Francis Naumann, *New York Dada 1915–23*, 1994; Henri-Pierre Roché, *Victor: Marcel Duchamp*, 1977, in *Duchamp*, 1977, vol. 4; Dickran Tashjian, *Skyscraper Primitives: Dada and the American Avant-garde, 1910–1925*, 1975. The most complete account of the *Fountain* scandal, with an interesting analysis of the machine aesthetic in relation to Duchamp is William Camfield, *Marcel Duchamp: Fountain*, 1989. On Duchamp during the Dada period see Dawn Ades, 'Duchamp, Dada and Surrealism' in *Duchamp*, 1984. André Breton's essays 'Marcel Duchamp', 'Clairement' and 'The Characteristics of Modern Evolution and Those Who Participate in It' were collected in his anthology *Les Pas Perdus*, 1924 (translated as *The Lost Steps* by Mark Polizzotti, 1997). Hopkins discusses Duchamp, Picabia and Dada blasphemy in 'Questioning Dada's Potency: Picabia's "La Sainte Vierge" and the Dialogue with Duchamp', *Art History*, vol. 15, no. 3, September 1992. On Rrose Sélavy and photography see Dawn Ades, 'Duchamp's Travesties' in *The Portrait in Photography*, 1992, and David Hopkins, 'Men before the Mirror: Duchamp, Man Ray and Masculinity', *Art History*, vol. 21, no. 3, September 1998. The text 'Men before the Mirror', signed as a 'literary readymade' by Rrose Sélavy is in *Writings*. Amelia Jones offers a feminist reading of Rrose Sélavy in *Postmodernism and the en-gendering of Marcel Duchamp*, 1994.

Chapter 7

Duchamp's remarks on the origin of the readymades are from the 1963 interview with Francis Roberts, op. cit., and the 1961 talk 'Apropos of Readymades', op. cit. His letter to Suzanne is quoted in Schwarz, 1997. Boccioni's 'Technical Manifesto of Futurist Sculpture' is translated in Apollonio, *Futurist Manifestoes*, 1973. Fascinating material has recently emerged on Duchamp's language in relation to the readymades, such as Molly Nesbit and Naomi

Sawelson-Gorse in Martha Buskirk and Mignon Nixon (eds.), *The Duchamp Effect*, 1996; see also Dalia Judovitz, *Unpacking Duchamp: Art in Transit*, 1995, and Katrina Martin, 'Marcel Duchamp's "Anémic-Cinéma"', *Studio International*, vol. 189, no. 973, January–February 1975. Jerrold Seigel's comment on the readymades is from *Bohemian Paris*, 1986. Surveys of the readymades occur in Walter Hopps, Ulf Linde, Arturo Schwarz, *Marcel Duchamp: Readymades, Etc. (1913–64)*, 1964, and more recently and exhaustively in André Gervais, *La Raie-alitée d'effets*, 1984. There is a controversial philosophical interpretation by Thierry de Duve, *Kant after Duchamp*, 1996, and a much earlier and famous discussion by Richard Wollheim, 'Minimal Art', 1961, reprinted in Gregory Battcock (ed.), *Minimal Art*, 1968. For Duchamp and Marx's theory of commodity fetishism see David Joselit, *Infinite Regress: Marcel Duchamp 1910–41*, 1998. Interpretations of the readymades as 'blagues' or jokes can be found in Jeffrey Weiss, *The Popular Culture of Modern Art: Picasso, Duchamp and the Avant-Garde, c. 1909–17*, 1994, and Roger Shattuck, 'Marcel Duchamp', *The Innocent Eye*, 1984. Duchamp's letters to Picabia and to Jacques Doucet about the Monte Carlo experiment are in *Writings*, 1975. On Duchamp's optical interests see also Rosalind Krauss, *The Optical Unconscious*, 1993.

Chapter 8

Ecke Bonk, *Marcel Duchamp: The Portable Museum: The Making of the Boîte-en-valise De ou par Marcel Duchamp ou Rrose Sélavy*, 1989, gives a meticulous account of the conception and production of Duchamp's *Boîte*. Henri-Pierre Roché's unpublished diary is quoted by Bonk. Walter Benjamin discusses the loss of 'aura' in relation to film and Dada montage in 'The Work of Art in the Age of Mechanical Reproduction', *Illuminations*, 1977; for Benjamin's more nostalgic account of the loss of aura see 'The Small History of Photography', *One Way Street*, 1979. The 'infra-thin' notes are translated in *Notes*, 1980. For an interesting reading of Duchamp's *With My Tongue in My Cheek* see Rosalind Krauss, 'Notes on the Index: Seventies Art in America', *October*, no. 3, spring 1977. Breton's critique of the Surrealist object is from *Les Vases communicants*, 1932.

Chapter 9

Anne d'Harnoncourt and Walter Hopps, '*Etant donnés: 1. La chute d'eau 2. Le gaz*

d'éclairage': Reflections on a New Work by Marcel Duchamp, April–September 1969, was the first account of the posthumous work, and explored its relations with the *Large Glass*. A facsimile of Duchamp's installation manual *Etant donnés* was published by the Philadelphia Museum of Art in 1987. On the gender ambiguity of *Etant donnés* see Jean-François Lyotard, *Les Transformateurs Duchamp*, 1977 (translated as *Duchamp's Trans/formers* by Ian McLeod, 1990). See also Dalia Judovitz, op. cit. The Maxime Ducamp quotation is taken from '*Les Yeux les plus secrets': André Masson chez Gustave Courbet*, 1991. 'The Creative Act' lecture given at the American Federation of the Arts, Houston, April 1957, is found in *ARTNews*, vol. 56, no. 4, spring 1977.

Postscript

For Duchamp's legacies in general, see John Tancock, 'The Influence of Marcel Duchamp' in *Duchamp*, 1973; Robert L. Pincus, '"Quality Material": Duchamp Disseminated in the Sixties and Seventies' in Bonnie Clearwater (ed.), *West Coast Duchamp*, 1991; Lynne Cooke, 'Reviewing Picabia, Man Ray, Duchamp et. al.' in *The Readymade Boomerang: Certain Relations in 20th-Century Art*, 1990; Edouard Jaguer and Jean-Jacques Lebel, *After Duchamp*, 1991; and the interviews and essays in Martha Buskirk and Mignon Nixon (eds.), op. cit. For Duchamp's reception in 'American Postmodernism' see Amelia Jones, op. cit. Calvin Tomkins gives anecdotal accounts of Duchamp's relationships with Rauschenberg and Cage in *The Bride and the Bachelors: The Heretical Courtship in Modern Art*, 1965. For Jasper Johns see Max Kozloff, 'Johns and Duchamp' in Joseph Mashek (ed.), *Marcel Duchamp in Perspective*, 1975, and Kirk Varnedoe (ed.), *Jasper Johns: A Retrospective*, 1996. Richard Hamilton's writings on Duchamp appear in Richard Hamilton, *Collected Words 1953–1982*, 1982.

List of Illustrations

43 *Virgin, No. 1*, 1912. Graphite on paper, 42.8 × 22 (16⅞ × 8⅝). Philadelphia Museum of Art: A. E. Gallatin Collection

44 *Virgin, No. 2*, 1912. Watercolour and pencil on paper, 40 × 25.7 (15¾ × 10⅛). Philadelphia Museum of Art: Louise and Walter Arensberg Collection

45 Leonardo da Vinci, *Coition of Hemisected Man and Woman* (detail) from *Quaderni d'Anatomia*, folio 3v, between 1492 and 1494. Pen and ink, 27.3 × 20.2 (10¾ × 8). The Royal Collection © Her Majesty Queen Elizabeth II

46 Fernand Léger, *The Wedding*, 1911–12. Oil on canvas, 257 × 206 (101⅛ × 81⅛). Musée National d'Art Moderne. Centre National d'Art et de Culture Georges Pompidou, Paris, don Alfred Flechtheim. © ADAGP, Paris and DACS, London 1999

47 *Bride*, 1912. Oil on canvas, 89.5 × 55 (35¼ × 21⅝). Philadelphia Museum of Art: Louise and Walter Arensberg Collection

48 Georges Rouault, *The Bride*, 1907. Oil on paper, 74.9 × 105.4 (29½ × 41½). Tate Gallery, London. © ADAGP, Paris and DACS, London 1999

49 Pablo Picasso, *Man with a Mandolin*, 1911. Oil on canvas, 162 × 71 (63¾ × 28). Musée Picasso, Paris. © Succession Picasso/DACS 1999

50 Odilon Redon, *Tête humaine (Human Head)* from *Homage to Goya*, plate 2, 1885. Lithograph, 27.5 × 20.5 (10⅞ × 8). © The British Museum

51 Wright of Derby, *The Alchemist*, 1771, but dated 1795. Oil on canvas, 101.5 × 127 (40 × 50). Derby City Art Gallery

52 *Aeroplane*, 1912. Wash on paper, 22.9 × 12.7 (9 × 5). The Menil Collection, Houston

53 *Portrait of Gustave Candel's Mother*, 1911–13. Oil on canvas, 61 × 43.5 (24 × 17⅛). Collection Yolande Candel, Paris

54 Francis Picabia, *Ass*, 1917, from *391*, Volume V, p. 1. © ADAGP, Paris and DACS, London 1999

55 *Chocolate Grinder, No. 1*, 1913. Oil on canvas, 62 × 65 (24⅜ × 25⅝). Philadelphia Museum of Art: Louise and Walter Arensberg Collection

56 *Chocolate Grinder, No. 2*, 1914. Oil and thread on canvas, 65 × 54 (25⅝ × 21⅜). Philadelphia Museum of Art: Louise and Walter Arensberg Collection.

57 *Study for the Chocolate Grinder's Leg*, 1914. Charcoal on torn tracing paper, 14.3 × 10 (5⅝ × 3¹⁵⁄₁₆). Collection Dina Vierny, Paris

58 A water mill. Engraving from Diderot and d'Alembert, *Encyclopédie*, 1762

59 *Network of Stoppages (Réseaux des stoppages)*, 1914. Oil and pencil on canvas, 148.9 × 197.7 (58⅝ × 6' 5⅝). The Museum of Modern Art, New York. Abby Aldrich Rockefeller Fund and gift of Mrs. William Sisler. Photograph © 1998 The Museum of Modern Art, New York

60 *3 Stoppages Etalon (3 Standard Stoppages)*, 1913–14. Assemblage: three threads glued to three painted canvas strips, 13.3 × 120 (5¼ × 47¼), each mounted on a glass panel, 18.4 × 125.4 × .6 (7¼ × 49⅜ × ¼); three wood slats, 6.2 × 109.2 × .2 (2½ × 43 × ⅛), 6.1 × 119.5 × .2 (2½ × 47 × ⅛), 6.3 × 109.7 × .2 (2½ × 43¼ × ⅛), shaped along one edge to match the curves of the threads; the whole fitted into a wood box, 28.2 × 129.2 × 22.7 (11⅛ × 50⅞ × 9). The Museum of Modern Art, New York. Katherine S. Dreier Bequest. Photograph © 1998 The Museum of Modern Art, New York

61 *La Mariée mise à nu par ses célibataires, même (The Bride Stripped Bare by Her Bachelors, Even)*, known as the *Large Glass*, 1915–23. Oil and lead wire on glass, 278 × 176.5 (109¼ × 69½). Philadelphia Museum of Art: Bequest of Katherine S. Dreier

62 Diagram based on Duchamp's etching entitled *The Large Glass Completed*, 1965

63 and 64 *The Box of 1914*, 1913–14. Exterior of box: Kodak box for photographic paper, 25 × 18.5 (9⅞ × 7¼). Photograph from Arturo Schwarz, Milan. Contents of box: facsimiles of 16 manuscript notes and a drawing, mounted on 15 boards, each 25 × 18.4 (9⅞ × 7¼), contained in a cardboard box. Philadelphia Museum of Art

65 *Nine Malic Moulds*, 1914–15. Oil, lead wire and sheet lead on glass (cracked 1915), mounted between two glass plates, 66 × 101.2 (26 × 39¹³⁄₁₆). Ex-collection Alexina Duchamp

66 *Glider Containing a Water Mill in Neighbouring Metals*, 1913–15. Oil and lead wire on glass, mounted between two glass plates, 153 × 83.5 (60¼ × 33). Philadelphia Museum of Art: Louise and Walter Arensberg Collection

67 Man Ray, *Dust Breeding*, 1920. Gelatine silver print from original negative, 7.2 × 11 (2¹³⁄₁₆ × 4⅜). Photograph from Arturo Schwarz © Man Ray Trust/ADAGP, Paris and DACS, London 1999

68 The *Large Glass* in Katherine S. Dreier's library. Photograph, c. 1936

69 The *Large Glass* in front of a window, 1958. Hand-coloured photograph, 30.8 × 21.2 (12⅛ × 8¾)

70 *Draught Piston*, 1914. One of three photographs determining the outlines of the irregular square of the top of *The Bride Stripped Bare by Her Bachelors, Even*, 1915–23. Gelatine silver-print 59.5 × 49.3 (23⁷⁄₁₆ × 19¾). The Philadelphia Museum of Art: Gift of Mme Marcel Duchamp

71 Steam-powered reaper by Aveling and Porter. Engraving from *Implement and Machinery Review*, 1876

72 *Le Célibat broie son chocolat lui-même (The Bachelor Grinds His Chocolate Himself)*, 1913. Ink on paper, 13 × 21 (5⅛ × 8¼). Private collection, Greenwich, Connecticut

73 *The Large Glass Completed*, 1965. Coloured etching, 50 × 33 (19¹¹⁄₁₆ × 13) in Arturo Schwarz, *The Large Glass and Related Works*, 1968

74 *Buffer of Life*, 1913–15. Manuscript note in pencil and violet ink on irregularly torn paper, 20 × 9.9 (7⅞ × 3⅞). Marcel Duchamp Archives, France

75 *Cemetery of Uniforms and Liveries, No. 1*, 1913. Pencil on paper, 32 × 40.5 (12⅝ × 15¾). Philadelphia Museum of Art: Louise and Walter Arensberg Collection

76 *Cemetery of Uniforms and Liveries, No. 2*, 1914. Watercolour and pencil, 66 × 99.8 (26 × 39¼). Yale University Art Gallery, Gift of Katherine S. Dreier to the Collection Société Anonyme

77 *Studies for the Bachelors in the Cemetery of Uniforms and Liveries, No. 2*, 1913–14. Pencil on paper, 21.3 × 16.5 (8¾ × 6½). Collection Sherry Hope Mallin, New York

78 *The Bride Stripped Bare by Her Bachelors, Even (Study)*. Pencil on tracing cloth, 33 × 28 (13 × 11). Collection Jacqueline Matisse Monnier, France

79 The Bachelors' Domain, 1918. Photograph, 6.2 × 8.6 (2⁷⁄₁₆ × 3⅜). Whereabouts unknown

80 *Oculist Witnesses*, 1920. Stylus on carbon paper, 50 × 37.5 (19⅝ × 14¾). Philadelphia Museum of Art: Louise and Walter Arensberg Collection

81 Albrecht Dürer, *Artist and Model*, illustration to *The Painter's Manual*, second edition, 1538

82 Jean Du Breuil, illustration from *La Perspective pratique*, 1642

83 Photograph of Duchamp using a hinged mirror, 1917

84 *To Have the Apprentice in the Sun*, 1914. India ink, pencil and grey wash on music paper, 27.3 × 17.2 (10⅝ × 6¹¹⁄₁₆). Philadelphia Museum of Art: Louise and Walter Arensberg Collection

85 Titian, *Assumption of the Virgin*, 1516–18. Oil on panel, 690 × 360 (271⅝ × 141¾). Sta Maria Gloriosa dei Frari, Venice

86 Francis Picabia, *Girl Born without a Mother*, 1915. Pen and ink on paper, 26.7 × 21.6 (10⅝ × 8½). The Metropolitan Museum of Art, New York. The Alfred Stieglitz Collection, 1949. © All rights reserved. The Metropolitan Museum of Art. © ADAGP, Paris and DACS, London 1999

87 From the notes found after Duchamp's death, published in facsimile with translations by Paul Matisse, 1980 (no. 162 recto)

88 Cover of *The Blind Man, No. 1*, April 1917

89 Cover of *The Blind Man, No. 2*, May 1917

90 Francis Picabia, *Portrait of a Young American Girl in the State of Nudity*, reproduced in *291*, nos. 5/6, July/August 1915. © ADAGP, Paris and DACS, London 1999

91 *A Sellers Ten Ton Swinging Crane Jib* in the 'Moving Sculpture Series' from *The Soil*, no. 2, January 1917

92 *Fountain*, 1917. Assisted readymade: porcelain urinal turned on its back. Original lost, dimensions not recorded. Photograph Alfred Stieglitz

93 Morton Schamberg with Baroness Elsa von Freytag-Loringhoven, *God*, c. 1917. Wooden mitre-box and cast iron plumbing trap, height 26.5 (10½). Philadelphia Museum of Art: Louise and Walter Arensberg Collection

94 *L.H.O.O.Q.*, 1919. Rectified readymade: reproduction of Leonardo da Vinci's *Mona Lisa*, to which Duchamp added moustache, goatee and title in pencil, 19.7 × 12.4 (7¾ × 4⅞). Private collection, Paris

95 Francis Picabia, *Tableau Dada par Marcel Duchamp* in *391*, March 1920, No XII, p. 1. © ADAGP, Paris and DACS, London 1999

96 *To Be Looked At (From the Other Side of the Glass) with One Eye, Close To, for Almost an Hour*, 1918. Oil paint, silver leaf, lead wire and magnifying lens on glass (cracked), 49.5 × 39.7 (19½ × 15⅝), mounted between two panes of glass in standing metal frame, 51 × 41.2 × 3.7 (20⅛ × 16¼ × 1½), on painted wooden base, 4.8 × 45.3 × 11.4 (1⅞ × 17⅞ × 4½). Overall height 55.8 (22): glass (cracked) 49.5 × 39.7 (19½ × 15⅝); metal frame 51 × 41.2 × 3.7 (20⅛ × 16¼ × 1½); on painted wood base 4.8 × 45.3 × 11.4 (1⅞ × 17⅞ × 4½). The Museum of Modern Art, New York. Katherine S. Dreier Bequest. Photograph © 1998 The Museum of Modern Art, New York

97 Cover of *New York Dada*, 1921

98 and 99 Marcel Duchamp as Rrose Sélavy. Photographs by Man Ray, 1921 and 1924? © Man Ray Trust/ADAGP, Paris and DACS, London 1999

100 *Monte Carlo Bond*, 1924. Imitation assisted readymade: photocollage on letterpress, mounted on flat cardboard holder, 31.5 × 19.5 (12⅜ × 7¹¹⁄₁₆)

101 Michelangelo Buonarroti, *Moses*, c. 1515. Marble. S. Pietro in Vincoli, Rome

102 Rrose Sélavy, 1938. Female wax mannequin dressed in Duchamp's clothes, with a red electric lamp in her breast pocket. Whereabouts unknown, dimensions not recorded

103 *Young Cherry Trees Secured Against Hares*, 1946. Cover for a volume of poetry by André Breton. National Gallery of Modern Art, Edinburgh

104 *Prière de toucher (Please Touch)*, 1947. Cover for the de luxe edition of *Le Surréalisme en 1947*. Modified readymade: collage of foam-rubber breast and velvet mounted on board, 25 × 22.8 (10 × 9). Collection Robert Shapazian, Los Angeles, California

105 Coal bags suspended from the ceiling over a brazier, 1938. Installation shot from the 'Exposition Internationale du Surréalisme', held at the Galerie Beaux-Arts, Paris

106 Photograph of the installation for the exhibition for the 'First Papers of Surrealism', an exhibition for the Coordinating Council of French Relief Societies, New York, 1942

107 *Duchamp's Compensation Portrait* from the *First Papers of Surrealism* catalogue, 1942. Photograph Ben Shahn. © Estate of Ben Shahn/DACS, London/VAGA, New York 1999

108 Eugène Atget, *Fountain at Berne, Switzerland*, with rack for drying bottles, c. 1900. Photograph

109 *Bicycle Wheel*, 1913, original lost; 1964 version. Assisted readymade: bicycle wheel and fork mounted upside down on a kitchen stool painted white, height 126.5 (49¹³⁄₁₆). Photograph from Arturo Schwarz

110 *Bottle Dryer (Bottlerack)*, 1914, original lost; 1964 version. Readymade: galvanized iron bottlerack, height 64.2 (25¼). Photograph from Arturo Schwarz

111 Man Ray, *Man*, 1918. Photograph Man Ray. Musée National d'Art Moderne, Centre Georges Pompidou, Paris. © Man Ray Trust/ADAGP, Paris and DACS, London 1999

112 Pablo Picasso, *Glass of Absinth*, 1914. Painted bronze with sand and perforated absinth spoon, 21.5 × 16.5 × 8.5 (8½ × 6½ × 3⅜). Musée National d'Art Moderne, Centre Georges

Pompidou, Paris. Gift of Louise and Michel Leiris, the donors retaining a life interest. © Succession Picasso/DACS 1999

113 *Pharmacy*, 1914. Rectified readymade: gouache on a commercial print, 26.2 × 19.2 (10¹⁵⁄₁₆ × 7⁹⁄₁₆). Collection Arakawa, New York

114 *In Advance of the Broken Arm*, 1915, original lost; 1945 version. Readymade: wood and galvanized-iron snow shovel, height 121.3 (47¾). Yale University Art Gallery, Gift of Katherine S. Dreier

115 Duchamp's studio in New York, showing *In Advance of the Broken Arm*, *Fountain* and *Hat Rack* suspended from the ceiling. Photograph, c. 1917

116 Anon., photograph of the 'painter Boronali'

117 *Comb*, 1916. Readymade: grey steel dog comb, 16.6 × 3 × .3 (6½ × 1⅛ × ⅛). Philadelphia Museum of Art: Louise and Walter Arensberg Collection

118 *Rendez-vous du dimanche 6 février à 1 h. ¾ après-midi*, 1916. Typewritten text and ink on four postcards, with tape, 28.5 × 16.5 (11¼ × 6½). Philadelphia Museum of Art: Louise and Walter Arensberg Collection

119 *Paris Air (50 cc of Paris Air)*, 1919. Readymade: 50 cc of Paris Air in a glass ampoule (broken and later restored). On printed label: *Sérum Physiologique*. 13.5 (5¼) high, 20.5 (8⅛) circumference. Philadelphia Museum of Art: Louise and Walter Arensberg Collection

120 *Pliant de voyage (Traveller's Folding Item)*, 1916, original lost; 1964 version. Underwood typewriter cover. Readymade: height 23 (9¹⁄₁₆). Photograph from Arturo Schwarz

121 *Sculpture de voyage (Sculpture for Travelling)*, 1918, original lost. Rubber and string, dimensions variable. Photograph

122 *Trébuchet (Trap)*, 1917, original lost; 1964 version. Readymade: coat rack nailed to the floor, 11.7 × 100 (4⅝ × 39⅜). Photograph from Arturo Schwarz

123 *Hat Rack*, 1917, original lost; 1964 version. Hat rack suspended from the ceiling, height 70 (27⅝). Photograph from Arturo Schwarz

124 and 125 *With Hidden Noise*, 1916. Readymade: ball of twine in brass frame, height 12.5 (5). Philadelphia Museum of Art: Louise and Walter Arensberg Collection

126 *Why Not Sneeze Rose Sélavy?*, 1921. Semi-readymade: marble cubes in the shape of sugar lumps, a thermometer and a cuttlebone in a small birdcage, 11.4 × 22 × 16 (4½ × 8⅝ × 6⁵⁄₁₆). Philadelphia Museum of Art: Louise and Walter Arensberg Collection

127 *Fresh Widow*, 1920. Miniature French window, painted wood frame and eight panes of glass covered with black leather, 77.5 × 44.8 (30½ × 17⅝), on wood sill 1.9 × 53.4 × 10.2 (¾ × 21 × 4). The Museum of Modern Art, New York. Katherine S. Dreier Bequest. Photograph © 1998 The Museum of Modern Art, New York
128 *Tzanck Cheque*, 1919. Ink on paper, 21 × 38.2 (8¼ × 15¹⁄₁₆). Collection Arturo Schwarz, Milan. Promised gift to the Israel Museum, Jerusalem
129 *Belle Haleine, eau de voilette (Beautiful Breath, Veil Water)*, 1921. Assisted readymade: Rigaud perfume bottle with label created by Duchamp and Man Ray. Bottle 15.2 (6) high. Photograph from Arturo Schwarz
130 *Rotoreliefs (Optical Disks)*, 1935, edition of 500. Set of six cardboard disks, printed on both sides in colour offset lithography, each 20 (7⅞) in diameter
131 *Rotary Glass Plates (Precision Optics)*, 1920. Motorized optical device: five painted glass plates (braced with wood and metal) turning on a metal axle; largest blade, set vertically, 166.3 (64⅞) high; at base 120.6 × 184.1 (47½ × 72½). Yale University Art Gallery. Gift of the Société Anonyme
132 *Rotary Demisphere (Precision Optics)*, 1925. Motor-driven construction: painted wood demisphere, fitted on black velvet disk, copper collar with plexiglass dome, motor, pulley and metal stand, 148.6 × 64.2 × 60.9 (58½ × 25¼ × 24). The Museum of Modern Art, New York. Gift of Mrs. William Sisler and Edward James Fund. Photograph © 1998 The Museum of Modern Art, New York
133 *Tu m'*, 1918. Oil on canvas, with bottle brush, three safety pins, and one bolt, 69.8 × 313 (27¼ × 10' 3").Yale University Art Gallery. Gift from the Estate of Katherine S. Dreier
134 Duchamp demonstrating the open *Boîte-en-valise*, New York. Photograph, 1942
135 *Paysage fautif (Wayward Landscape)*, 1946. Seminal fluid on Astralon, backed with black satin, 21 × 17 (8¼ × 6¹¹⁄₁₆). The Museum of Modern Art, Toyama, Japan
136 *Of or by Marcel Duchamp or Rrose Sélavy* (the *Boîte-en-valise*), 1935–41; 1941 version. Miniature replicas and colour reproductions of works by Duchamp contained in a cloth-covered cardboard box enclosed in a case of leather, imitation leather or cloth-covered board. De luxe edition of 20 Boxes enclosed in leather cases, numbered I/XX–XX/XX; box,

c. 39 × 35 × 8 (15 × 14 × 3); case, *c.* 41 × 38 × 10.5 (16 × 15 × 4) (size given in subscription bulletin differs: 40 × 40 × 10 (15¾ × 15¾ × 3⅞)). Philadelphia Museum of Art: Louise and Walter Arensberg Collection
137 Photograph of *Sonata* (1911), with colour notes for pochoir colouring, 1936, 24 × 18 (9.4 × 7.1)
138, 139 and 140 *Fountain*, model for the miniature in the *Boîte-en-valise*, 1938. Papier mâché covered with paper metal components varnished, 8.9 × 4.5 (3.5 × 1.8)
141 *Fountain*, 1938. Miniature ceramic model produced for the *Boîte-en-valise*
142 *Why Not Sneeze Rose Sélavy*, 1921. Photograph taken in 1940 for the miniature in the *Boîte-en-valise*. Enamel paint, marble, wood, thermometer, 7.2 × 12.1 (3 × 4⁹⁄₁₆)
143 and 144 *Couple of Laundress's Aprons*, 1959. Rectified readymade: two potholders (male and female) cloth and fur, male 20.3 × 17.7 (8 × 6¹⁵⁄₁₆); female 20.5 × 19.8 (8¹⁄₁₆ × 7¹³⁄₁₆)
145 *Feuille de vigne femelle (Female Fig Leaf)*, 1950. Galvanized plaster, 9 × 14 × 12.5 (3⁹⁄₁₆ × 5½ × 4¹⁵⁄₁₆). Collection Jasper Johns, New York
146 Cover for *Le Surréalisme, même*, winter 1956
147 *Objet-Dard (Dart-Object)*, 1951. Galvanized plaster with inlaid lead rib, 7.5 × 20.1 × 6 (2¹⁵⁄₁₆ × 7¹⁵⁄₁₆ × 2⅜). Ex-collection Alexina Duchamp, France
148 *Coin de chasteté (Wedge of Chastity)*, 1954. Sculpture in two interlocking parts: galvanized plaster for the wedge and dental plastic for the base: overall 5.6 × 8.6 × 4.2 (2³⁄₁₆ × 3⅜ × 1⅝). Ex-collection Alexina Duchamp, France
149 *With My Tongue in My Cheek*, 1959. Sculpture-drawing: plaster on pencil and paper, mounted on wood, 25 × 15 × 5.1 (9¹³⁄₁₆ × 5⅞ × 2). Musée National d'Art Moderne, Centre d'Art et de Culture Georges Pompidou, Paris
150 *Etant donnés: 1. La chute d'eau 2. Le gaz d'éclairage (Given: 1. The Waterfall 2. The Illuminating Gas)*, 1946–66. View of door. Mixed media assemblage, approximately 242.5 × 177.5 (95½ × 70). Philadelphia Museum of Art: Gift of the Cassandra Foundation
151 *Etant donnés*. View through door. Philadelphia Museum of Art: Gift of the Cassandra Foundation
152 *Le Gaz d'éclairage et la chute d'eau (The Illuminating Gas and the Waterfall)*, 1948–49. Painted leather over plaster relief, mounted on velvet, 50 × 31 (19¹¹⁄₁₆ × 12³⁄₁₆). Moderna Museet, Stockholm. Gift of Tomas Fischer, in honour of Ulf Linde

153 *Etant donnés: Maria, la chute d'eau et le gaz d'éclairage (Given: Maria, the Waterfall and the Illuminating Gas)*, 1947. Pencil on paper, 40 × 29 (15¾ × 11⁷⁄₁₆). Moderna Museet, Stockholm. Gift to the Museum dedicated to Ulf Linde from Tomas Fischer, 1985
154 Note from *The Green Box*
155, 156 and 157 Pages from Duchamp's installation manual for *Etant donnés* (1946–66), published in 1987
158 Gustave Courbet, *Origine du monde*, 1866. Oil on canvas, 46 × 55 (18⅛ × 21⅝). Musée d'Orsay, Paris
159 Hans Bellmer, *La Poupée (Doll)*, 1938. Photograph. © ADAGP, Paris and DACS, London 1999
160 Robert Rauschenberg, *Bed*, 1955. Combine painting: oil and pencil on pillow, quilt and sheet on wood supports, 191.1 × 80 × 20.3 (6'3¾ × 31½ × 8). The Museum of Modern Art, New York. Gift of Leo Castelli in honour of Alfred H. Barr, Jr. Photograph © 1999 The Museum of Modern Art, New York © Robert Rauschenberg/DACS, London/ VAGA, New York 1999
161 Jasper Johns, *Target with Plaster Casts*, 1955. Encaustic and collage on canvas with plaster casts, 129.5 × 111.8 (51 × 44). Private collection © Jasper Johns/DACS, London/VAGA, New York 1999
162 Eva Hesse, *Right After*, 1969. Fibreglass, *c.* 152.4 × 548.64 × 121.92 (*c.* 5 × 18 × 4'). Milwaukee Art Museum, Gift of Friends of Art. © The Estate of Eva Hesse
163 Joseph Beuys, *The Silence of Marcel Duchamp is Overrated*, 1964. Action tool, paper, oil colour, ink, felt, chocolate and photograph, 157.8 × 178 × 2 (61¼ × 70⅛ × ¾). Stiftung Museum Schloss Moyland, Collection van der Grinten, MSM 03087. © DACS 1999
164 *Wanted: $2000 Reward*, 1923. Rectified readymade: 'Wanted' poster, 49.5 × 35.5 (19½ × 14), with photographs and the name 'RROSE SELAVY' added

Index

Figures in *italic* refer to illustrations